Working with style

Working with style

Traditional and modern approaches
to layout and typography

Suzanne West

Watson-Guptill Publications / New York

A Read/Write Press book

First published in 1990 in New York by Watson-Guptill
Publications, a division of BPI Communications, Inc.,
1515 Broadway, New York, N.Y. 10036

Library of Congress Cataloging-in-Publication Data

West, Suzanne.
 Working with style : traditional and modern
approaches to layout and typography / Suzanne West.
 p. cm.
 Includes bibliographical references.
 ISBN 0–8230–5872–7
 1. Printing, Practical—Layout. 2. Printing, Practical—
Style manuals. 3. Type and type-founding. I. Title.
Z246.W48 1990
686.2'24—dc20 90–33522
 CIP

Distributed in the United Kingdom by Phaidon Press Ltd.,
Littlegate House, Ebbe's Street, Oxford

Distributed in Europe, the Far East, Southeast and Central
Asia, and South America by RotoVision S.A., 9 Route
Suisse, CH-1295 Mies, Switzerland

Manufactured in the United States of America

First printing, 1990

1 2 3 4 5 6 7 8 9 10 / 95 94 93 92 91 90

Acknowledgments

I wish to thank the many people who have helped me with this book: Randy Moravec, not only for his design contributions, invaluable observations, and technical advice, but for his unwavering good humor; my family, for their moral support; past and present students for their questions, spirit, responsiveness, individuality, and quest for knowledge and understanding of design; the Graphics Programs of the University of California, Santa Cruz, Extension for providing an environment in which to develop my ideas, and Judy Rose, whose encouragement, confidence, and understanding made such an environment possible; Catherine Lush and Penelope West for their production support; Dorothy Spencer of Read/Write Press, not only for setting the wheels in motion, but for her continued support throughout the project; Barbara Fishman, Carl Rosen, and Penelope West for their patient editing; Watson-Guptill, particularly Mary Suffudy and Candace Raney, for helping to make this book possible; the many designers and instructors who have shared their valuable time and thoughts, including André Gürtler, Wolfgang Weingart, and Lisa Pomeroy at the Design School at Basel, Kathryn Stark, and Ed Seubert; and the following contributors: Randy Moravec, Russell Leong, and Mitchell Mauk for design examples; Felicia Rice of Moving Parts Press and Terry Moran of Drager & Mount for typography samples.

To my parents, who taught
me to see both sides of
every issue

Contents

Preface

This book provides an overview of two quite different approaches to the printed page: the traditional style, which reflects the classic aesthetics of the Renaissance; and the modern style, which reflects a German-Swiss design philosophy. The concept for this book was developed in response to persistent requests from students over the years for design rules. The universal design rules they are seeking do not exist: A design problem, by nature, has no single correct solution; we cannot look in the back of the book to see if we are right.

A formal design process provides guidance for establishing design objectives and creating concepts, but it offers little guidance during implementation, the phase in which a concept is converted into reality. During the implementation of a design concept, a multitude of small design decisions about layout and typography are made, and these decisions, at least as much as the concept itself, determine the relative success or failure of the design as a whole. This book provides a foundation on which to base these decisions.

Although there are no universal design rules, a set of rules can be determined for a specific style, then used for working within that style. This approach ensures a basic design integrity and cohesiveness. Each of the two basic communication styles presented in this book has its own set of rules; this book, then, could be thought of as a kind of rule book for two games of design.

As with other games, if we mix up the two sets of rules there may be no way to win. As with other games, there are endless variations—each play of the game is different from the last. The better we understand the rules and strategies of a game, the more likely it is that we will win consistently. As with other games, we can only win if we actively participate in playing the game—we cannot win if we remain passive observers.

It's important to have something solid to deviate from.

—William Safire

Introduction

A society evolves in relation to its environment and its history; its culture is manifested through its artifacts—such diverse objects as icons, architecture, clothing, and the printed page. Specific styles for these artifacts emerge as outward expressions of a society's underlying philosophies and attitudes. We can gauge the amount of change within a society by studying the degree of change in the style of its artifacts. The style that endures within a society is that which best reflects it, and this is the style considered traditional within it. Those within a society learn their traditional style but tend to be unaware that they have done so; they often view their traditional style as natural, instinctive, and right.

The traditional style of Western society reflects classical Greek and Roman aesthetics; our touchstone is the Renaissance, during which classical aesthetics were revived and redefined. Printing was invented during the Renaissance; the traditional printed page reflects classical aesthetics and has changed little since the Venetian page of the early 1500s. Generations have worked in the traditional style, and although variations have emerged from time to time and regional differences have arisen, these differences have all been within the framework of the traditional style.

At the beginning of this century, however, as society was undergoing change, a new, modern style began to emerge. Dismissed for decades by many traditional typographers as a whim, this modern style has nevertheless taken root and has developed into a comprehensive new approach to layout and typography. The modern style is as radically different from the traditional style as our urban industrialized society is radically different from the Europe of the 1500s. The modern style is based on a philosophical and aesthetic foundation different from the traditional; it reflects the needs of modern society.

Most of us are familiar with both styles to some degree and have inadvertently absorbed parts of each. Exposure to styles with conflicting goals, however, leads us to develop conflicting preconceptions of design. To understand the basis for these preconceptions and resolve the conflicts, we must learn and understand each of these key styles. This understanding will provide not only a framework in which to make design decisions, but a basis on which to build a deeper understanding of layout and typography.

Structural style

Establishing the rules

Although basic design and visual principles are a common foundation for both art and graphic design, any further connection between art and graphic design tends to relate only to the way in which the page is decorated or illustrated. The typography and fundamental structure of a page remain largely unchanged by trends in art.

The basic structural style of our printed communication is taken for granted because it has changed so little for so long a time: the traditional style has lasted for over five hundred years, and only in the past forty years has the modern style begun to replace it.

Although numerous decorative styles occurred during this five-hundred-year period, these were applied to the surface of the page and did not alter its structural style. Beneath the Art Nouveau decoration on a page from the 1880s, for example, we find traditional typography on a traditionally structured page; beneath the geometric shapes and flying elements on the New Wave page of the 1980s we find modern typography and a grid structure.

When we strip away the decorative and expressive elements on a printed page, we find that the page falls into one of two general style categories—traditional or modern. A page that does not fall clearly into one category or the other is likely to be one on which the typography of one style has been combined with the structure of the other.

The structure of a page is a fundamental part of visual communication. Whereas the decorative and expressive aspects of the page may be understood and implemented only by the designer, the structure of the page must be understood by the writer, the typesetter, and the production artist as well, because all make decisions that directly affect the outcome of the design.

A style can be thought of as a closed circle; within the circle is an established aesthetic from which a definitive set of rules can be extracted. By following these rules we can produce new pieces that fit within the parameters of the style. Within such a framework there are right ways and wrong ways to proceed—a different set of rules would be followed for a dada style, for example, than for Art Nouveau.

It is seldom that such rules are defined in advance; it is more likely that we identify pieces as a group or style well after they were created. Because categories are created and rules are extrapolated after the fact, however, does not negate the value of categorizing works and extrapolating rules.

The rules we extract from a style embody characteristics of many pieces within that style; following these rules, we often create pieces that are stereotypical—they have more of the qualities of a style than some of the original pieces within it. Care must be taken not to exaggerate the qualities of a style, however, or a caricature is created instead.

Working within a style is not like copying— copying a specific piece is a good learning experience but an ineffective way to produce original design solutions. Existing printed pieces can act only as models and points of departure. Working within a structural style provides a framework in which creative problem solving can occur.

The benefits of learning a style

Most design education today provides neither a grounding in the traditional style and its classic aesthetics nor a clear understanding of the modern page, with its grids and asymmetry. Instead, we learn layout and typography in a somewhat haphazard manner, deriving our information from a wide variety of philosophies and approaches to the page. This eclectic approach is often confusing and contradictory. Trends and fads in graphic design are sometimes useful in gaining attention or setting a mood, but they should not be confused with design itself, and cannot be used in place of a structural style.

Whatever our goals and whatever role we are to play in the design of a printed piece, we need a foundation—a set of guidelines to use as reference when making basic design decisions. Such a foundation must be coherent and inclusive; it must provide us with a reference for making a multitude of design decisions; and it must simplify rather than complicate the process of designing. Working within a structural style provides such a foundation.

In learning a structural style we learn about design: we begin to learn that all of the design decisions we make are interdependent; we see that seemingly minor decisions may be of critical importance to the overall success of a design; we find that a good design is not due simply to the merits of a single element but rather to the way in which all of the elements are combined. We learn that unless we begin with a coherent concept and establish a coherent aesthetic standard, we cannot produce a design in which diverse elements will fuse together into a coherent whole.

Working within an existing style helps to reduce the arbitrary nature of the design decisions we make. In developing a foundation on which to base our design decisions, we make more effective typographic and layout decisions and work more efficiently.

The impact of desktop technology

With the introduction of desktop technology more people than ever before are being asked to make design decisions. Encouraged by overzealous promoters, many organizations arm employees with desktop technology and ask them to assume the responsibility for design, layout, and typography despite the fact that their areas of expertise and primary responsibilities lie elsewhere.

Although there has been an attempt to "package" graphic design into templates and other such design aids, these are largely ineffective unless the user has some knowledge of design and typography. Such aids may raise more questions and create more problems than they solve.

Those who are learning to design on the job often find that the new capabilities offered by desktop technology are overwhelming; options become more a curse than a blessing because each option requires a decision. For most, the tendency is to do either too much or too little.

Because virtually everyone who uses desktop technology assumes new responsibilities, even those with a solid foundation in basic design may not be prepared for the new tasks they are being asked to perform: designers may function as typographers, typographers as layout artists, and writers as layout artists and typographers.

As with any radical new technology, roles are redefined as the technology matures. Each new technology demands new knowledge and skills. With desktop technology, this must include a basic knowledge of typography and layout for anyone who is involved in creating or producing visual communication.

About using this book

This book is structured as three books: books 1 and 2 are overviews of specific design styles; book 3 is a workbook that offers supplemental information and exercises to further the reader's understanding of the first two books. Books 1 and 2 are models of the styles they describe, and allow the reader to experience the style firsthand for additional insight. Books 1 and 2 are not parallel—that is, they do not contain exactly the same information, nor are they structured in the same way. These differences tend to reflect the spirit of the styles. Some of the information included in the first book may be relevant to the second— typographic terms, for example, are defined in book 1 but are relevant to all typography. Some topics in book 2, such as visual perception, may help to clarify the discussion of design principles in book 1.

It is assumed that few readers will read the book sequentially from beginning to end, so much of the information can be read out of sequence. The reader should be careful to spend some time within each style, however, so that the relationship between format and communication can be realized firsthand; the reader's own reaction to each style during reading may be as informative as the information on the page.

So that each style can be seen on its own merits, rather than only in comparison with the other, it is important that the reader take a break between books 1 and 2 to clear the visual palate.

Don't just read. The exercises in book 3 provide a framework within which to apply the information presented. The insight and clarification gained from applying what we learn can be obtained no other way. Some of these exercises require only observation and analysis; they have been included to help the reader develop awareness and clarify concepts. Most of the exercises require participation.

No special tools or technologies are required for the majority of the exercises. Those working with desktop computers or typesetting equipment, however, will find that many of the exercises are considerably easier and faster to do using these tools. A disk containing examples and templates has been provided for the convenience of those readers for whom desktop technology is available.

BOOK 1

THE
TRADITIONAL
STYLE

CONTENTS

The conventional formats that have developed for specific printed pieces, particularly those used for formal communication, are in the traditional style because this has been the dominant style for centuries. Even when seeing very small layout sketches, we can differentiate a wedding invitation from a business card, or a book page from an advertisement. These formats are not the "right" ways to design these pieces, simply conventional layouts that have evolved within the traditional style.

One of the reasons the traditional style has remained so consistent is that printing was learned through the master-apprentice system in which there was a right way and a wrong way to do everything. The right way was the way that the master, and probably his masters before him, had worked; the wrong way was anything that did not meet the standards set in the past.

Classical aesthetics

While it would be reassuring to think that the intrinsic rightness of classical aesthetics is what established them so firmly in our culture, it is more likely that the seeming timelessness of the style is rooted in the fact that printing and typography were born in and of the Renaissance, during which classical Greek and Roman aesthetics were dominant. The first typographic masters were of the Renaissance, and their classical standards established our typographic tradition.

LANGUAGE-BASED DEVELOPMENT

Written language was developed to record thought, and this objective continues to dominate and direct the traditional style today. The traditional style has evolved structurally from our written language, which reads across from left to right in lines; it begins at the top and ends at the bottom. The Rosetta stone is as characteristic of this structure and the texture produced as the manuscript page of the monastic scribes or the typed page of today.

Utilitarianism

Because it is language based, the traditional style is considered *linear* in structure—we present information by beginning at the beginning and continuing until the end. Stanley Morison, the late British typographer, noted that the typographic page was "the efficient means to an essentially utilitarian and only accidentally aesthetic end." It is only because we perceive of the

recording of thought as craft, and craft as art, that aesthetic standards have developed in association with the printed page. It is the typeface designer's quest for aesthetic excellence as much as the desire to develop a means for recording thought that inspires a new typeface. After years of development, the typeface will be appreciated by a relative few, for if the typeface is successful it will be *transparent* and go entirely unnoticed by the reader. Transparency must be a quality of any communication, since our awareness of the means by which a message is being transmitted diverts our attention from the message itself.

Transparency

It was the concern for aesthetics more than the utilitarian goal of recording thought that encouraged the Renaissance printer to transcend the notion of "artificial writing" and to turn typography into an art. The traditional style shares with typing and the "processing" of words only the linear presentation of information through language, using a predesigned set of letterforms.

Conventions

When we learned to write themes and to type reports, most of us were unaware that we were learning the basics of traditional layout and typography. School children today still struggle to center the titles of their themes on notebook paper and to fill the page evenly and consistently. It is the traditional approach we see reflected in typed manuscripts, technical papers, and the novels we read for pleasure. To use this structure as a design style, however, we must learn how to use it in an artful way. The first step in this process is to begin to separate convention from style.

TRANSCENDING THE TYPED PAGE

Many of us are familiar with the typewriter and have studiously learned to adhere to typing formats. The typewriter has contributed to our cultural conditioning; word processing has more closely followed the conventions of type*writing* rather than the principles of type*setting*. We must transcend the habits learned at the typewriter if we are to use typography effectively.

Typewriter restrictions

The typical typewriter has a single size and weight of typeface. The typeface is a *monofont;* that is, each letter occupies exactly the same width on the line, whether it is an *i* or an *M*. Two lines of typing the same length, then, have

exactly the same number of characters. Because there is so much space between letters, we put two spaces after periods and colons; this practice also helps us differentiate a comma from a period when print reproduction is poor. Because of the openness of monofonts and the length of the line of type, we indent a new paragraph a full five spaces.

Since the typewriter has only one size and weight of type, the only way it can be used to emphasize a word is to capitalize it, underline it, or change the spacing before, after, or within it. Even though the typewriter does not center words easily, centered heads and page numbers are common, a testament to the tenacity of classic symmetry.

Word processing Although word processors and personal computers now have typesetting capabilities, many people continue to use the format conventions that were developed to compensate for the limitations of the typewriter. Word processors use type fonts with variable spacing; unlike the typewriter's monofont, each letter uses only as much space as it needs. Because of this we do not need the extra spaces that were inserted into typing for clarity. Because word-processing equipment has the capability of making the type bold or italic, there is no longer a need to add underlines or use capitalization for emphasis.

CHARACTERISTICS

The goal of the traditional page is the harmonious blending of textures within a passive and symmetrical framework. The traditional page offers no surprises and no drama unless the writer has included such characteristics in the words themselves. The traditional page is as predictable and familiar as the other parts of our cultural continuum. Although its primary uses today have been limited to book design, the conservative corporate image, and such stalwart defenders of conventional taste as the *Wall Street Journal, Harper's,* and the *New Yorker,* the traditional style remains a viable choice for any printed piece in which linearity, symmetry, formality, and typographic emphasis are appropriate.

SECTION I

LAYOUT AND DESIGN

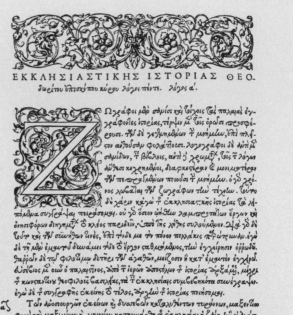

1.1. A TYPICAL TRADITIONAL PAGE

The simple structure of the traditional page has been used for centuries. The structure is determined from the outside in—the page size and proportions are used to construct margins. The example shown is from Eusebius's *Ecclesiastical History*, printed in Greek by Robert Estienne in Paris in 1544.

CHAPTER 1: STRUCTURE

We begin to gain an understanding of the traditional page by learning about its structure and its relationship to the proportions of the page. Traditional page structure is classically simple, based on the principles of Greek mathematics and geometry rediscovered during the Renaissance. The structure of the traditional page commonly consists of only a central axis and margins; other structure is seldom added.

By constructing margins geometrically, we avoid the use of numbers and calculations and need not understand the mathematics involved. Although margin construction techniques used to be included in layout and lettering books, these techniques were abandoned for commercial purposes around World War II and replaced by tables of numbers, many of which were rounded off for easy calculation. Not only were the relationships inherent in the construction process lost in this transition from geometry to arithmetic, but traditional proportions ever since have been modified to suit whatever scale of measurement is convenient. When we construct margins, we can *see* the proportions and relationships between lengths and areas—numbers can only imply these relationships. This visual understanding of proportion makes constructing page margins a valuable exercise even if we later convert our results into numbers to suit whatever technology is being used.

Construction

CONSTRUCTING PAGE MARGINS

Constructions define areas and subdivide the page. A typical traditional construction method divides the page into margins and *live area* (the space enclosed by the margins). The margin nearest the binding is called the *inside* margin (also referred to as the *gutter*). Typically, pages are viewed in pairs as a *spread* (two facing pages), and it is the spread rather than the single page that is the basis for the construction of bound pages. (Unbound, single pages are considered separately later in this chapter.) Margin construction systems

have been used for centuries, and while there are several similar methods, all use page and spread diagonals and produce similar results.

A typical margin construction system is shown in figure 1.2. Margins are based on the shape and size of the spread and defined by the diagonals of the page and spread. Notice that the outside corners of the live area fall on spread and page diagonals. Traditional margins characteristically divide the page area in half, so that half is reserved for margins, half for live area (see workbook topic 3).

MODIFYING MARGINS

Although margins are occasionally adjusted for aesthetic reasons, most margin modifications are made either to suit function or economy. The most common adjustment to constructed margins is to make them narrower so that more information will fit on a page. Margins are seldom, if ever, made narrower for aesthetic reasons. Adjusting margins may be the most obvious way to fit more on a page, but it is only one of several adjustments that allow

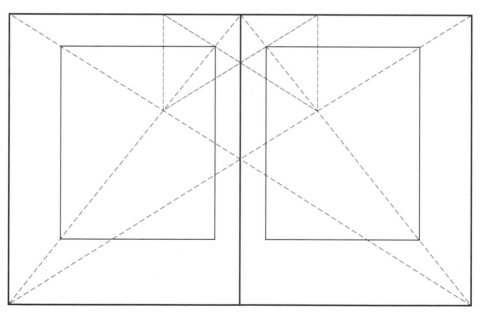

1.2. A TRADITIONAL PAGE CONSTRUCTION

more information to fit on the page. The designer can also consider resizing elements, repositioning elements, or changing a typeface to save space. These other adjustments are often more effective overall, and they will not upset the balance of the page.

When margins are adjusted, it should be along the page and spread diagonals, as shown in the diagram at right, so that basic proportions are maintained. Margin adjustments need not be extreme to be effective; because the live area on the traditional page is filled, a rather minimal change can have a significant impact. In England during World War II, for instance, designers were required to use a full 58 percent of the page for live area rather than the usual 50 percent created by margin construction—a modest concession considering the severity of the situation and the shortage of paper.

Our perception of narrow and wide is based on our view of what is normal. On the traditional page, "normal" is the 50-50 division of page area established hundreds of years ago. Margins that vary to any great extent have come to have different connotations; for example, we often associate very narrow margins with cheap novels and disposable information. Slightly narrower than normal margins, however, may only connote seriousness—we would not expect wide margins on a scientific report. And while extremely wide margins may be viewed as ostentatious and the content within them may be assumed to be superficial, somewhat wider-than-normal margins connote worth, elegance, and care.

Defining normal margins

Whereas wider margins are only limited by appropriateness, the narrowness of margins is limited by function: Margins must allow ample space for binding, provide allowances for trimming, and leave space for the reader to hold the printed piece without obscuring information. Thick documents and some types of bindings cause pages to curve excessively when the piece is opened, so inside margins must be wide enough to allow text to be read. Because mechanical bindings, such as plastic-comb bindings, are visible when the piece is open, the designer may wish to construct margins that do not include the area of the page taken up by the binding. Many printed pieces are trimmed after binding, often in bulk, and allowance must be made

Functional considerations

for this as well. Inaccuracies that have occurred during layout, printing, binding, and trimming are made more obvious by very narrow margins.

On the traditional page, margins are especially critical because they provide necessary contrast to the live area. They may also serve other functions. In the past, the reader often used the wide margins in old texts for notes; today's readers may welcome wide margins for the same reason. Printers of old often included editing notes in the printed piece for reference. This use of margins for supporting elements often leads to the division of the live area into two columns, one for text and the other for captions and subheads.

Aesthetics as function

Adjustments and final decisions about margins must always be made on a case-by-case basis, considering the requirements of the style. These include aesthetic as well as functional considerations. Many designers consider aesthetics a part of function, in that a potential reader must be attracted by the design before information can be communicated.

STRUCTURAL SYMMETRY

Symmetry is an integral part of traditional page structure. The structural basis for symmetry is the vertical *axis*, centered in the live area on each page. Symmetrical layout is sometimes referred to as *axial* layout. Elements within the live area are centered on this vertical axis. Though a single page is asymmetrical because it has uneven side margins, pages combine in a spread to produce a symmetrical whole, much like the wings of a butterfly combine to make a symmetrical form. Each page has its own axis; the inside edges of the pages meet to form a third axis, central to the spread. Elements placed in the margins are often aligned to this third axis. Structurally, then, the traditional page has two mutually exclusive alignment structures, both requiring symmetry. Although the spread axis is effective for aligning such reference elements as page numbers, the symmetry of the page axis must dominate.

ADDING COMPLEXITY

The classic page structure just described is sufficient for most layout purposes. We must keep in mind that visual interest most often is derived from the elements on the page, not from the structure supporting them. This

lesson is evident in nature: the simple structural framework of the butterfly, for example, has been appreciated for its beauty and in its diversities for centuries. So it is with the printed page. The simple structure should not be tampered with except when it does not serve the need for organization.

A decision to use multiple columns, for example, is often made arbitrarily, simply because the designer has become familiar with multiple columns in newspapers and magazines. Multiple columns add complexity to the page structure; each column adds another axis to the page, often making it more difficult to apply headings and to position other elements. The use of multiple columns requires the insertion of a space interval between the columns, which often disturbs the characteristic texture, harmony, and overall balance of the traditional page.

By thinking creatively from *within* the limitations of the style rather than breaking out whenever the going gets tough, we can find solutions that don't cause style conflicts. Margins, for example, can often be used for supporting elements so that a second column is not necessary.

Working within the style

STRUCTURING THE SINGLE PAGE

A single page is a sheet of paper that is unbound and nonsequential, such as a label, poster, announcement, or flier. It offers considerably more flexibility in structure and layout than sequential pages, which must be organized for consistency and are limited by such considerations as binding. Historically, a considerable amount of diversity and creativity has been shown on the single page; at least as many single pages have been created for decorative use as for communication. Fewer structural restrictions demand that the designer pay especially careful attention to the subtleties of the style. The designer or layout artist desiring to capture the feeling of the traditional page may find it useful to study examples of single pages from the past.

Wider diversity

Margins are useful only when there is a sufficiently large amount of information to contain, and the amount of information may influence how much the margins are adjusted. When only a small amount of information will be placed on the page, margins may be of no use. The designer may need to rely on such additional or supplemental structures as positioning guides,

which subdivide the page into proportionally related spaces (see workbook topic 7). These provide a way of making placement decisions that would otherwise be arbitrary, and can be used with any margin construction method.

When margins are constructed for the single page, different methods must be used than that used for constructing margins by spread. These enable us to establish margins that are symmetrical by page (see workbook topics 5 and 6). On the broadsheet below, for example, the sizes and proportions of the illustrations have helped determine the margins by defining the area in which type could be placed. Printed in about 1500, the message on this broadsheet could be understood by both a literate and illiterate audience.

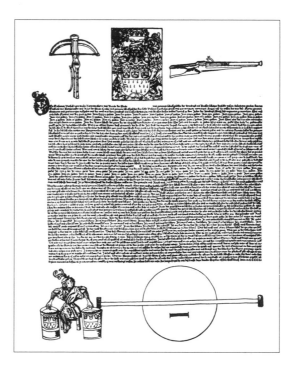

1.3. AN UNSTRUCTURED SINGLE PAGE

CHAPTER 2: DESIGN PRINCIPLES

The traditional page embodies a set of principles that reflect the classic simplicity of the early Renaissance and the linearity of alphabet-based written language. The careful understanding and application of traditional principles must govern our design decisions within this style; however, the constant visual barrage of television commercials, junk mail, magazines, desktop-published leaflets, and billboards permeates our design sensitivity to such a degree that, for better or worse, it may have begun to affect our own design aesthetics. We may be affected so strongly by these influences that we cannot work within the traditional style at all, or we may react so strongly against modern influences that we become more traditional than the traditionalists and express a sort of stereotypical version of the style.

Aesthetic influences

The particular choices we make as we work are direct reflections of our personal aesthetic tastes and preferences beyond the scope of style, technology, or the concept of the project itself.

AESTHETICS

Design is concerned not only with function and structure but with aesthetics. Although aesthetic quality in general may refer to whatever we find pleasing or beautiful, in the traditional style it refers to classical aesthetics, which, by definition, find beauty in simplicity and passive harmony. Working within a set of design parameters does not, however, guarantee a particular result; individual tastes emerge as well. We must be aware, then, of our preferences and be prepared to integrate or sublimate our personal tastes for the sake of the style or the design. If we like wild colors, for instance, we may need to find areas other than the printed page to express such preferences. If we make aesthetic decisions consciously and with the purpose of the work in mind, we support a design and style rather than subvert it.

Personal tastes

Familiar vs. exotic

We often find something familiar more pleasing than something unfamiliar; likewise, we may find something new and exotic more attractive to us than something we already know. If we have been surrounded by simplicity, a decorative approach might be appealing. Conversely, if our world is a visually noisy one we may find comfort in simplicity. We must take care that we do not make a choice only for the sake of change or only to avoid change.

An inherent fascination with the exotic may interfere with our work in the traditional style at times, but it is also one of the factors that contributes to successful revivals of this style. The traditional style owes its periodic surges of popularity as much to its novelty as a calm and passive element in a fast-paced modern world as to its comfortable familiarity.

VISUAL PRINCIPLES

The visual perception principles so familiar to today's designer were not formally defined until the beginning of this century with the birth of experimental psychology. Although the traditional typographer did not know Gestalt principles by name, their use had evolved through the centuries. The modern style embraces these visual principles, but it is fair to consider that many of the principles embodied in the modern style were a reaction to the graphic environment of the time. An active layout is only more attractive than a passive one, for instance, when it is in a passive environment: if a supermarket shelf is filled with packages featuring active layouts and high contrast, however, it is often the passive layout that catches our eye because it contrasts with its environment.

Visual awareness

The traditional designer relied on his eye rather than on precision tools or abstract principles. He knew through observation that the optical center was always a little above the mechanical center, and he therefore placed the weight of a layout above the midsection of the page. The traditional designer anticipated that the reader's trained eye would begin at the top of the page and work down in a linear fashion. He set titles and small blocks of text, so that each line was progressively shorter, to create an inverted pyramid that would lead the eye down the page. Another established practice

was to make changes in the sizes of such elements as type sufficient enough to be obvious to the reader, but not so great as to require a shift in the reader's perception. This practice also helped to maintain an even texture on the page and a balance between elements.

A good testament to the value of classic principles is that the text page developed by Venetian printers in the Renaissance is still the style of choice of readers today, with very little modification. The visual principles embodied in the traditional style reflect centuries of refinement and testing. *The enduring text page*

ORDER VS. CHAOS

One of the areas of agreement between the traditional and the modern style is that communication is dependent on order. It is often said that humans create order in an otherwise chaotic universe, and it is safe to assume that readers look for order and meaning on the page. Meaning is attached to changes in size, spacing, and capitalization of type, for instance, and such changes made only for the sake of change confuse the reader. Changes in size, contrast, texture, and relative position imply a *visual hierarchy,* or order of relative importance, which should echo the hierarchy of the writing. Visual hierarchy helps to create a subtle distinction between elements and must be used carefully. *Visual hierarchy*

Consistency and repetition establish pattern, which is an important aspect of order, particularly in such sequential layouts as books and magazines. As experienced readers, we have learned to anticipate and expect pattern. Too much consistency on the page, however, is like too many days of gray weather—a bit of variety on the page is as welcome a sight as an occasional ray of sunshine. For young readers, variety is often provided in the form of illustrations, which give welcome contrast to the the bleak gray of the text page. Children often judge the worth of a book by the number of illustrations it contains; adults tend to respond to more subtlety. Elements such as subheads and large initial caps can provide sufficient variety on the text page. Adult readers sometimes find too much variety distracting. *Pattern vs. variety*

Decorative devices offer only visual relief; additions such as diagrams,

illustrations, and photographs offer meaning as well. Because visual elements vary in quality they must be judged on their individual design merits rather than be included only to compensate for a dreary page.

SYMMETRY

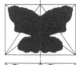
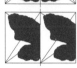

There are different kinds of symmetries. On the traditional page, the symmetry we use is *bilateral symmetry*—the symmetry of the butterfly and the human body. This type of symmetry is based on a central vertical *axis*, an invisible line that divides the whole down the middle into two equal halves. A symmetrical layout is balanced, but a balanced layout is not necessarily symmetrical. In the drawings on the left, both spreads have the same weight on either side of the axis, but only the top one is symmetrical. While symmetry is mechanical and relatively easy to achieve, balance is more subjective and requires practice and training.

Symmetry is an integral part of our culture, used freely at all levels of design sophistication. Packaging and labels tend to be symmetrical; appliances tend to be symmetrical even when symmetry does not contribute to their function. A telephone receiver, for example, is characteristically symmetrical although each end serves a different function and fits a different part of the anatomy. ("Modern" telephones tend to be called so because of their asymmetry.)

Symmetry bespeaks formality and continues to be used on invitations to formal events. Because symmetry conveys stability, it continues to be the choice of bankers, stockbrokers, lawyers, and others to whom we willingly entrust large amounts of our money. Where symmetry clearly dominates we perceive balance and order, when symmetries are mixed we may perceive chaos and disorder.

BALANCE AND HARMONY

Harmony can be described as the peaceful coexistence of elements on the page. Symmetrical balance is passive rather than active, contributing to harmony. Harmony is achieved when elements are in proportion, when

contrasts are minimal, and when elements seem at rest; nothing on the page should seem to be in motion, nor should anything pull the eye in a diagonal direction. Moderate rather than extreme contrasts in *value* (light-dark relationships) and *scale* (relative size) contribute to the feeling of harmony and balance on the traditional page. The space on the page will seem flat and two-dimensional when a balance in contrast has been reached. (The illusion of depth is created by contrast and is more appropriate to the modern page.)

Harmony

PROPORTION

Proportion is essential to harmony and balance. It is an important aspect of the traditional style and is relevant not only to the page and its structure but to the elements themselves. The classical proportions rediscovered in the Renaissance have remained a part of Western culture for centuries, and we see them as normal and pleasing. We might almost consider this feeling of normality as a criterion for judging the appropriateness of a particular proportion for the traditional page. The International Typographical Union's 1945 edition of the Lessons in Printing series listed only five rectangles deemed appropriate for use by printers, all of which echo classic proportions. Proportion is expressed as a ratio (sometimes called an *aspect ratio*). The ratio of a square, for example, is expressed as 1:1.

Aspect ratio

Classical proportions had special significance during the Renaissance, because meaning was attached to the special mathematical qualities of certain numbers. Classical proportions have been reflected not only in the aspect ratio of the page but also in the shapes of elements on those pages. Probably the best-known classical proportion, and the one that has elicited the most avid devotion over the centuries, is the *golden rectangle*, which has a ratio of 1:1.618. This golden ratio, or *golden mean*, was referred to by Pythagoras as the *divine section*. It figures prominently in Greek and Renaissance art and has been the subject of study for many generations of artists and mathematicians. The *Divina Proportione*, written by Pacioli in 1509, is only one of numerous books devoted to this subject. There are several methods for geometrically constructing a golden rectangle (see workbook topic 4).

Golden rectangle

Fibonacci numbers were also of interest during the Renaissance; these are the numbers in the sequence 2, 3, 5, 8, 13, 21, 34,…, in which the next number in the sequence is the sum of the previous two. Any two numbers in sequence produce an aspect ratio similar to, but not identical with, the proportion of the golden rectangle. This similarity has often caused people to confuse the two. Because Fibonacci numbers calculate more easily, they have been commonly used for proportions in printing, particularly since the decline of geometric construction methods.

Fibonacci

To prove (or disprove) the inherent superiority of one proportion over another, a number of studies have been conducted over the years to test our "innate" preferences. One of the best known of these studies was by Gustav Fechner in the 1870s, and his results were confirmed by later studies. Fechner began by measuring literally thousands of common items such as playing cards and books. From these measurements, he created a range of rectangles, which were shown to subjects. The subjects' preferences were then recorded. All the rectangles preferred by the subjects had proportions between those of a square (1:1) and a double square (1:2); a marked preference was shown for the golden rectangle. If we look at the common rectangular objects around us today, we will find that most, if not all, fall within this range. Those most similar in proportion to the golden rectangle seem the most traditional (see workbook topic 10, variation 5, and topic 11).

Fechner

SPACE AND TEXTURE

Unlike the modern page, on which space intervals between elements are predetermined by a grid, spaces between elements on the traditional page are established visually so that an even and pleasing texture is created. The texture should be consistent over the page; no large gaps or unevenness should appear. The material included in the layout should be appropriately sized so that it can be distributed evenly. Too much contrast in the sizes of elements may cause an uneven page texture. Breaks in texture are often seen as distracting white shapes, the most common of which are *rivers*, that sometimes run vertically through the text because of the unintentional

alignment of uneven spacing between letters and words. This problem may be compounded when multiple columns are used.

The texture produced by the evenness of the text is said to have *color*, a term that refers to the relative level of gray (*value*) produced by the texture rather than the *hue* (e.g., red, green.) Text establishes the color of the page, and elements on the page should harmonize with it; for example, whereas woodcuts had been relatively bold during the Middle Ages in keeping with the darker color of the text, Renaissance woodcuts used more delicate lines to match the lighter color of the typography. This harmonizing of space, texture, and color is particularly important to consider when several kinds of elements appear on a spread.

Text color

COLOR AND PAPER

The traditional page has most often been printed with black ink on a natural white page. This combination evokes a traditional feeling even today. The bright white papers available today increase contrast and cause the page to lose its passive quality. The choice of paper color and surface alone can enhance or detract from an otherwise pleasing and traditional page.

As with all other aspects of the traditional style, simplicity is the touchstone. Colored paper stocks and colored inks often add nothing to the page, distracting from rather than enhancing the design. Like decoration, they are often used to compensate for weak design.

Ink colors other than black are seldom used on the traditional page, and in fact many people do not refer to black printing ink as a color at all. When colors other than black are used, they tend to be for accent only and appear in small amounts. The most common traditional accent color is red. Black, white, and red provide an optimum color variation—one light, one bright, and one dark—and this combination continues to be used widely for both traditional and modern styles.

Accent color

The paper and ink colors made today are sharper and more intense because of chemical processes and dyes. With such a wide range of paper and color choices before us, we must learn to exercise the restraint typical of the

traditional style: we should use only colors that help retain the harmony and subtle contrasts of the traditional page. The most obvious choices are colors we associate with old leather bindings and natural dyes, such as dark, dull greens, browns, and reds. Bright colors are less traditional.

Dulling colors We can mix an appropriately dull color by adding its complement (e.g., some green to muddy the red, orange to dull the blue). Black added to a color may make it darker but will not necessarily make it duller. Standard ink formulas mixed from complements tend to be good choices for accent colors on the traditional page.

Decorative elements are often printed in color so that they have lower contrast with the paper and become subordinate to the text. Hierarchical typographic elements that need to stand out on the page may thus be inappropriate candidates for color, because colored ink contrasts less than black ink with the color of the paper. Colored ink helps to differentiate an element but does not necessarily give it emphasis.

Traditional principles should be the guide for determining how color is used on the traditional page. Color should not distract the reader's eye from the message being presented; it should help the page retain its traditional formality. (A vibrant color on an otherwise formal and traditional page may be the visual equivalent of a bright pink tuxedo at an embassy banquet.)

Non-artists are apt to exaggerate the
value of what they admire.
—Sir Cyril Burt—

CHAPTER 3: ELEMENTS

The primary purpose of the traditional page is to communicate, and the elements that appear on the page must enhance rather than interfere with that communication. The page structure provides a framework for placing elements on the page; the nature of the elements—their relative importance, how they relate to one another, and their purposes on the page—dictates how they are to be combined into an organized, cohesive layout with a single, predefined purpose.

It is useful to categorize elements by purpose—as typographic, graphic, illustrative, or decorative. Typographic elements include text, titles and subtitles, captions, page numbers, and any other typographic symbols used to communicate through language. Graphic elements include any visual elements that enhance typographic communication, including *rules* (lines), *dingbats* (typeset nonlanguage symbols), single-line borders, and other such nonpictorial elements that separate and clarify. Illustrative elements include drawings, diagrams, photographs, charts, and any other such elements used to augment or clarify the message being communicated by the text. Decorative elements are those that are neither necessary nor useful for communication. An element can be categorized as decorative if it is included simply for its visual interest.

Classification

In the process of determining the purpose and relative importance of the elements, many layout decisions are made. A layout cannot be completed without the designer assigning priorities to the elements, whether consciously or unconsciously. Typographic elements have the highest priority, both because they carry the message and because they can be changed the least to stay within readability standards. Decorative elements have the lowest priority, as they do not directly contribute to communication, and are often added only when the page "needs something."

Priorities

ILLUSTRATIVE ELEMENTS

Early illustration was generally limited to woodcuts and engravings; today we have a far greater diversity of techniques and tools for creating and reproducing illustrations. An illustration may still be a line drawing, but it is *Diversity of techniques* just as likely to be a photograph, airbrush illustration, marker sketch, painting, or computer-generated image. This diversity is possible because of the introduction of photographic techniques for print reproduction: Anything that can be photographed can be printed. With technical restrictions eliminated, technique is decided by the resources available to us—talent, time, funds, reproduction method, and the nature of the printed piece.

Early illustrations were "cut to fit"; the amount of detail in the illustration was determined by the limitations imposed by the materials and the skill of the artist. Today's illustrators can create their illustrations in any size they find convenient to work in, because the illustrations can be resized (*scaled*) photographically. Illustrators must take care to include neither so *Consideration for scale* much detail that clarity is lost when the illustration is reduced, nor so little detail that the illustration seems empty unless it is reduced. It is important that the illustrator know the approximate final size of the illustration before beginning the work.

Typographic details such as call-outs used to be included in illustrations for technical reasons. If an illustration is to be scaled, it is better to add typographic elements later. Typographic elements, more than any other factor, limit the potential size of an illustration. The more flexibility that is built into an illustration, the easier will be the work of the layout artist.

In planning an illustration, we should consider the proportions of the illustration and how it will fit our page. Many illustrations can be composed either vertically or horizontally without losing their classic proportions, and how each choice would affect the layout should be considered before the illustration is commissioned. In general, an illustration should be large enough to fill the width of the live area or small enough to float in a margin.

Illustration can be broadly classified as either diagrammatic or pictorial. *Diagrammatic* illustrations include drawings such as flow charts and wiring

diagrams, they are often but not always technical in nature. *Pictorial* illustrations for the traditional page are most appropriately representational, or "realistic." Both diagrammatic and pictorial illustrations used on the traditional page should obey traditional design principles by being balanced, relatively symmetrical, and within the range of classic proportions. In the past, pictorial illustrations often were symbolic and were used the way we use diagrammatic illustrations today. A hundred years ago, an illustration explaining the telephone would have been likely to combine people, telephones, poles and lines, and switchboards into an explanatory drawing; today, that same kind of information would typically be explained with boxes in diagram form. When we create diagrams, we should take care to retain the color and texture of the page.

It is more typical to create a single complex illustration for the traditional page than to fragment that information into many simple illustrations. A complex illustration may indeed be worth a thousand words, and it is generally easier to use than many small illustrations, which may fragment the layout, interrupt the reader, and convey less information.

One vs. many

GRAPHIC ELEMENTS

One familiar graphic element on the traditional page is the box, or line border, that defines the edges of an element and separates it from the other elements on the page. On the traditional page, illustrations are characteristically boxed to define their edges, as are blocks of information not part of the flow of the text, such as tables and lists. Boxes and borders are typical of graphic elements that are used to enhance communication by clarifying hierarchy and organizing space. Graphic elements must be used sparingly for effect.

Dingbats are graphic elements more characteristic of the Gothic than the classic page. Although dingbats are sometimes useful as paragraph markers in a long text or to signal the end of a section, they are more commonly used for their decorative qualities. The bullets often placed at the beginning of listed items are an exception. When used sparingly, bullets help to highlight and clarify.

Large initial capital letters may be classified as graphic devices as well, since their visual importance often takes precedence over their function as a language element. Considered *de rigueur* by many working within the traditional style, large initial capitals often serve as a marker for the beginning of new topics in long tracts of text that are not otherwise broken by hierarchical elements. As with any other graphic element, overuse dilutes their effectiveness. Large initial capitals are often lavishly decorated, reminiscent of the Gothic manuscript page.

DECORATIVE ELEMENTS

Enrichment vs. clutter

Although it is said that humans have an innate need to decorate, the use of decoration on the printed page seems to be more a manifestation of taste and style than a basic human need. The floral wallpapers enthusiastically applied by one generation are steamed off just as enthusiastically by the next as decoration goes in and out of fashion. One designer will view margins as empty voids crying out for decoration, whereas another will see beauty only when the page has been stripped bare of all but the essentials. The perception of decoration as either enrichment or clutter does not seem to depend on the quality of the decoration itself. Lavish decoration is alternately viewed as a manifestation of decadence or an ultimate expression of Art.

Decorative elements include borders, bands, illustrations, typography, and anything else that is used for the sake of embellishment rather than communication. Traditional motifs range from the simplicity of the classic to the lavishness of the baroque and rococo.

Some of the decoration we associate with the traditional style has Gothic roots, characterized by boldness and typified by the Arts and Crafts Movement. Gothic-inspired decoration must be accompanied by heavier, darker text for balance and color. In recent decades, decoration has been all but banned from the designer's palette but it is coming back into vogue with a vengeance. To work within the spirit of the traditional style, our standard should be the Renaissance model of classicism in which decoration was used with a light hand.

In the days of metal type, a printer typically stocked a variety of decorative elements (*printer's devices*); today's typesetter may also offer decorative elements. These stock items have all the advantages and drawbacks of other prefabricated designs, and although they can enrich a well-designed page, they are as often used to compensate for weak design. Because it has always been relatively expensive to hire an artist to create decorative devices, original decoration for a specific printed piece is rare, and prefabricated decoration will continue to be used.

The use of decoration implies the priority of aesthetics over communication, formalism over function. Decoration, then, may be viewed as a statement of intent. Decoration connotes leisurely contemplation. A page of romantic poetry, then, is a more appropriate candidate for decoration than a train timetable; classic decoration is more appropriate on a Mozart festival poster than on an album cover for a hard-rock band. Lack of decoration is a statement of intent as well, implying the ascendancy of function over aesthetics and the economy of time and space over leisure and luxury.

Implications

Decoration has a history of its own, independent of style and era. Regions and nations differ in their use of decoration, some being noted for their simplicity, others for their lavishness. A particular motif may be used within a region for centuries with little modification. Whereas the traditional style has adapted to decoration, however, decoration is antithetical in philosophy to the modern, perhaps because the modern style is too young to have adapted to this foible of human nature.

Simplification and formalization are decorative in themselves, and an illustration which observes the integrity of the page seldom fails to be decorative in its total effect.

—Times Literary Supplement, *1927*—

POLIPHILO QVIVI NARRA, CHE GLI PARVE AN-
CORA DI DORMIRE, ET ALTRONDE IN SOMNO
RITROVARSE IN VNA CONVALLE, LAQVALE NEL
FINE ER A SER ATA DE VNA MIR ABILE CLAVSVR A
CVM VNA PORTENTOSA PYRAMIDE, DE ADMI-
RATIONE DIGNA, ET VNO EXCELSO OBELISCO DE
SOPRA. LAQVALE CVM DILIGENTIA ET PIACERE
SVBTILMENTE LA CONSIDEROE.

A SPAVENTEVOLE SILVA, ET CONSTI-
pato Nemore euaso, & gli primi altri lochi per el dolce
somno che se hauea per le fesse & prosternate mébre dif-
fuso relicti, me ritrouai di nouo in uno piu delectabile
sito assai piu che el præcedente. Elquale non era de mon
ti horridi, & crepidinose rupe intorniato, ne falcato di
strumosi iugi. Ma compositamente de grate montagniole di non tro-
po altecia. Siluose di giouani quercioli, di roburi, fraxini & Carpi-
ni, & di frondosi Esculi, & Ilice, & di teneri Coryli, & di Alni, & di Ti-
lie, & di Opio, & de infructuosi Oleastri, dispositi secondo laspecto de
gli arboriferi Colli. Et giu al piano erano grate siluule di altri siluatici

1.4. TEXT ON THE TRADITIONAL PAGE

Text establishes color and texture on the page; all other elements are subordinate to it. This
example was printed in Venice by Aldus Manutius in 1499.

CHAPTER 4: LAYOUT

Traditional layout is straightforward—a process of constructing margins and then filling the live area symmetrically and sequentially, top to bottom, page by page, from beginning to end. The traditional style is linear, structured to facilitate the flow of text. Illustrative elements (e.g., diagrams, photographs, drawings) should neither distract the reader nor disturb this flow.

The flow of text is an important aspect of traditional layout. If we think of the text as a flowing river, margins as the banks of the river, and illustrative elements as obstacles such as rocks, we can better understand the relationship between the text and the other elements on the page. While the river can tolerate small obstacles along its banks, a small obstacle in the center of the river is a navigation hazard. An element that cuts through the center of the page from margin to margin stops the flow just as a dam stops the flow of a river. Elements positioned at the top or the bottom of a page minimize this because the flow is already being diverted to the next page. In general, the more obstacles, the more likely it is that the flow will be interrupted. On a vacation cruise down the river, obstacles may seem charming; these same obstacles lose their charm if we are on a business trip. We cannot determine the relative value of charm versus efficiency without knowing the purpose of the trip or the priorities of communication.

Consider how flow is affected in the layouts below: the first solution stops the flow; the second causes turbulence, or confusion. The last three provide the best alternatives because they interrupt the flow the least.

The traditional page has been called the writer's page because it gives priority to the text; all other elements are subordinate to text. Because our layout will either reinforce this message or contradict it, we must consider each layout decision as a message to the reader. A large illustration blocking the flow of text, for instance, says, "Stop reading right now and look at this." It is not uncommon to read books in which illustrations are inserted midparagraph, midsentence, and even midword. Although it is unlikely that the designer's intention was to imply that it is critical for the reader to see the illustration before reading the next syllable, this is nevertheless the effect such placements have. It is the writing rather than the layout that should direct the reader's eye from element to element. Although the agile reader will learn to jump any hurdles presented by elements other than text, a well-designed page will not demand such agility of the reader.

KEEPING TEXT DOMINANT

The more elements other than text that must be included on the page, the fewer options we have for placing them. Only so many images fit along a margin or the bottom of a page. Grouping elements on a separate page is a viable option only if they appear near the text that refers to them. Forcing the reader to hunt for illustrative elements referred to in the text is as distracting and undesirable as interrupting the text.

Traditional page structure evolved in response to the needs of text. When elements other than text dominate, either because of their frequency or their relative importance, the designer must either eliminate elements, provide additional structure, or abandon the traditional style for the more flexible modern style.

When a graphic element appears too frequently it may distract from or overpower the text; both text and graphics lose their effectiveness in such cases. Large initial capitals, for instance, lose their charm when they begin each and every paragraph. Frequency of use is a key factor for determining the size and appropriateness of graphic elements; overuse reduces graphic elements to mere decoration.

THE ROLES OF THE ELEMENTS

Each element plays a role in communicating to the reader and contributing to the appearance of the page as a whole. The text carries the message, and illustrative elements explain or enhance the message. Graphic elements clarify the message and direct the reader's eye. It is important to think of each element as having a specific role and to consider that role when including the element in the layout. Just as in a play, some elements have starring roles and some are in the supporting cast.

Too often, we include elements without thinking of their roles in the project at hand. Captions are a prime example: When an illustration is inserted into the text and is near the text that refers to it, no caption is really necessary, since the text offers ample explanation. The role of the caption is to explain an illustrative element that is separated from the text that directly refers to it. Today we often see a kind of belt-and-suspenders approach, particularly in technical manuals, in which an illustrative element, complete with title and caption, is inserted directly into text. If the text is referring to the illustration specifically, the caption is extraneous; if the text is not referring directly to the illustration, the illustration need not disturb the flow. Captions in browsing material such as magazines, however, may play other roles—that of substituting for text that won't be read, for example, or as enticements to draw the reader in.

Captions

ESTABLISHING PRIORITIES

Many factors contribute to the success or failure of a layout. These include the amount of text that must fit on the page; the number of illustrative elements and the frequency with which they appear; the relationship between illustrative elements and text; the relationship between the illustrative elements themselves; the role of each element; the writing hierarchy and how it can be reflected in the visual hierarchy; and the purpose of the information and the printed piece. The designer must find time to consider all of these factors in the face of budgets and deadlines, aesthetics and opinions, corporate politics, misdirected creativity, and the notion that making everything bigger makes it better.

We can clarify the purpose of our layout task by first assigning priorities to the information to be included. This helps us to anticipate and avoid potential conflict, and it introduces issues that are better resolved in advance. Once we are immersed in the process of layout we tend to solve problems on a case-by-case basis as they arise. If we are working on a single page, we can see the effects of our decisions immediately, but if we are working on a multiple-page document, we may not realize the effects or implications of a decision until a few pages or chapters later. In general, the larger the job, the more important it is to plan carefully and to establish overall objectives. During layout it is important to stop once in a while and take a look at our progress in terms of consistency, balance, and how close we are to reaching our overall objectives.

DESIGN, LAYOUT, AND AESTHETICS

To be able to make a series of design decisions that will achieve a specific goal, the designer must consider the audience for the printed piece, what the client hopes to achieve with the printed piece, the image the client wants to project, budget and printing limitations, and how the piece will be distributed, used, and stored. Without planning, success is left to chance. Without specified objectives, there is nothing against which success can be measured.

Design is frequently misconstrued as something that intuitively flows from the fingertips or as the decoration of the page in the style of the day. Although design may involve both intuition and decoration, it is more importantly a synonym for *plan*. The design process begins with the clarification of the project's objective, continues through an analytical phase in which that objective is further clarified and detailed, and then proceeds through a visualization phase in which the overall look and feel of the piece is determined.

It is not unusual in the day-to-day corporate world to take shortcuts in the design of projects that have a communication orientation or have limited budgets. Layout, which should be only one phase in design, often becomes the only time anyone thinks about the project with any thoroughness. The more fragmentary and superficial the design process becomes, the less likely are the chances for success and the greater is the potential for problems.

We should think of layout as a two-step process, the first being to clarify functional design parameters and the second being the arrangement of specific elements within those parameters. If we begin making aesthetic decisions without completing the first step, we often become immersed in functional problems that make aesthetic considerations seem trivial. By loosely organizing elements and resolving functional conflicts in the first step of layout, we can fine tune the layout in the second step; that is, we can freely focus on aesthetics because we have the assurance that the page will serve its intended purpose. Neither step can be eliminated if we are to produce work of better than mediocre quality.

*The designer must work from the beginning with the
finishing clearly in mind—all considerations, choices,
decisions must support the total plan, but the plan
is not inflexible; indeed it will often evolve as
the answers are sought to the problems
that arise along the way.
—John Ryder—*

SECTION II

TRADITIONAL TYPOGRAPHY

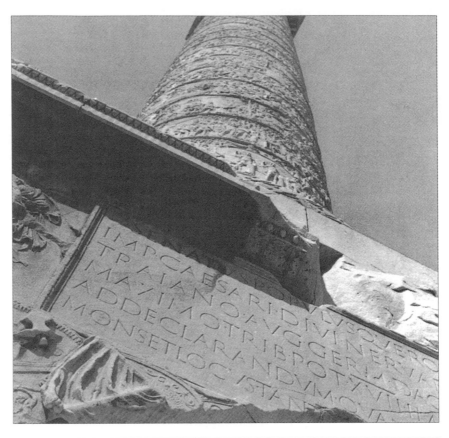

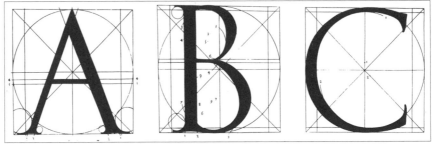

2.1. ORIGINS OF TRADITIONAL TYPOGRAPHY

The inscriptional characters on the base of the Trajan column, A.D. 114 (top). Geometric constructions by M. A. Rossi, 1598, were derived from Roman inscriptional letters (bottom). Such constructions established standards for the capital letters in use today. (From James Moseley, *Trajan Revived*)

CHAPTER 1: BACKGROUND

Of the thousands of typefaces that have been designed in the past five hundred years, most owe the shape and proportions of their capitals to the Roman inscriptional letters on the Trajan column carved about A.D. 114. Roman letterforms are an integral part of our culture and have profoundly influenced the design of typefaces. Most attempts to deviate from Roman standards have been greeted with strong resistance. Typography catalogues still contain typefaces bearing names such as Trajan, Roman, and Classic.

The Trajan model is incomplete; it does not include the modern letters *H, J, K, U, W, Y,* and *Z.* Many architectural inscriptions even today use *V* in place of *U.* The Trajan model did not group letters closely into words as we do, but used wide spaces between all the letters. It has been traditional ever since to widely space words set in all capital letters.

The Trajan model

Over the centuries, Trajan letterforms have been measured, quantified, analyzed, constructed, photographed, traced, and redrawn by countless typographers, artists, and designers. Numerous methods for geometrically constructing these letters have been devised: the earliest datable attempt was in 1460, and in 1982 David Lance Goines published yet another system, continuing the tradition. Construction systems have given rise to the notion that Trajan letterforms can (and should) be mechanically devised. But as Stanley Morison observed, constructed letterforms often "suffer from the monotony of laboured imitation. Letter-forms may well begin with geometry, but only the sovereignty of eye and hand can transmute a diagram into a work of art."

Construction systems

Our lowercase letters (*minuscules*) have a long and convoluted history of their own. They were developed for the Latin language between the sixth and the eighth centuries. It was not until the fifteenth century and the Renaissance preoccupation with pre-Gothic styles that these minuscules were

Minuscules

oraculis ne pręliū ineat cohibent & exercitus omnis męrore ac ſtupore cōfeċtus
eſt : Sed eo neceſſitatis uentum eſt ut uel audendo furtuna tentanda ſuel diucius
ſtando extrema fames expeċtanda ſit . Hęc cū dixiſſet Alexander ariſtidē orabat
ut ipſe conſtius memoria teneret & nemine participē faceret . Cui tunc ariſtides
iniquū eſſe Pauſaniam ſ cui ſumma retū cōmiſſa erat hęc ignorare . Cum cęteris
aūt nullum ſe ante pręlium uerbum faċturū . At ſi uicerint quod dii faxint oſbus
Alexandri uirtutem ac promptitudinem notam fore . Iis ultrocitoǫ diċtis Rex
macedonū equo reueċtus eſt . Tū Ariſtides ad Pauſanię tabernaculū profeċtus
quo inſtatu res eſſet expoſuit ſ cęteris poſt aduocatis ducibus imperatū ut quiſǫ
ſuos in ordinem inſtruerent & paratos iam pede collato confligendum eſſet
continerent . Per id ſerme tempus pauſanias ut ſcribit Herodotus Ariſtide cō
uento dignum putabat mutato loco athenienſes dextro loco conſtitut & aduerſus
perſas obici . melius enim cū ipſis decertaturos : cum & eorum belligerandi arte
experti & recenti uictoria audaciores eſſent . Se autē Siuiſtro in cornu futurū quo
ex loco grecos qui medorum partes cōſeċtarentur exciperet . Reliqui Athenieſiū
principes ualde ſuperſluis in rebus occupatū & difficalē Pauſaniā diċtitabantſ
ſi cunċti ſuis in locis dimiſſis ſolus Athenienſes uelut ilotes ſupra & infra collo
caret & arbitratu ſuo nūc pugnatiſſimę gēti obiectaret . Ariſtidis autēeos magno
in errore uerſarii docuit Nam ſi paulo ante cōtēdere cū tegeatis inquit ut ſiniſtrū
cornu haberetis ad ueſtrā amplitudinē pertinere credidiſtis ſ& eis iuditio pręlati
uos honoſtatos cenſuiſtis In preſentia Lacedemoniis ſponte nobis ex dextro cō
cedentibus & quo Dammō ſumum nobis principatū conferentibus : cur gloriā
nobis propoſitam non amatis : preſertim cum in lucro ponere debeatis ſi uero
aduerſus Tribules & neceſſarios ueſtros ſed Barbaros hoſtes nobis a natura da
tos dimicandum ſit . Hęc cum differuiſſet Athenienſes ſiniſtram Lacedemoniis
aciem ſummo ſtudio dare in dextram ipſi concedere . Plurimę ſe inuicē exortātū
uoces diſperſę hoſtes aduētare : qui nec armis nec aïs ſuperiores illi eſſent : quos
apud Marathona profligaſſent . Aſt eoſdem artus maiorem eandem ueſtis uarī
etatem eundem aureum circa mollia corpora & iules aïos apparatū . Nobis eadē
arma & corpora & plenſǫ ſecundis pręliis maiorem audatiam . Certamen uero
non agrorū aut urbis cauſa ur maiores noſtri ſed pro trophets quę Marathone
ac Salamine conſtituimus ut non Milciadis aut fortune ſed Athenienſiū potius
eſſe uideantur . Interea mutato loco aciem inſtruere & ſe inuicem cōponere ſolicit.
Hęc Thebani pertranſſugas explorata Mardonio renuntiant . Qui ex tēplo ſiue
Athenienſes timeret ſiue cum Lacedemoniis maiori cum laude congredi uellet
dextro cornu perſas aduerſus Lacedemonios inſtruxit . ceteros uero grecos qui
ſecum erāt aduerſus Athenienſes ſtare iuſſit . Palam autē mutatione acierū facta
Pauſanias iterū indextrum cornu ſe recepit & Mardonius ſicut inito habuerat
ut manum cum Lacedemoniis cōſereret in ſiniſtrum reuertit . Eo die nihil aċtū
grecis in concilium uocatis lōgius caſtra mouere uiſum atǫ locū indagare unde
oportune aquationes eſſent . propinqua enim omnia fluenta Barbari ſedauerāt
& maximo equitatu occupauerant . Sequenti noċte cum duces ad deſtinatum
caſtris locum ſuos agerent multitudo uix conſtare ac difficile ſubſequi . Vt enim
ex prioribus exceſſeruit munimentis magno numero uerſis Plateenſium urbem
paſſim diſcurrere . Vnde cum ſine imperio Palati diſpergerentur & tabernacula

2.2. THE RENAISSANCE TEXT PAGE

Fifteenth-century Venetian printers created text pages that continue to serve as
models for the typographic page today. This page is by Ulrich Han (1471).

revived. Being more open than the Gothic black letter, these earlier rounded letters were easier to read and were lighter and more graceful on the page; it was probably their readability as much as their aesthetic qualities that led us to adopt them as the model for the lowercase letters we use today.

Our model for the typographic page was established by fifteenth-century Venetian printers of the Renaissance such as Aldus Manutius and Nicolaus Jenson. Noted twentieth-century typographers such as Stanley Morison and Jan Tschichold (who is also known for his pioneering work in the modern style) have helped to keep the aesthetics of the Renaissance page alive. The traditional typographic page of today bears a remarkable resemblance to the pages of books produced four hundred years ago. The traditional style survives, bruised a bit but relatively unscathed, ready for the computer revolution and all that will follow.

The typographic page

THE DEVELOPMENT OF TYPE TECHNOLOGY

In about 1454, Gutenberg, a goldsmith by trade, perfected a system of casting individual metal letters from a mold. By printing with predesigned, reusable letters—inventing the system we call *typography*—he started a communication revolution. The concept had been used for several thousand years in China and Korea for woodblock pictograms. Gutenberg's system, however, worked with an alphabet; metal allowed finer detail. To create a typeface, a master alphabet was designed, then carved as raised letters onto the ends of hard metal sticks (*punches*). These raised letters were punched into a softer metal which acted as a mold; the mold was then used to cast many identical letters that could be arranged (*set*) as text. The raised surface of the type was inked and pressed against paper.

Birth of typography

Before the development of typography, each letter of each word had to be created in place and was either written by hand or cut into a woodblock page. Typography is often referred to as the first mass production and the first enterprise to establish standardized parts. The system has remained unchanged in principle for centuries, although improvements have been made in printing presses, punch cutting, and typecasting to increase speed and efficiency.

a RSTUV

b PQRST

c PQRST

d PQRST

e PQRST

2.3. THE LETTERFORM AND TECHNOLOGY

Technology subtly affects how type looks on the page. Compare these examples of 24-point Goudy enlarged 400%: (*a*) letterpress printing with hand-set metal type; (*b*) commercial digital typesetting; (*c*) a photocopy of *b*; (*d*) laser printer output; (*e*) Linotronic 300 output of the same Macintosh file as *d*.

At first, printing with movable type was referred to as "artificial writing," and books produced this way were considered inferior to handwritten manuscript books. Nevertheless, printing spread throughout Europe like wildfire, and it helped to standardize writing and language and to disseminate Renaissance ideas to an increasingly literate populace. By the year 1500 there were 1,100 printing presses in 200 towns, and about 36,000 publications had appeared, comprising over 10,000,000 volumes.

About one hundred years ago, typesetting by hand was mechanized by such devices as the Linotype, a machine operated by a keyboard that could cast lines of type on demand. The Linotype virtually replaced hand-set type for high-volume printing such as that of newspapers, but was in turn made obsolete by phototypesetting technology in the early 1960s. Phototypesetting is being replaced today by digital typesetting technology. Each breakthrough in technology has been motivated by the need for speed and economy, and each new technology has offered new capabilities and limitations.

Mechanization

TECHNOLOGY AND FORM

A letterform reflects its technology—not just the technology or tool that is used to create the original shape, but also the technology that prints it onto paper. In lettering and calligraphy these are one in the same; in typography they are not. The typographic form is the product of the tool that creates the original design, the technology that creates the master (whether it be a metal punch, a ray of light, or a pattern of dots), and the technology that finally prints the image onto paper. Typeface designs from old technologies must be adapted to suit not only the characteristics of the new technology that creates the letter, but also the technology that will print the letter.

Carved Roman letters exhibit both the characteristics of the brush that painted them on the stone and the chisel that inscribed them. The letters that we see on paper are considerably different. The image created by movable metal type has been coated with sticky ink and pressed against an absorbent, fibrous paper surface; under the pressure required to print, the ink spreads to create a form that is softer and thicker than the shape of the metal surface that printed it. Phototypesetting technology creates thin, crisp

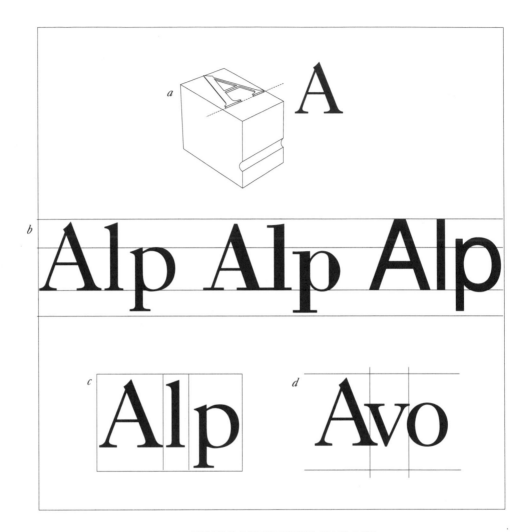

2.4. ORIGINS OF TYPE TERMINOLOGY

(*a*) The type *body*, or the block on which the raised letter rests, determines the point size of the type. (*b*) From left to right, Caslon, Bodoni, and Helvetica set in 72-point type, have different *appearing* sizes (the sizes we see printed on the page). The top and bottom lines indicate the body height. (*c*) Unkerned type is set so that bodies touch side to side; the width of the type body determines the spacing between letters. (*d*) Kerned type, in which space is removed from between the letters, is an optical adjustment uncharacteristic of traditional typography. Kerned type is easily identified because an unobstructed vertical line cannot be drawn between many of the letter pairs.

letters; printed on today's coated papers on large offset lithographic presses, the phototypeset letter retains its original shape and character. When choosing a typeface, then, we must consider how it will be generated and what will happen to it before it reaches the reader.

TYPESETTING TERMINOLOGY

Typographic terms reflect early technology and practices; learning typographic terminology has become a sort of rite of passage, and attempts at updating the terms have been largely unsuccessful. Terms have evolved piecemeal because of the evolutionary nature of typography. Partly because of the widespread misuse or misunderstanding of some of the terms, terms vary between specialties, disciplines, regions, nations, and technologies.

A *typeface* is a specific design of all the characters we use for our printed language, including numbers and punctuation. This collection of symbols makes up a *character set*. A specific size of a typeface was once called a *font*, but today font has come to be used interchangeably with *typeface*. In the days of metal type, each character rested on a block called a *type body*, which varied in width to fit the shape of the character. The height of the type body determined the minimum space between lines of type. Extra space was created between lines of type by inserting strips of lead, so the distance between lines of type (measured from baseline to baseline) has become known as *leading*. The width of the type body determined the spacing between letters; today we refer to the adjustment of this space as *kerning*. The concept of a type body is retained in phototypesetting and digital typography.

Type is measured in the *point* and *pica* system. An inch contains approximately 72 *points;* 12 points equal one *pica*. An inch then contains about 6 picas. Typefaces are measured by the height of the type body; the size of the printed letter, or the *appearing* size, will differ, however, from typeface to typeface among type that is classified as being the same size (e.g., 12 point). Unless we actually set metal type, we never see the type body, so it is virtually impossible to determine the point size of a printed sample without a printed specimen with which to compare it. We can approximate the point size from a printed sample by measuring from the tip of an ascender

to the tip of a descender, but this method is only accurate with technologies that have limited point sizes. With photo and digital technology, we can set type in any point size, and in smaller increments.

Digital type Today we use letters that are generated electronically and that consist of dots (*digital* type) with specific *resolutions*, measured in dots per inch. The more dots per inch (*dpi*), the higher the resolution and the more likely it is that the shape of the letter will have all the subtleties and nuances of its predecessors. The visual effect of the letter on paper depends very much on the type of printer used. A *laser printer* uses electrostatic printing (photocopying) and a resolution of 300 dpi. This process produces a letter with a soft appearance and imperfect edges; laser-printed letters have been compared in character to the products of old letterpress printing. The same digital type printed with a laser printer can also be printed with high-resolution printers that use photographic paper and a resolution of about 2500 dpi. Letters printed with this technology more closely resemble phototype in crispness.

STANDARDIZATION

Early typefaces showed subtle variation in serifs and detailing from letter to letter. Such variations were thought to make reading easier and typography more pleasing, and a typeface could exhibit a number of these changes without losing its coherence. Subtle changes were also made between sizes within a typeface, both because of technical limitations and because of how much detail we could perceive. Today a single master letter is used to create all sizes of a specific letter in a specific typeface; subtleties have been averaged and standardized. Today's type designer creates interchangeable parts, such as serifs and strokes, to ensure uniformity within a typeface. The old letters reflected the hand of man rather than the precision of the machine. The lack of these subtle irregularities makes it difficult to recapture the texture of the Renaissance page, and although typefaces are designed from time to time with the "imperfections" of early type painstakingly put back in, they lack the subtlety of the originals.

CHAPTER 2: CHOOSING TYPEFACES

Despite the myriad of typefaces available today, those typefaces most appropriate for the traditional page fall into a narrow category and follow the Roman tradition. Several appropriate typefaces are shown on the next page. Each has characteristics and subtleties that differentiate it from the others, but common to all are the characteristics that most typify the Renaissance tradition.

Each typeface reflects the era in which it was designed to some degree; many have been redesigned countless times since their original appearance. In the twentieth century, each change in technology has required that typefaces designed for previous technologies be adapted for the new technology; such adaptations are subject to inevitable reinterpretation and redesign. New typefaces continue to be based on the Renaissance tradition as well, and Renaissance letterforms continue to be the standard by which we judge the normal weight, form, and proportion of a typeface.

A typeface appropriate for the traditional page should meet all five of the following criteria:

1. *A stroke-to-height ratio of about 1:10.* That is, the height of a capital letter is about ten times the width of a vertical stroke. This varies a little from typeface to typeface, but a typeface with too bold or too thin a stroke should be avoided. Tests have shown that most readers prefer a medium-weight type.

2. *Relatively open letterforms.* Those typefaces in which the outside of the capital *O* is nearly a perfect circle are most appropriate; typefaces in which the letters are narrow (*condensed*) or wide (*extended*) should be avoided.

3. *Moderate, bracketed serifs.* Bracketed serifs ("feet") are those that blend with the strokes of the letter with a curve. The typefaces in figure 2.5 have bracketed serifs, as does the type you are reading now. Typefaces with hairline serifs or slab serifs that meet the stroke abruptly are inappropriate, as are serifs that are very abrupt or exaggerated in length.

ABCDEFGHIJKLMNOPQRSTUVWXYZ
abcdefghijklmnopqrstuvwxyz
1234567890

Garamond (1532), based on fifteenth-century designs by Aldus Manutius

ABCDEFGHIJKLMNOPQRSTUVWXYZ
abcdefghijklmnopqrstuvwxyz
1234567890

Goudy (1916), modeled on Renaissance lettering

ABCDEFGHIJKLMNOPQRSTUVWXYZ
abcdefghijklmnopqrstuvwxyz
1234567890

Caslon (ca. 1725), modeled on seventeenth-century Dutch designs

ABCDEFGHIJKLMNOPQRSTUVWXYZ
abcdefghijklmnopqrstuvwxyz
1234567890

Times New Roman (1932), by Stanley Morison for the London Times

2.5. TYPICAL TRADITIONAL TYPEFACES

These typefaces all share characteristics of weight, shape, and proportion
that make them appropriate for use on the traditional page.

4. *Strokes with a moderate thick-thin variation.* Typefaces categorized as *old style,* such as Garamond, and *transitional,* such as Baskerville, have a moderate variation between thick and thin. Some recently designed typefaces, although they do not fit neatly into either of these categories, may also be appropriate. Extreme variations in stroke widths are less appropriate.

5. *Easily recognizable letterforms with conventional shapes.* Letters should never require study or a second glance but should be immediately and unconsciously recognized during reading. This excludes typefaces in which shapes have been stylized, ornamented, or otherwise altered. An appropriate response to an appropriate typeface is that it is "ordinary," not that it is interesting or unusual.

These five criteria define a wide range of typefaces from which to select. Each typeface has an individual character and looks best set a particular way. The specific choice depends on a number of factors, such as how efficiently the type fills the page, its relative *color* (the shade of gray when set as text), the personal preferences of the designer, and the characteristics that best reflect the overall design. Goudy, for instance, is a rounder, softer interpretation of Trajan forms, whereas Caslon tends to be rather crisp. Though we may choose a typeface that is sympathetic to the topic being communicated, this should remain a secondary concern. Traditional typography should be neutral—it need not "act out" the meaning of the words.

Neutrality

It is rare that the designer needs to combine typefaces; interest and variety should come instead from the way in which the type is set. This is not to imply that combining typefaces is atypical of the traditional style, only that it is no longer necessary. Most examples of mixed typefaces occurred because many printers stocked only a limited number of fonts; mixing typefaces was necessary to get a range of sizes. In this sense, mixing typefaces was a functional choice more than an aesthetic one. Today the need for combining typefaces has been all but eliminated because we can set any size of any typeface to which we have access. On occasion a designer might prefer to use one typeface for text and another for the title, but both would meet the criteria for choosing a traditional typeface.

Mixing typefaces

The student of type must start by realizing that any fount is absolutely at the mercy of the printer, and, conversely, that a very agreeable book can be made of any but a 'freak' type, simply by humouring its particular needs. —*Times Literary Supplement*, 1927

(Times, 10/13)

The student of type must start by realizing that any fount is absolutely at the mercy of the printer, and, conversely, that a very agreeable book can be made of any but a 'freak' type, simply by humouring its particular needs.—*Times Literary Supplement*, 1927

(Goudy, 10/13)

The student of type must start by realizing that any fount is absolutely at the mercy of the printer, and, conversely, that a very agreeable book can be made of any but a 'freak' type, simply by humouring its particular needs. — *Times Literary Supplement,* 1927

(Garamond, 10/13)

The student of type must start by realizing that any fount is absolutely at the mercy of the printer, and, conversely, that a very agreeable book can be made of any but a 'freak' type, simply by humouring its particular needs.— *Times Literary Supplement,* 1927

(Caslon 540, 10/13)

The student of type must start by realizing that any fount is absolutely at the mercy of the printer, and, conversely, that a very agreeable book can be made of any but a 'freak' type, simply by humouring its particular needs. —*Times Literary Supplement,* 1927

(Palatino, 9/13)

The student of type must start by realizing that any fount is absolutely at the mercy of the printer, and, conversely, that a very agreeable book can be made of any but a 'freak' type, simply by humouring its particular needs. —*Times Literary Supplement, 1927*

(Janson, 10/13)

2.6. SOME TRADITIONAL TYPEFACES AND THEIR ITALICS

Each example is followed by the typeface, point size, and leading used. (Point size and leading are expressed as a fraction: size/leading.)

CHAPTER 3: TYPESETTING TEXT

Whether we are specifying type to be set or setting type ourselves, we must know what to consider to achieve a readable and pleasing page. A successful traditional page is the result of the right combination of typographic decisions that produces an even texture, color (grayness), and shape on the page. Choosing an appropriate typeface is only the first step in creating a traditional page and, within the range of traditional typefaces, the least critical.

Type can be divided into two main categories by size: *text*, which is usually between 9 and 12 points, and *display*, which is 14 points and larger. Because there are fundamental differences in how text and display type are used and perceived on the page, we must consider the setting of them separately. Text type (sometimes called *body copy*) is used for the body of the message, as well as for captions and footnotes. Display type is reserved for titles, headings, subheads, and large initial capitals. We see text and display type differently on the page. When we set text type we are more likely to see the forest rather than the trees; our focus is on the overall color and texture created on the page rather than on specific relationships between letters. In display type we begin to become aware of each letter, and the exact relationships between letters and words are more critical; we must adjust the spacing because inconsistencies become apparent. We also tend to be much more aware of the design characteristics of display type and, unlike with text, we can readily differentiate one typeface from another. Few readers will notice that this sentence was set in a different typeface.

Text vs. display

CONSIDERING TEXT

Many designers tend to think of text as gray matter that fills space, and they pay little attention to the subtle differences that changes in the text setting can achieve. This lack of attention is owing in part to lack of training and in part to the casual way designers commonly indicate text in sketches. Often

You may take the most beautiful type in your stock, and if it be carelessly set, if it be too large or too small for the page, or the page badly placed on the paper, then no beauty of type or paper will compensate for any one of these violations of proportions. (Bruce Rogers, *Paragraphs on Printing*, 1943)

You may take the most beautiful type in your stock, and if it be carelessly set, if it be too large or too small for the page, or the page badly placed on the paper, then no beauty of type or paper will compensate for any one of these violations of proportions. (Bruce Rogers, *Paragraphs on Printing*, 1943)

You may take the most beautiful type in your stock, and if it be carelessly set, if it be too large or too small for the page, or the page badly placed on the paper, then no beauty of type or paper will compensate for any one of these violations of proportions. (Bruce Rogers, *Paragraphs on Printing*, 1943)

You may take the most beautiful type in your stock, and if it be carelessly set, if it be too large or too small for the page, or the page badly placed on the paper, then no beauty of type or paper will compensate for any one of these violations of proportions. (Bruce Rogers, *Paragraphs on Printing*, 1943)

2.7. A RANGE OF READABLE TEXT SIZES

These samples were set in Caslon 540 in point sizes ranging from 12 to 9 (top to bottom). Each has an additional 3 points of leading (9/12; 11/14). Line lengths have been adjusted so that each sample fits the same number of characters on a line; this relates directly to the size of the page on which each will fit most appropriately. Although each example is consistently one point size smaller than the last, the visual difference between each is not consistent.

typographic details about text are left to the typesetter, who may or may not know what effect the designer wants to achieve.

When setting text, detailing is everything. Typeface, size, kerning, leading, line length, and justification are all interdependent factors; a decision about one generally affects decisions about the others. One cannot simply change one factor, such as point size, without considering how it effects the overall texture and color of the page. Many typographic decisions are visual, and although machines can approximate "rightness," it is the human eye that must make the final judgment because humans are the final audience.

POINT SIZE

Metal type was limited to only a few text sizes: Today we can set virtually any point size. Text should still range between 9 and 12 points for readability. (Figure 2.7 shows this range of typical sizes.) The overall design of the page must be considered when selecting the size for text type. Remember that we see size as relative: overly large subheads may make text seem smaller; a large page may make small text look even smaller; and large text on a small page may look out of scale.

Contrasts

Each typeface sets differently; for example, Times Roman was designed to fit more characters on a line. When space is at a premium it is better to choose a space-efficient typeface than to choose a smaller point size of a typeface that fits fewer characters on a line. When a page is difficult to read, the point size of the text is often blamed. People often automatically assume that a larger point size will improve readability. In fact, size is only one of many factors that affect the readability of text. Increasing the leading, changing the typeface, adjusting the kerning, changing the line length, or repositioning the type on the page will improve readability as well.

Readability

JUSTIFICATION AND LINE LENGTH

When text is *justified,* it is aligned along both the right and left margins, as is the text you are reading now. Virtually all traditional text is set justified. Because each letter occupies a different amount of space on a line, the spacing between letters and words from one line to the next is likely to vary.

Printing was from the beginning a completely mechanical achieve-
ment. Not merely that: it was the type for all future instruments of re-
production; for the printed sheet, even before the military uniform,
was the first completely standardized product, manufactured in series,
and the movable types themselves were the first example of com-
pletely standardized and interchangeable parts. (Lewis Mumford,
Technics and Civilization)

Printing was from the beginning a completely mechanical achieve-
ment. Not merely that: it was the type for all future instruments of re-
production; for the printed sheet, even before the military uniform,
was the first completely standardized product, manufactured in series,
and the movable types themselves were the first example of com-
pletely standardized and interchangeable parts. (Lewis Mumford,
Technics and Civilization)

Printing was from the beginning a completely mechanical achieve-

ment. Not merely that: it was the type for all future instruments of re-

production; for the printed sheet, even before the military uniform,

was the first completely standardized product, manufactured in series,

and the movable types themselves were the first example of com-

pletely standardized and interchangeable parts. (Lewis Mumford,

Technics and Civilization)

2.8. THE EFFECT OF LEADING ON TEXT

All three samples are set in 11-point Goudy. The first sample (top) uses 12-point leading,
leaving a gap between lines of about the height of a capital letter. The second sample (center)
is set with 13-point leading, which leaves a gap of about the height of two lowercase letters.
The third sample (bottom) is set with 16-point leading, leaving a gap of about one and one-
half times the height of the capital. Judging leading by the spaces left between lines will en-
sure a consistency between different typefaces and different technologies.

A minimum of about sixty characters per line is required if we are to create a consistent texture on the page with justified type. Shorter line lengths do not provide enough spaces between words in which to add or subtract extra space. Justified text should be hyphenated so that more adjustments to the number of characters per line occur. Additional adjustments must often be made by hand on a line-by-line basis so that an even texture is achieved.

LEADING

The texture, color, and fit of the text on the page are in large part determined by the choice of leading. Leading is the factor that determines the number of lines of type that will fit on a page and is often adjusted on that basis alone. In general, the longer the line of type, the more critical is the leading for readability. Over the centuries, measurement systems have changed and typefaces have been modified so much from technology to technology that no absolute leading specifications exist. Leading should be determined on the basis of texture and the spaces between the lines of type, both of which we judge visually rather than mechanically.

We can best describe the ideal range of traditional leading by looking at the gaps between lines of upper- and lowercase text, which typically range from no less than the height of a capital letter to no more than two *x-heights* (height of the lowercase *x*). (The samples shown in figure 2.8 use from one to four points of leading.) The exact amount of leading required to leave the same gap between lines will vary from typeface to typeface because of the differences between designs. The adaptation of typefaces to new technologies has included increasing the x-height in relation to the height of the capitals to suit modern tastes. By determining leading on a visual basis, we can compensate to some extent for this modernization, so that the color and texture of the page retain their traditional character.

Judging visually

TEXTURE AND READABILITY

The quality of typeset text is judged by its even texture and its readability. An even texture is critical for readability no matter what design style is being used. The right combination of typeface, point size, leading, kerning,

Printing was from the beginning a completely mechanical achieve-ment. Not merely that: it was the type for all future instruments of re-production; for the printed sheet, even before the military uniform, was the first completely standardized product, manufactured in series, and the movable types themselves were the first example of completely standardized and interchangeable parts. (Lewis Mumford, *Technics and Civilization*)

Printing was from the beginning a completely mechanical achievement. Not merely that: it was the type for all future instruments of reproduction; for the printed sheet, even before the military uniform, was the first com-pletely standardized product, manufactured in series, and the movable types themselves were the first example of completely standardized and interchangeable parts. (Lewis Mumford, *Technics and Civilization*)

Printing was from the beginning a completely mechanical achievement. Not merely that: it was the type for all future instruments of reproduction; for the print-ed sheet, even before the military uniform, was the first completely standard-ized product, manufactured in series, and the movable types themselves were the first example of completely standardized and interchangeable parts. (Lewis Mumford, *Technics and Civilization*)

2.9. THE EFFECT OF KERNING ON TEXT

All three examples are set in 10-point Goudy on 15-point leading, but each has different *kerning*, or spacing between letters and words. Kerning not only affects how the type fits the page, but the color, texture, and readability of the type as well. The first example (top) is char-acteristic of unkerned type in the traditional style; the second example (center) strikes a good, readable balance. In the third example (bottom) the letters and words appear crowded.

hyphenation, and line length will result in a page that has an even texture and is not only pleasing to look at but pleasing to read.

KERNING

Perhaps the most subtle and overlooked factor in setting traditional text today is *kerning,* or the spacing between characters. Kerning affects not only the fit of the type on the page, but its color, texture, and readability. The trend in commercial typesetting since World War II has been for tighter kerning. Tight kerning is inappropriate for most traditional typefaces because of their open proportions; it is also atypical of the traditional page, which was typically set unkerned with metal type. The openness of a typeface can be judged by the roundness of its letter *O* and is an indication of how tightly it can be kerned. (All of the examples in figure 2.6 were set the same except for the kerning.) When kerning the spacing between letters, spaces between words should be adjusted as well so that the texture remains even and readable.

PARAGRAPHS

Traditional text indicates paragraphs with indents. Sometimes a small amount of extra leading is added between paragraphs as well. Indents vary but should stay between one and two *ems* (the width of the capital *M*). In 12-point type, this translates to between one and two picas.

Paragraphs beginning new sections are sometimes indicated by setting the first word, phrase, or line in all capital letters, usually in conjunction with an oversized initial capital. When a large initial capital letter is used, its baseline should align with one of the baselines of the text. A typical modern (eighteenth-century) variation of this practice used by Bodoni is to make the initial capital only a little larger than the text, aligning it with the base of the first line of text.

Although graphic elements such as large initial capitals should be used with restraint, they often serve as visual relief in long tracts of text that are not otherwise interrupted by such hierarchical elements as subheads.

Perception

e

Looking at a single letter, large and isolated, can be
compared to looking at a single tree—we can see and ap-
preciate its subtleties and its uniqueness. When we see
the letter in a small group called a word it is like seeing a
cluster of trees. The individual characteristics begin to
lose their identity, and together the trees in the cluster
create a shape with its own unique characteristics. The
characteristics of the cluster or the word are determined
not just by the individual elements comprising it but also
by the spacing and arrangement of those elements. A
page of text is like a forest in that the shapes of the indi-
vidual elements and the shapes of the clusters blend to
form an overall texture and shape with its own identity.

2.10. HOW WE SEE TEXT AND DISPLAY TYPE

The size and quantity of type affects the characteristics we notice. Because of the way in
which we perceive elements alone and in groups, most readers will not notice that the shape
of the lone letter *e* is different from the *e* in the word *Perception*, and different again in the block
of text. Most readers will be more aware of the spacing of the display-sized word *Perception*
than the spacing of a word in the paragraph.

CHAPTER 4: DISPLAY TYPE

Display type has been used with more diversity than text type within the traditional style; however, display and text type consistently share the need for such common characteristics as symmetry, the use of traditional letterforms, an even texture, and a linear sequencing of information.

Display type offers the designer a new set of challenges and considerations. With display type, we are still concerned with optically consistent spacing, so that an even texture is created on the page, but we must be more aware of details. It is imperative that we do not treat display type as "big text"; it is far less likely that we will be able to enter display type into a computer and use what the machine generates as final typography.

Part of the reason we cannot depend solely on what the machine can generate automatically is that our perceptions change with different sizes and amounts of type. The specific characteristics of an isolated letter lose their importance as the letter becomes smaller and is surrounded by other letters. In the single word we are as aware of the relationships between the letters as we are of the letters themselves, whereas in the text these relationships are subordinate to the texture of the block as a whole (see figure 2.10).

The spaces between letters change with scale as well. If we photographically enlarge well-spaced text to a display size, the spaces between letters are too wide; kerning is often necessary for optical balance between letters.

Size relationships

Display type automatically creates contrast and emphasis on the page through changes in size, shape, capitalization, leading, and kerning. On the traditional page it is uncharacteristic to use bold type—as the type increases in size it will appear bolder on the page because the letters will have larger solid areas (see figure 2.10).

Contrast

Display type and layout are interdependent. We can begin a layout by setting display type and then fitting the other elements on the page; or, we

2.11. CONTROLLING THE SHAPE OF A TYPE BLOCK

All of these book covers show the same title set in Goudy. Differences between them were achieved by changing line breaks and capitalization. The point size for any particular set of line breaks is limited by the width of the page.

can arrange the other elements and then fit the display type into the remaining space. The procedure we choose will depend on what the other elements are and whether or not the page is part of a sequence of pages, as in a book or brochure. If this is the case, a single strategy must be determined and used consistently.

Margins determine the maximum width of a line of type, but a title whose shape is determined solely by margins is perhaps the least interesting. *Shape* Setting display type is an art more similar to setting poetry than setting prose and should be given the same care. Working within the traditional style, we can create numerous variations in shape by changing such simple things as line breaks and capitalization. Lines should either remain similar in length to create a rectangle with a traditional proportion, or get progressively shorter to create an inverted pyramid. The number of words in a title and the lengths *Variations* of those words determine how many options are possible and what those options will be. (See figure 2.11 for a typical range of variations.)

TEXTURE AND SPACING

Each combination of typeface, capitalization, leading, and kerning produces its own subtle texture. A consistent texture is a sure indication of good typography, the result of a careful balance between all the spacing factors in combination with the choice of capitalization and typeface.

All the spacing parameters—letterspacing, word spacing, leading, and the internal spacing of the letters themselves—must balance. The internal spaces in a typeface set the limits for the other spacing factors. Type should be spaced to echo its internal spacing characteristics; a typeface with rounded, open letters such as Goudy should be spaced more loosely than the compact typeface Times.

Consistent letterspacing is generally easier to achieve with lowercase letters than with capitals, in part because they were designed for writing and fit *Letterspacing* more neatly together. Capitals were designed to be set widely apart, or *letterspaced* in the tradition of Roman inscriptional type; this makes spacing easier than if they were spaced compactly, but it makes reading more difficult.

FIBONACCI
QUARTERLY E

36-point Goudy on 50-point leading

FIBONACCI
QUARTERLY E

36-point Goudy on 38-point leading

FIBONACCI
QUARTERLY

36-point Goudy on 30-point leading

2.12. A TYPICAL RANGE OF LEADINGS

The width of the space between the lines of traditional display type generally ranges from about the height of a capital to about the width of a letter stroke. In these examples, kerning has been adjusted to balance with the leading.

LEADING AND KERNING

As we read, leading and kerning must balance so that our eye is drawn along a line of type. When spaces between words exceed spaces between lines, our eye will be drawn to the line above or below rather than to the next word. Leading and kerning, then, are interdependent concerns. If leading is loose and kerning is tight, however, the title will take on a striped appearance just as text does.

Although leading and kerning minimums are established by the internal space of the typeface used, considerable diversity is still possible. The three leading variations shown in figure 2.12 are typical leadings; a specific layout would help to determine which is used. In general, the more space there is within a title, the greater must be the space that surrounds it. *Internal spacing*

The leading been changed in the examples in figure 2.12, and the kerning has been changed to correspond to the leading; it grows tighter as the leading becomes narrower. The particular settings that achieve a balance between leading and kerning will depend on the words being set, the typeface, and the size. Although typesetting specifications have been included in figure 2.12, these can only be a point of departure—the eye must determine when a final balance has been achieved.

Today's computerized typesetting gives us more control over leading and kerning than did metal type. The inherent integrity of the spacing that was so firmly established by the metal typeface body is often lost in the sea of options available with modern technology. The responsibility for spacing is now in our hands, and we must be more sensitive than ever to the spacing subtleties of typesetting, if we are to use our new tools to advantage. *Taking control*

The kerning of display type takes a practiced eye; there is no sure way to control it mechanically despite the promises of modern technology. Different letters have different shapes; different combinations of letters and words require adjustments. The even spacing of display type is an essential skill for anyone who assumes typesetting tasks. When either the equipment at hand or our lack of expertise limits our ability to space display type evenly, we should avoid larger display sizes and use sizes nearer to text so that visual inconsistencies will be minimized.

1 FIBONACCI QUARTERLY

2 FIBONACCI
QUARTERLY

3 FIBONACCI
QUARTERLY

4 FIBONACCI
Quarterly

2.13. CREATING VARIATIONS

All of these examples are set in Goudy. Variations are achieved by changing capitalization, size, kerning, and line breaks. All the type is the same weight; the size of the type determines its contrast on the page. Each arrangement retains traditional symmetry. There are many other variations possible within the limitations imposed on these examples.

VARIATIONS

The book title samples shown in figure 2.11 each used a minimum of variation. When we consider the possible combinations of size and capitalization, a whole new set of arrangements emerge. Such combinations are more characteristic of the traditional page than the modern. This kind of variation is particularly appropriate when the type is to be used for identity, such as for a logotype or masthead, or when the decorative quality of the type dominates, such as on a magazine spread or book cover. It is less appropriate to consider such variety when the type is to be used predominantly for communication, such as in headings on a technical document.

Because of the number of possible variations, it is often desirable to impose limits. The examples in figure 2.13, for instance, are all alike in the size and proportion of the area in which the type will appear; the typeface and weight; the symmetry; and the typographic style (in this case, traditional). The only variables, then, are the line breaks, the capitalization, the leading, and the kerning. Example 1, a single line of letterspaced capitals, is perhaps the most classical; it fits the shape of the area and gives equal stress to both words. In example 2, the title is broken into two lines; this does not match the shape of the area. In example 3, the emphasis is on the first of the two words, which is sized and letterspaced to fit the area. In example 4, the emphasis is on the second word. This solution is the one most dependent on the specific words being set.

NEUTRALITY

In general, type need not "act out" the meaning of the words being communicated. The word *baroque*, for instance, need not appear in an ornate typeface; neither does the word *carousel* need to be set in an 1890s decorated style; nor should the word *happiness* dance across the page.

Traditional typefaces tend to be used in a neutral way, independent of meaning, and remain subordinate to the message. They are carriers of the message rather than the message itself. For the experienced typographer, there is enough variation within the narrow range of appropriate traditional

typefaces to satisfy the typesetting needs of any project. The illustration of the message does not come from the type itself but from the illustrative elements, such as drawings and photographs, intended for this purpose. Logotypes and monograms are a different matter; these are not typography so much as letterforms designed to be illustrative and distinctive—in these, expression may be given priority over neutrality.

STYLE VARIATIONS

It has been common to give priority to aesthetics rather than to function when setting display type, particularly on title pages and such display material as posters. Many variations have arisen within the traditional style, mostly associated with or emphasized by decoration.

One typographic device that has become a stereotype of the traditional style is the use of gradually smaller type on each line down the page. This practice originated with the sizing of inscriptional lettering on monuments: If all the type on a monument was the same height, it appeared to get smaller as it became more distant from the viewer. To compensate, the type was made progressively larger as it moved up the monument. This approach was applied to the page during the Renaissance as an aesthetic device with classical charm. It lends itself to the traditional linear hierarchy by placing the most important information at the top of the page. The drawing below shows how the scale for determining the decreasing sizes of letters was constructed: the point from which the lines project represents the viewer's eye and is the centerpoint for an arc. Points are evenly spaced on the arc; radiating lines are drawn through these points to a vertical line. Where these lines meet, the vertical line establishes the base and height of the type.

CHAPTER 5: HIERARCHY

Most printed pieces have a significant amount of text. Usually, this text is structured by the writer into levels that take the reader from general to specific and from most important to least important. We call this writing structure a *hierarchy*, and it typically consists of heads and subheads that segment the text and act as references for the reader. We most commonly indicate hierarchical changes typographically and sometimes add graphic elements to the type as well.

The relative importance attributed to a level in the hierarchy is implied by the degree of contrast of that element to the text. The relationships between the elements on the page create a *visual* hierarchy; the reader assumes that the visual hierarchy reflects the structural hierarchy of the writing. It is the visual hierarchy more than what the type actually says that distinguishes a page number from a chapter number, a caption from text.

Visual hierarchy

If a hierarchical change is too subtle it may either go unnoticed, assumed to be an error, or thought to be an optical illusion. If a hierarchical change is too dramatic, however, it may imply more emphasis than it should. Worse, such a change may interfere with the flow of reading by causing a shift in the reader's focus. So that each progressively higher level receives the appropriate amount of emphasis, the designer must establish the hierarchy as a whole.

Hierarchy must be an integral part of layout considerations, as well as typographic decisions. When there are few hierarchical levels and these appear infrequently, such as the chapter headings in a book, the visual changes between them can be significantly more dramatic than when there are many hierarchical levels or when changes in level are frequent. The point of departure for establishing a hierarchy is the writer's outline or table of contents, which shows the designer what to expect in terms of the number of levels and the frequency with which they will appear.

SECTION II: TYPOGRAPHY

5
HIERARCHY

II: TYPOGRAPHY

Chapter Five

HIERARCHY

SECTION II TYPOGRAPHY

Chapter 5: *Hierarchy*

2.14. ALTERNATE VISUAL HIERARCHIES

We understand each of these examples to be showing the same information. Each exhibits subtle differences in visual hierarchy, however. Notice the changing importance of the word *chapter*—in the first example it is eliminated, in the last it dominates. This kind of change in visual hierarchy can make a significant difference in the layout and balance of a page.

Perhaps the most effective way of establishing hierarchy is to use the text as a point of departure. Once the text and general structure of the page have been established, the hierarchy can be developed in relation to it, so that each level in the hierarchy contrasts both with the text and with the levels above it. The larger the text, the more likely it is that hierarchical levels will enter the realm of display type and will need optical adjustments. When it is inappropriate to devote time to such adjustments, the visual hierarchy should be designed so that display sizes are avoided.

We perceive a change in hierarchical level when the texture of the page changes or is interrupted. The relative contrast of one level to the next implies a change in relative importance; lower-level subheads, then, should be changed only a little, and higher-level subheads must be changed more dramatically to show their relative importance. Each hierarchical level must be clearly differentiated from the others, whether levels appear in close proximity on the page or are separated by several pages.

A texture change is relatively subtle, generally the result of changes in capitalization, size, kerning, italicizing, or some combination of these. Capitalization alone is perceived as a change in size, since the height of the capital is greater than the height of lowercase letters. Changes in size alone should be at least two points in text sizes, and more for display sizes, if such changes are to be seen as intentional and obvious. Letterspacing to change texture is only appropriate when capitalization is used. *Changing texture*

Our perception of size is relative and optical. Capitals used with text of the same size will appear larger. If we want capitals to appear the same size as the text we may need to reduce the point size or use *small caps*, which have the shapes of capitals but are generally the height of the lowercase letters. If the text has an uneven texture because of the frequent use of capitalized and italicized words, more differentiation will be required to show a hierarchical change. The boldface of most traditional typefaces offers little contrast and is seldom appropriate except for directories and other such lists.

Breaking texture has more impact than changing it. A break creates more emphasis on the page and is most commonly achieved by increasing the lead- *Breaking texture*

Metaphor and Visual Images

To make the familiar strange is to distort, invert, or transpose the traditional ways of looking at, and responding to, the secure and familiar world. It results in achieving a new look at the same old world. The attempt to make the familiar strange involves several different methods of achieving an intentionally naive or apparently out-of-focus look at some aspect of the known world. Such a look can transpose both our usual way of perceiving and our usual expectations about how we think the world will behave.

Kinds of Analogies

Direct Analogy

The conscious comparison of parallel or nearly parallel facts is called direct analogy and requires searching one's experience and knowledge for an image that has some relationship with the subject at hand.

Personal Analogy

The individual's empathetic identification with the inanimate elements of a problem is called personal analogy. To make the familiar strange, one may personally identify with an

(From an essay by William J. J. Gordon, "The Metaphorical Way of Knowing" [1965].)

METAPHOR AND VISUAL IMAGES

To make the familiar strange is to distort, invert, or transpose the traditional ways of looking at, and responding to, the secure and familiar world. It results in achieving a new look at the same old world. The attempt to make the familiar strange involves several different methods of achieving an intentionally naive or apparently out-of-focus look at some aspect of the known world. Such a look can transpose both our usual way of perceiving and our usual expectations about how we think the world will behave.

KINDS OF ANALOGIES

DIRECT ANALOGY. The conscious comparison of parallel or nearly parallel facts is called direct analogy and requires searching one's experience and knowledge for an image that has some relationship with the subject at hand.

PERSONAL ANALOGY. The individual's empathetic identification with the inanimate elements of a problem is called personal analogy. To make the familiar strange, one may personally identify with an element or object, being empathically pushed and

(From an essay by William J. J. Gordon, "The Metaphorical Way of Knowing" [1965].)

2.15. INDICATING HIERARCHY CONSISTENTLY

ing before and after a hierarchical element. Short subheads break texture and need to be differentiated from text less than wordy ones. As a general rule, when leading is increased for lower-level subheads, add at least one-fourth of the original leading; for example, a 15-point minimum leading for a hierarchical element when the text has 12-point leading. When additional leading separates paragraphs, the amount of extra leading used between paragraphs sets the minimum for separating low-level hierarchical elements. The space above a subhead should generally be greater than the space below it. The leading between a subhead and text should not be less than the leading between paragraphs. The only exception is for very low-level subheads that refer only to a single paragraph. *Adding variety*

The subhead on this page both changes and breaks the texture. Changes in texture are created by capitalization and kerning; breaks in texture are created by increases in leading and because subheads do not fill the width of the line. Although the subhead on this page is two points smaller than the text, it does not seem smaller (this is important to note, because point size is often assumed to be the primary strategy for indicating change). When there are many levels of subheads, display sizes may be reached rapidly. Display-sized subheads require greater differences in size between them—a two-point change in a text size is no longer noticed in display sizes. This increases the amount of space used on the page. *Effects of size changes*

If the page includes a variety of elements, the hierarchy should remain relatively subtle so that the text retains consistency as a whole. If the page is dominated by text, hierarchical elements are needed to add variety; they offer visual relief as well as represent language structure.

SUBJECTIVE HIERARCHY

When no specific hierarchy is dictated by the writing structure, the relative importance of each piece of information is subjective—open to interpretation. Advertisements, announcements, and fliers typically have subjective hierarchies. Information can be presented a number of ways: The specific audience, timing, and purpose help determine what the visual hierarchy will be. Although the writer, designer, art director, client, and marketing manager

may all have different views of what hierarchy should be established, the correct subjective hierarchy is the one that best meets the communication objectives of the project.

As markets and audiences change, the hierarchies change as well. A book cover for an Agatha Christie mystery early in her career featured the title of the book prominently; when her name became a household word the hierarchy reversed—her name became the dominant element. A character in a novel can take priority as well: The cover of a novel about Sherlock Holmes may feature his name so prominently that we are not even aware that the book was written by someone other than Sir Arthur Conan Doyle.

Shifts in emphasis

A subjective hierarchy must often attract the eye as well as differentiate the elements on a page. It is useful to try several variations and consider their effects. These should include not only shifts in visual emphasis but changes in sequence as well. Although both of the ads below contain the same information, the information assumes a different level of importance in each, and each variation may serve a different audience.

AT THE EXPLORATORIUM FROM JULY 6 TO SEPTEMBER 5:

MEMORY

THE ART AND SCIENCE OF REMEMBERING

EXPLORATORIUM

MEMORY: THE ART AND SCIENCE OF REMEMBERING

JULY 6 TO SEPTEMBER 5

2.16. TWO VERSIONS OF AN ADVERTISEMENT

EXAMPLES AND SUMMARY

reyno. Este es el primero que con ambicion demando el reyno: y el que hizo oracion so
bre ello: por atraher a su volütad al pueblo/pponiendo q̃ no pedia cosa nueua : pues o-
tros esträgeros hauiã ya en roma reynado: y q̃ el la mayor pte de su vida hauia allí mo
rado. El pueblo atraydo por sus palabras: mandarõ le todos de vna volũtad/q̃ tomas
se el reyno. E como todas las cosas le succediessen a su volũtad: tan poco enel reyno pu
do carecer de ambicion: poniẽdo mas estudio en assegurar su impio/q̃ no enlo acrecen
tar. E por esto eligio ciẽt padres delas gẽtes menores: porq̃ conociẽdo q̃ erã su hechu-
ra/fauoreciessen siẽpre sus cosas enel senado. La pmera guerra q̃ tuuo fue cõ los lati-
nos. y tomoles por fuerça vn lugar q̃ era llamado Apiola. E torno a roma cõ mayores
despojos/q̃ fuera la fama dela batalla. Este hizo mas ricos juegos q̃ los otros reyes
passados. Entõces fue señalado el lugar pa los juegos q̃ era llamado circo. E q̃riẽdo
Tarq̃no cercar a roma cõ muro de piedra : estoruole la guerra delos sabinos. los q̃les
vinierõ tan de subito : q̃ primero passarõ el rio Aniene/q̃ los romanos pudiessen salir
cotra ellos. E mucho temor houierõ entõces los romanos. Y pelearõ la pmera vez cõ
grã daño de entrãbas las partes. E despues juntãdo el rey Tarq̃no mas gente: vino
cõtra los sabinos. E comoq̃ra q̃ el exercito romano hauia crescido en gẽte: tã biẽ q̃sie
ron a puechar se de vn engaño oculto. y fue q̃ mãdarõ poner enel rio vna grã multitud
de maderos atados: y ponerles fuego: porq̃ llegãdo ala puente delos sabinos q̃ era de
madera/la q̃masse. E viẽdo los sabinos (q̃ estauã enel cãpo) este peligro: fuerõ espan-
tados. τ como no se pudiessen recoger en su ciudad: vinierõ ala batalla : enla q̃l fueron
muchos muertos/y otros se ahogarõ enel rio. E sus armas fueron por el rio a roma:

Nota q̃ los jue
gos q̃ eran lla
mados circen
ses se baziã cõ
espadas: onde
circẽses tãto q̃
re dezir como
circa enses . vi
de ysidori. lib.
xviij. etbi.

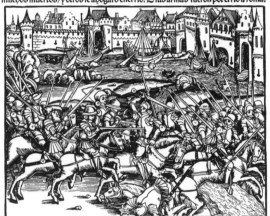

3.1. A WOODBLOCK PAGE

 Printed about 1500, this book is more Gothic than Renaissance in character. Its structure
and approach are decidedly traditional. Bordered illustrations fall either at the top or the bot-
tom of the page so that text flow is uninterrupted. A strong relationship exists between illustra-
tion and text color. A Renaissance version of this relationship is shown in figure 1.4 on page 42.

FOR CENTURIES
IN THE VANGUARD
OF TYPE DESIGN

E

ENSCHEDÉ-HAARLEM
HAVE BEEN ACTIVE
SINCE 1743
IN THE
PRODUCTION OF
FINE PRINTING
TYPES

3.2. A CLASSIC ADVERTISEMENT

In 1964 this ad ran side-by-side with fashionable unstructured modern ads. Today the modern ads have become mere novelties, but this ad retains its elegance and timelessness. Neither hierarchical differentiation nor decorative devices were needed to make this page clear and visually pleasing. The beautifully even texture could not have been achieved with tight letterspacing, and this wide letterspacing would not have been possible unless information had been kept to a minimum. To add to its classic character, the ad was printed on vellum.

THE BOOK CLUB OF CALIFORNIA

Quarterly NEWS LETTER

Published four times a year for its members by The Book Club of
California, 1125 Russ Bldg., San Francisco. Edited by Oscar Lewis

March-June 1942

Volume IX CONTENTS Number 4
Keepsakes—Ninth Series — A New Field of Activity — The
Bierce Centenary — Elected to Membership — Notes on Pub-
lications — California on Canvas — Miscellany.

KEEPSAKES—NINTH SERIES

FOR ITS NEW SERIES of keepsakes, the first part of
which is scheduled to appear this month, the Club has
selected a subject closely allied to contemporary interests.
In this year 1942 the lands bordering on the Pacific Ocean
are claiming a larger share of the world's attention than
at any other period in history. In recognition of that fact
the Club plans to issue a series of six pamphlets which in
subject-matter and treatment are intended to honor the
countries within this area that are allied in the present

4 The Book Club of California

$5.00 per year, you would not only encourage interest in
beautiful books but you might also influence sincere and
talented young men and women to enter that field and
contribute to the further development of fine bookmak-
ing here in California—which, I believe, is one of the
Club's purposes.

To the objection that dues of $5.00 per year would not
cover the cost of such memberships, my reply would be
that many of those admitted at this lower rate would no
doubt want to continue their membership on the regular
basis once their student days are over. Also, if it proved
necessary to equalize the loss on such memberships by
inviting some of us to pay a proportionately higher rate
(of, say, $15.00 per year) I am sure the response would
be generous.

No doubt there are aspects of this matter that I have
not fully considered and certain difficulties that would
have to be ironed out. But I sincerely believe the Club
will serve a worthy cause and in the end greatly broaden
its influence and strengthen its position if a way can be
found to enter this new field.

THE BIERCE CENTENARY

THIS MONTH OF JUNE marks the hundredth anni-
versary of the birth of one of the most important (and
controversial) figures in Pacific Coast literature, Ambrose
Bierce. His centenary is of particular interest to Califor-
nians. Bierce was not born within the state, nor did he die
here; in fact, more than two-thirds of his long life was
spent elsewhere. Yet he is everywhere regarded as a Cali-

3.3. THE BOOK AS A MODEL

Today's newsletters are commonly modeled after newspapers, a format that often causes
layout problems of fit, hierarchy, and organization. In contrast, this 1942 newsletter was mod-
eled after a traditional book; because the articles were treated as sequential chapters, layout
has been simplified dramatically. Just as in a traditional book, the live area has been filled top
to bottom—spaces between articles have been adjusted as necessary to keep the top and
bottom margins consistent. Typical of the traditional style, contrast has been kept to a mini-
mum—even the type for the words *News Letter* has open strokes to minimize what might other-
wise be dramatic contrast on the page. A relatively thin paper could be used for printing
because the live area on both sides of the paper aligns. This alignment, combined with an even
page texture, prevents the reader from noticing that the printing on the back of a page shows
through.

INTERTYPE'S ELEGANT NEW TYPE FACE

Egmont

Light and **Medium**

Egmont is Intertype's newest contribution to fine typography, a face to make your line machine composition smarter and more attractive than ever. You can use it judiciously for a booklet, an advertisement series and for much of your jobbing display. Egmont has a nicely blended reverse serif to add a jaunty sparkle to an otherwise sedate character; it is flowing in form, as elegant as the svelte Gazelle, and has discreet variation between its heavy and light strokes. Its italic is uncommonly clear and unusually readable in a single line or a lengthy paragraph. And small caps? With Egmont comes ROMAN *AND ITALIC TRUE CUT* CHARACTERS which, instead of being duplexed with figures in the usual way, are duplexed together so that the narrow letters have no more space than they need, and the wider characters may be accommodated appropriately. Egmont Light and Egmont Medium are at present available from eight to twenty-four point — cut, of course, on Intertype WIDE TOOTH matrices. The full series is presented in the Egmont booklet. Executives may obtain a copy from head offices, Farnham Road, Slough, Bucks

Available for keyboard composition only from
Intertype Limited

41

3.4. BLENDING MODERN WITH TRADITIONAL

This 1937 advertisement for a new typeface does not use classic margins, nor does it rely upon axial symmetry. Instead, elements have been carefully, if conservatively, placed off-center. Because the asymmetry is minimal, a passive balance is maintained. The color and texture of the page remain passive as well. Leading is exaggerated, as was the fashion of the day; the typeface, with its long ascenders and short descenders, reflects this fashion as well. No bold weight for this typeface was offered.

SIDEREVS NVNCIVS

MAGNA, LONGEQVE ADMIRABILIA
SPECTACULA PANDENS

GALILEO GALILEI

THOMAM BAGLIONUM

VENETIIS

3.5. THE EVOLUTION OF A TITLE PAGE

In the original title page, above left, a complex hierarchy has been established through a wide variety of text settings; it is structured as a single sentence. A considerable amount of information was included on the original; today a title-page format is limited to a title, subtitle, author, and publisher—any other information appears elsewhere.

These title pages reflect the conventional formats of their time; the differences between them, however, are proof of the fact that formats change, and such changes could not occur if formats were followed consistently. Judgment must sometimes take precedence over convention, even within the most conservative interpretation of a style.

The original title page was hand-set with metal type and the new version was composed on a computer, but it is the difference in the structure of the information and not the difference in the technology, the typeface, or the style that has made the most dramatic difference.

MINDSIGHTS MINDSIGHTS

PETROGLYPHIC

At the urrld, it has becnds, and colleagu pictures might be regaere making available, to a wider public, a series of ink dr pictures might be regaera dozen years ago, inrld, it has bece drawings, beialous, ambiguous, or illusory, illustrate soment, they camys in which thng variously anomind behind the eye can be tricked into an interpretive flip or mental som pictures might be regaegan dointion with my sciengs primarily for my own recreation anuseme to achieve a degree of connecntific professiong variously anomarch psychologition with my scielizing in perception and related mental—or, as they are nong variously anomalled, *cognitive*—processes. Induch anomalousrded as probes, of a sort, of the human visual-cognitive system. Because this systent, they camuct of millions of years of evolution in the thretion with my sciemensional woome so efficiing us witly. Weridical interntion with my sciehat is going on in that world that we seem to experieeed, sorld directe are generent as providely unaware of the complex and highly sophisticated interpretive processes that autnal Euccally construct for us a representation of a stablrld, it has becensidd objeean layout of solim the shifting, upsodwn, curved, two-dimensional

3.6. THE TRADITIONAL PAGE AS BACKGROUND

This book design proposal is for a collection of illustrations with accompanying text. A traditional axial layout structure was chosen because of its inherently passive nature, placing emphasis on the illustrations rather than on the design of the page. Because illustrations vary widely in detail, color, proportion, and character, each was positioned for optical balance rather than according to a predetermined formula. Because line weights and detail vary considerably from illustration to illustration, scaling decisions were on a case-by-case basis as well. The squarish page format accommodates a variety of shapes and proportions. Wide margins frame and separate illustrations so that they do not compete with one another on spreads. Hairline borders around illustrations help provide unity. Text pages, with their consistent size, shape, color, and texture, provide additional unity. Titling and reference information is small and letterspaced to minimize contrast.

THE **18**^{*th*} EXHIBITION

OF BOOKS

PRODUCED BY WESTERN PRINTERS

SPONSORED BY

THE ROUNCE & COFFIN

CLUB

◊

THE ROUNCE & COFFIN CLUB of Los Angeles again presents examples of outstanding printing in the Far West in this, the *Eighteenth Western Books Exhibition.* Since 1938 this annual show has selected and exhibited books which a host of highly-qualified judges have deemed outstanding in design and craftsmanship. This year the jury accomplished the difficult task of selecting for award 40 books from a total of 54 submitted. The award winners represent the work of 20 printers. Our judges this year were Gordon R. Williams, Assistant Librarian at UCLA, and

3.7. THE TRADITIONAL STYLE AS FASHION

Since the introduction and acceptance of the modern style, the traditional style has become an option rather than a convention, and it goes in and out of fashion. Although earlier versions of this booklet were decidedly modern, this 1959 version adopted a traditional style. In this example, not only the typography but the proportion of the page was changed—the modern, squarish format used in earlier years was replaced by this more traditional page proportion. The borders and line illustration on the cover (above left) were intended to add to the traditional character of the booklet. Although the covers of earlier versions were printed in two colors, this was printed in one color, black, on a dull green uncoated stock. (A modern version of this booklet, designed in 1950, is shown on page 156.)

SUMMARY

Information and ideas, great and small, have come to us in the traditional style for almost five centuries. We learn its principles as schoolchildren and accept its approach to the page as right and natural. It is the style most of us inadvertently assume when we begin working with typography, and it is often only through the concerted efforts of our art and design instructors that we depart from it to explore other avenues.

The structure of the traditional page begins with the proportions of the page on which margins are constructed. Within these margins, information is organized sequentially, making the traditional style an appropriate choice for long tracts of text and for the presentation of linear information. This inherent linearity provides no structure for organizing complex information, however, and the successful application of this style to a complex page or an assortment of elements is achieved only by a capable designer with a thorough understanding of traditional design principles. Only through careful attention to the subtle details of typography does the designer achieve aesthetic excellence within the traditional style, taking the page beyond its basic role as a mere vehicle for recording thought and imparting information.

Born of the Renaissance and the invention of typography, the traditional style today continues to reflect the aesthetic standards of that time. Classical proportions, symmetry, and passive balance continue to dominate, and our model for the typographic page remains the page of the Renaissance typographer. Reflecting the constraints of the hand-set metal type from which it developed, the traditional style has survived the mechanization of typesetting and the impact of phototypesetting technology, and it seems destined to survive the digital revolution as well. Formal in nature, the traditional style continues to be the choice for tombstones and wedding invitations, financial institutions and law firms, jelly jars and cosmetic labels.

The modern style

2

Contents

Although radical changes have taken place in typesetting and printing technology in the sixty-five years separating these two designs, the leaflet cover designed in 1923 by El Lissitzky has much the same modern character and works with type in much the same way as the cover by Randy Moravec for a book about Joseph Niépce. Both use typography as much for design value as for communication.

At the beginning of the twentieth century, Europe was still adjusting to the impact of the Industrial Revolution. The early decades were marked by great social upheaval, owing to both industrialization and World War I and its aftermath. Traditional ways of doing things were seen as inadequate for dealing with modern problems—the modern world demanded modern solutions.

This attitude was expressed by a rampant experimentalism in the arts, producing many new schools of thought. New movements ranged from dada in Switzerland to de Stijl in the Netherlands and Constructivism in Russia. Some of these movements were coherent philosophies; others were radical reactions to the old order of things.

Although considerably different from one another in style and philosophy, these movements had in common the desire to reflect modern times and to reject tradition for tradition's sake, just as later generations would reject art for art's sake.

The Arts and Crafts Movement, started in England in the late 1800s by William Morris, was a reaction against industrialization and an attempt to integrate art and handicrafts in the tradition of Gothic guilds.

In Germany, enthusiasm for this movement spread; schools were established in which art and craft could merge. One of the most famous of these schools was the Bauhaus, opened in 1919. Bringing together diverse instructors and diverse philosophies, the Bauhaus fused the modern movements together.

As it developed, Bauhaus philosophy expanded to include technology. Bauhaus teachings combined the newly formed theories of Gestalt psychologists with art theories of form, color, and abstraction. Art education today is based on Bauhaus theory.

The Bauhaus became a symbol of modern technology, modern art, and modern life. As a forum for new ideas, the Bauhaus had widespread influence and inspired a broad audience. Jan Tschichold, whose book *Die Neue Typografie* became the cornerstone for the Swiss design movement, was strongly influenced by the Bauhaus.

A product of turbulent times, it was perhaps inevitable that the Bauhaus be short-lived. The school was closed by Hitler in 1933, but only after the Nazi movement had applied Bauhaus design theory to its own identity, using the simple form of the swastika with such power and consistency that it can probably never again be used in a benign way.

Two seals used by the Bauhaus, the early one reflecting its crafts orientation and the later one, designed by Oskar Schlemmer, reflecting the Bauhaus' change in attitude toward modern technology.

Styles express attitudes and philosophies as much as eras. Many of the design experiments from the early decades of this century continue to look "modern" today because of the spirit in which they were created. We cannot easily disassociate modern or traditional thinking from modern or traditional styles of design. People's thinking does not change all at once—many find that they work with a little of this style and a little of that, blending style characteristics on the page. Such a page may have little or no character of its own because there is no coherent philosophy behind the decisions.

When a style is revived, a stereotypical image of that style emerges. This stereotype is disassociated from the specific historical period in which the original style developed; instead of representing a period, it represents an attitude. The attitude represented becomes an implicit message that is often used in marketing and advertising.

A cosmetic line packaged in a crisp Swiss style, for example, may suggest that the product is a serious functional necessity rather than a frivolous luxury. A jar of jam, on the other hand, might be packaged in a traditional style to remind people of the good old days, when food came from Mom's kitchen rather than from a factory or laboratory.

In the beginning of this century, machines were being invented to assist with virtually all facets of human endeavor. In printing and typesetting, old technology was improved to increase speed and efficiency, and new technologies were developed to advance the march of progress.

Mechanization of printing meant faster and more-efficient presses; mechanization of typesetting meant "cast-on-demand" type, which significantly reduced the demand for hand-set type.

New technologies were typically applied first to those areas of the industry in which speed and economy took precedence over quality and only later to areas in which quality was a dominant concern. Many new technologies, therefore, have had their origins in the production of the daily newspaper.

Available today is a whole spectrum of technology, ranging from the most innovative computerized typesetting and printing equipment to a small but dedicated fine press movement that uses letterpresses and continues to set type by hand.

As a technology becomes outmoded it tends to become an art medium.

Each new technology first proves its worth by imitating the capabilities of the technology it was designed to replace—hand-set type first imitated hand lettering; 450 years later, mechanized type had to meet the standards set by hand-set type. Computer-generated type in the 1980s had to meet the criteria of phototypesetting, the technology that had replaced mechanized type nearly three decades before.

Once a technology has proven itself as an accepted alternative to the previous technology, its new capabilities are explored as well. Initially, this exploration is primarily in the hands of people who would not otherwise be using the equipment. Blissfully unaware of prevailing wisdom and tradition, they freely explore these new capabilities, often developing techniques and strategies that might be overlooked by the professionals in the field. The typesetter with new capabilities may experiment with layout or illustration; the computer operator turned color separator may devise new ways to tint photographs. Whatever the success of these experiments, they inspire those with more experience in the field to explore the new technology as well. As a new technology becomes the dominant technology, it tends to replace the previous technology almost entirely.

With each advance in technology is a parallel reactionary movement to revive earlier technologies; we lament the loss of the old just as we embrace the promise of the new. The twentieth century has been marked by periodic and radical changes in technology that seem to emphasize this push and pull between the old and the new.

The successful development of a new technology requires an understanding of what the new device is to accomplish. Such an understanding must be based on information about how the old technology is used as well as what the users wish it could do, or could do better.

In the mid 1400s, Gutenberg applied his knowledge of metals to the development of a technology to replace the visible-word technology of the day—writing. First known as "artificial writing," this technology later became known as typography, and it followed the style already established for putting words on paper.

In the early 1900s, the Monotype and Linotype machines set type to meet the needs of those working in the traditional style. By the time phototypesetting was developed after World War II, however, the modern style had gained a foothold. Meeting the needs of modern as well as traditional designers, phototypesetting allowed freer experimentation with typography and inspired new directions in design.

The typewriter was developed in the late nineteenth century, and its capabilities were modeled on the traditional style. The word processor added to the traditional capabilities for producing a traditional page by making the tasks of centering headings and justifying type easier. The computer hardware and software that we call desktop technology has attempted to integrate the needs of both styles, often satisfying one at the expense of the other.

In the never-ending quest for speed and efficiency a conflict arises between doing a job fast and doing it right.

Each step forward in technology can be seen either as an attempt to resolve this conflict or as another way of aggravating it. The quest for speed and efficiency tends to be motivated primarily by economy; for those who are motivated by the bottom line, quality is virtually always a secondary issue. The results of this attitude are all around us.

Printed pieces are produced so economically today that they have become quite literally disposable. We face a daily barrage of printed matter that is not only constant and pervasive, it is in full color.

Color printing was once reserved for high-quality work with correspondingly high budgets. It is now so accessible that a color brochure is commonly disposed of as readily as the daily newspaper.

The quality of design is a key factor in determining which of the printed pieces we see will be noticed, read, and saved.

Good design is independent of technology, style, budget, subject matter, or any other single factor. A good designer can produce good design in the worst of situations and with the poorest of materials; an ineffective designer with the best of everything still does not produce good design.

Design is the one factor that can be counted on consistently to make a particular printed piece stand out from the rest. Ironically, it is also the factor most often considered expendable in a budget discussion.

The marketing of desktop computers has reinforced this notion of the expendability of design. Just as advocates of the Industrial Revolution perceived of the machine as the solution for all problems, so do advocates of the Electronic Revolution perceive of the computer as the solution for today's problems, and graphic design as simply another problem waiting to be solved.

A concerted effort is under way in the computer world to create a "designer in a can." Motivated as much by the excitement of the chase as the quest for excellence, many undertaking such tasks are unaware of the complexities and subtleties involved. The designer-in-a-can has potential as a useful tool, just as a thesaurus is a tool for a writer; it also has the potential to be the computer equivalent of the cheap, predesigned business cards available from the instant printer. Although design includes a fair amount of analysis, it is much more like art than like engineering; as such, it remains an essentially human endeavor.

We are more often limited by our thinking than by our technology. The typewriter, for example, is one of the most restrictive type-producing devices and is rarely used in an innovative way. This is not due as much to the typewriter's limitations as to the fact that we think of it in a restricted way—only as a device for putting words in sequence. Those who are using personal computers for layout and typesetting often find that a major obstacle in raising the quality of their design is that they are using the computer as they would use a typewriter.

If we compare the four examples below, we can see that the quality of the layout and visual interest are neither guaranteed by typesetting technology nor prohibited by the typewriter. The typeset pages are not automatically better simply by virtue of the technology used.
We cannot begin to work with the modern style effectively until we become aware of and transcend the restrictive thinking of the traditional style and the conventions of familiar technologies.

```
       DADA: AN EXHIBITION OF TYPOGRAMS
                 FROM 1916-1923
            June 26- September 21

  The experiments of the dadaists re-
  defined our views of letterforms and
  communication. Fields of tension
  and contrasts mark the conception of
  letterforms as formal values. Par-
  ticularly significant are the works
  of Tzara and Hausmann, whose tech-
  niques, including collage, provided
  new insights into the visualization
  of language.
```

DADA: AN EXHIBITION OF TYPOGRAMS

FROM 1916-1923

June 26-September 21

The experiments of the dadaists redefined our views of letterforms and communication. Fields of tension and contrasts mark the conception of letterforms as formal values. Particularly significant are the works of Tzara and Hausmann, whose techniques, including collage, provided new insights into the visualization of language.

```
The experiments of the dadaists rede-
  fined our views of letterforms and
   communication. Fields of tension
    and contrasts mark the conception
     of letterforms as formal values.
      Of particular significance are
       the works of Tzara and Haus-
        mann, whose techniques, in-
          cluding collage, provided
            new insights into the
              visualization of
                 language.
           June 26-September 21

         d  a  d  a

              an exhibition
             of typograms
             from 1916-1923
```

The experiments of the dadaists redefined our views of letterforms and communication. Fields of tension and contrasts mark the conception of letterforms as formal values. Of particular significance are the works of Tzara and Hausmann whose techniques, including collage, provided new insights into the visualization of language.
June 26—September 21

d *a* d *a*

an exhibition
of typograms
from 1916-1923

The modern style is based on visual principles that were formally defined at the beginning of this century by Gestalt psychologists. These principles were clarified and applied at the Bauhaus, and they have evolved into a coherent and rational theory of design based on logic and science rather than on custom.

When the Bauhaus was closed, many of the instructors continued their teachings in Switzerland. In Zurich and Basel in particular, the design principles developed before World War II became refined and formalized into the communication style generally referred to today as *Swiss.*

Bauhaus teachers and students also emigrated to other countries, including the United States, taking their revolutionary design ideas with them. Moholy-Nagy opened the New Bauhaus in Illinois in 1939. Just as the design in the United States that evolved from the Bauhaus style has been influenced by American culture, the work in Switzerland and Germany reflect those cultures.

Overall, however, there is a remarkable consistency in the Swiss style; this consistency is in large part a result of the design principles on which the style is based.

"Form follows function" and "less is more" are two primary axioms of the modern style. Layout and design decisions are governed by these two axioms.

Function governs what appears on the page; only those elements that serve a function are included, and these elements are only as large as necessary to fulfill that function. Because modern design is based on axioms, it is said to be *objective* and rational rather than *subjective* and arbitrary. Expressiveness per se is ruled out of any design for which communication (function) is a dominant consideration.

The modern page only reaches its aesthetic goal when it is stripped bare of all but the essentials, and when all the elements, in serving their intended functions, only are as large or small, dark or light, as is necessary for them to be effective. Blank space, an essential element on the modern page, provides contrast between elements and directs the viewer's eye.

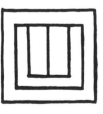

Both of these symbols exhibit a similar modern character that can be attributed to their functional natures, although the top symbol is a porcelain trademark from the 1720s and the bottom symbol is a design by Herbert Bayer from the 1920s.

An overriding principle throughout modern art and design is the balance between unity and variety. This balance between unity and variety lets us identify a group of letters as belonging to the same typeface at the same time that we recognize them as different letters in the alphabet.

Without unity, the modern page is chaotic. Without variety, the modern page slips from "less is more" to "less is a bore," a phrase coined by traditional designers to describe the new style.

In the examples below, unity is represented by the consistent right angles and parallel sides of the squares and the black bars. In the first two, unity is also provided by the parallel placement of the bars to the squares. In the first example, the bar is placed in the center of the square so that the space has unity as well.

Variety is introduced by the proportions of the shapes and the contrasting value of the black bar in the white square. In the second two examples, variety is also introduced by the asymmetrical placement of the bar. In the third example, additional variety is added by changing the orientation of the bar. Nothing was added to introduce variety. This is an example of the less-is-more philosophy, in which the basic elements provide all the visual interest.

The modern page uses asymmetry to create a *dynamic* (active) rather than *static* (passive) page. The traditional page uses symmetry to achieve passive balance. Dynamic layouts often imply that the elements are in motion rather than at rest (static).

In this sense the modern page reflects modern physics: the classic Newtonian view that the natural state of the universe is at rest has been replaced by the belief that the universe is in constant motion (dynamic). Consider the three examples below. In the first example the *composition,* or layout, is classically static and symmetrical. The center layout is more dynamic—the bar has moved toward the top right corner. In the last example the tilted bar implies motion. Note that the layout changed from static to dynamic simply by changing the shape of the surrounding space. The shape of the bar did not change, and no new shapes were added—another example of the less-is-more philosophy.

Using the less-is-more approach, a composition is changed from static to dynamic simply by changing the position of the element.

It seems that humans have an innate tendency to create order in the world around them. (This tendency is so strong that science today defines chaos as simply a "higher level" of order.) We perceive order through consistent repetition, or *pattern*. It takes at least three elements to establish a pattern. Once a pattern is established, changes made to it must also follow a pattern if order is to be perceived. If changes are arbitrary and random, the viewer may come to regard any change as meaningless. An essential part of the communication process is that the viewer perceive a meaningful pattern.

We use pattern and order in layout and design to unify— a series of pages becomes a book or brochure, a group of books becomes a set. We break patterns to fragment. In a magazine, for example, patterns are systematically broken to help the reader differentiate between such things as an editorial column and a feature article.

Variety works within an ordered system; *chaos,* in contrast, is generally defined as the absence of order. We often perceive chaos when the relationship between unity and variety is too heavily biased toward variety. Order is part of rational design, while chaos is part of the irrational and the frivolous (also called *fun* when appropriate). Because the communication process relies on order, chaos interferes with communication to the extreme.

Because humans tend to seek pattern and order, it is generally more difficult to create chaos than to create order. In most of what we initially see as chaotic we can find some pattern or order.

Consider the examples below. In the center example we probably perceive some order; the unified pattern is broken, but in a systematic way. In the last example, while we may initially see chaos, we will have a tendency to impose order after a moment and will probably find a pattern to this example as well.

In design, chaos tends to function only as counterpoint—as a statement against order, whether in design or society or both, rather than as a style in itself.

It is easier to create pattern and order than to create chaos. Most of us will find some pattern in all of these examples.

Every element has *attributes,* which include value, size, shape, edge, and texture. It is the relative uniqueness of its attributes that causes one element to contrast with the other elements on a page.

Contrast, then, can be said to be *relative.* This means that a specific attribute, in and of itself, does not guarantee contrast. We often think that a large size will command attention, for instance, but this will be true only if there is something small in the layout with which it can contrast; it is large only in relation to what is around it.

To be effective, changes in attributes must be dramatic enough to be perceived at once and without question. Changes that are too subtle are generally seen as inconsistencies or errors, if they are noticed at all.

—*Value,* or how light or dark an element appears to be, is one of the most powerful attributes of an element. Because attributes are relative, our perception of a particular value in a composition is influenced significantly by the values appearing with it. Color has value as well; a color is light or dark independent of whether it is bright or dull, purple or green. Kandinsky classified blue and black as dark in value, red and green as medium, and yellow and white as light.

—*Size* (scale) is how relatively large or small an element appears to be. Size is influenced not only by the sizes of the other elements in a composition, but also by the size of the page on which the composition appears.

—*Shape,* the two-dimensional form of an element, may be *regular* (uniform) or *irregular.* Regular shapes include geometric shapes such as squares. Irregular shapes include freely drawn elements and "natural" shapes such as leaves and vines.

—*Edges* are the borders between shapes. Most often, the tool determines whether an edge will be smooth or rough, soft or crisp.

—*Texture* is the irregular distribution of value within an element. (*Regular* texture is called *pattern.*) Texture tends to diffuse the impact of an element's shape as well as its value. Textures have attributes of their own.

There is more contrast in the first example because it contrasts with the white square in both scale and value.

The designer uses contrasting attributes to create a visual hierarchy between elements, to direct the viewer's eye, and to maintain a balance between unity and variety. Unity and variety can be modulated by changing the attributes of the elements. Not all attributes are equal. Size and value tend to be more powerful than other attributes. Other factors such as orientation and recognition also help to create contrast.

On the modern page, space is an element and has attributes as well. Changing the attributes of the space, such as enlarging or reducing the size of the page, alters the potential contrast of all other elements.

In the first example the only difference between the two elements is shape; in the second, size has been changed as well, and we become aware of the shape of the space. In all three compositions the relative positions of the elements are the same—the square is in the upper left and the circle is in the lower right.

Because attributes are relative we compare all of the things within our field of view. In the examples below, for example, we cannot see one composition without seeing another. It is only possible to see each as a separate composition by blocking the others from view.

The *recognition* of elements as representing "something" is part of the process of making order out of what we see. In the third example below, for instance, we probably see a face in the lower right corner of the composition, even though what is actually on the paper is a black circle on which are two circles and a line.

It is often difficult to avoid recognition; two circles and a line, for example, will be recognized as a face in an amazingly wide array of arrangements. The logo designer must remain acutely aware of the recognition factor during design. While creating a logo the designer may be seeing only shapes, but when these shapes are presented someone else may see them as a bunny or a duck.

Understanding *visual perception* (how we process what our eyes see) helps the designer anticipate and avoid some of these problems.

All three examples have the same arrangement of square and circle, but the scale of these elements has been changed in each.

Many of the principles of modern design are embodied in the psychological factors involved in *visual perception*—how our brains organize and interpret what we see. When combinations of these principles cause misperception we call them *optical illusions*.

Perception principles are inherently inter-dependent and inseparable, and the simple categories presented here (or anywhere) are necessarily artificial. Categories merely provide a way of organizing and referring to information. By understanding and using these visual principles we can better antici-pate what the viewer will see, and we will be less likely to design with one interpretation in mind, only to have the viewer interpret it another way.

Figure-ground differentiation, defined by Danish psychologist Edgar Rubin in 1921, is a fundamental perception principle— the process we use to determine which region is *figure* (object) and which is *ground* (space). Figure and ground are also referred to as *positive space* (figure) and *negative space* (ground).

The area to which we assign the *edge*, or border, determines which we see as figure. We most often see solid black areas and en-closed symmetrical regions as figure. On the pages of this book, for instance, the reader automatically assumes black areas to be figure and white areas to be ground. (Two exceptions to this are shown below.) When we cannot clearly differentiate which area is figure and which is ground, the image is said to be *ambiguous*.

Figure-ground reversal is the result of this ambiguity. We can perceive the examples below in two ways—because they are am-biguous we cannot say for certain which way is correct. We can control the reversal effect to some extent by looking directly at the area we want to perceive as figure.

Is the figure below a white circle on black or a black square with a round hole in it?

Is the puzzle piece black or white?

Grouping is an important perception principle; it helps us answer the question, How many? Grouping is the way we hear a song (one) rather than just notes (many), or see a word (one) rather than just letters (many). We group things in three ways—by *continuation,* by *similarity,* and by *proximity.* In the first example below, we may *perceive* a square (or an incomplete square) but we are only *seeing* four straight lines. In perceiving a square we have grouped by *continuation*— that is, we have perceived the four separate objects as a whole.

A related principle, *closure,* is another way to explain why we perceive a square rather than four lines. In closure we automatically fill in the blanks; in this case, we use closure to connect, or *close,* what we perceive as an incomplete square.

When we group by *similarity,* we associate elements that have similar attributes. Team uniforms, for example, make it possible to group players by similarity.

In the center example below we tend to separate circles and squares into groups by similarity even though the spacing between all nine objects is consistent.

When we group by *proximity,* we associate elements by their relative positions. In the third example below, the squares with less space separating them are seen as a group; the square separated by more space is automatically excluded, even though it shares the same attributes. Proximity tends to take precedence over similarity.

When we read words rather than letters we are grouping by proximity. Letters that are spaced very widely apart are difficult to read as words because we cannot group them. Unevenly spaced letters may group differently than intended. An entertainer is reported to have taken his stage name from a No Smoking sign painted across two doors—Nosmo King.

Most of us see a square whose corners are blocked by white shapes.

Most of us associate the circles together as a group separate from the squares.

Most of us see the fourth square as separate from the group of three.

Optical illusions

Artists and scientists have been researching the misperceptions we call *optical illusions* for over a century. Although we may think of these as merely amusements, as designers we must be aware that the misperceptions triggered by certain shapes and relationships often interfere with communication unless we compensate for them. Optical illusions can be used to create visual interest as well, particularly in the design of logos.

A number of factors influence whether or not illusions will occur. These include scale, viewing angle, color, lighting, and the attributes of the other elements on the page.

Two lines of the same length, one vertical and one horizontal, will appear to be different lengths, as you can see in the first example below. Even the strokes of precisely drawn letterforms will not measure exactly the same—to look the same they must be different in size. In the first example below, the two strokes are exactly the same length; the vertical stroke looks longer.

Viewing angle has a strong influence on illusion. The same pattern of strokes (stripes) will not look the same oriented vertically as it does oriented horizontally. In the examples below, both patterns of strokes are exactly the same. You can see this if you rotate the page 90° so the verticals become horizontal and vice versa. If you tilt the page up so that you are facing it squarely, or down so that it is flat, the impact of the illusion changes. Because viewing angle is so strong an influence on the horizontal-vertical illusion, it is a difficult illusion to compensate for.

If you see a *T* in this first example, you grouped by proximity and continuation. If you associated the second two examples as a pair, you grouped by similarity.

These two bars in the example below are exactly the same length.

The two striped patterns are exactly the same, but they seem different because we see horizontal lines differently from vertical ones.

110

Contrast illusions are those in which an attribute of one element is enhanced by the *opposite* attribute of another. A classic example of the contrast illusion is shown below—the neutral gray square looks darker on the white square and lighter on the black square. Color is strongly influenced by contrast. For instance, a red square on a neutral gray field makes the gray appear greenish. (Green is the *complement*, or opposite, of red on the color wheel.) A green square on a neutral gray field gives that same neutral gray a reddish cast.

When we cannot compensate for the contrast illusion by modifying the color we are using, we should use a combination of colors in which the illusion is minimal.

The *assimilation illusion* is the converse of the contrast illusion—a classic case of being judged by the company you keep. In assimilation the characteristic of one element is transferred to another.

The circles shown below in the *Delboeuf illusion* demonstrate this: The outer circle in the top pair of circles is the same size as the inner circle of the second pair. In each case, the circle has *assimilated,* or taken on an attribute (size) of the other circle in the pair, appearing smaller with a small circle and larger with a large one.

One of the more well-known illusions is the *Necker cube* shown below, which seems to be a transparent box. Because the squares representing the front and the back are the same size and equal emphasis is given to both, the cube is ambiguous—are we looking up at the box or down on it?

In the *Ponzo illusion,* two equal bars appear to be different lengths when framed by converging lines. Psychologists disagree about what makes this illusion work—some attribute it to depth illusion, and others attribute it to contrast or assimilation illusions. Such disagreement serves to illustrate the complexity of perception.

Many other illusions have been identified as well. As designers we must gain an understanding of the more common illusions. If we can recognize them when they occur, we can either successfully avoid them or use them to advantage, gaining the attention and holding the interest of a potential viewer.

The gray squares appear to be different values because of the contrast illusion. The small white square may seem larger than the small black square because of the *value reversal* illusion.

Seeing three-dimensional space on a two-dimensional surface is illusion. The painter creates depth through the interaction of many factors. These include such attributes as size, contrast, edge, and color and such compositional factors as the relative positions of elements. These factors are interdependent and reinforce each other. Flat-field painters strive to avoid the illusion of depth by recombining these factors in new ways. Structures such as vanishing-point perspective help the illustrator and painter enhance the illusion of depth by helping to establish the exact sizes and positions of elements. Learning to control the illusion of depth continues to be an important lesson in basic design, whether the goal is to minimize it or to enhance it.

In layout we often use references to depth when describing the visual hierarchy of the elements. We speak of an element as "coming forward" when it is large and contrasts in value with the page and the other elements on it; another element might be said to be in the "background" if it is small and contrasts very little in value. We are using the illusion of depth, then, when we make a headline bold and large. The element seen as "closest" tends to get our attention first, even if it is not "first" (top left) in the layout. The illustrations below show some of the ways in which we imply depth on the page.

Figures in two dimensions that are intended to represent three-dimensional objects are called *impossible* figures if they could not actually exist, and they are sometimes used to create visual interest.

Overlapping squares in outline form are ambiguous in terms of depth. We see a solid square and an L-shape as overlapping squares; overlapping implies depth. Depth is implied even when the element we see as in front is smaller in scale and lighter in value. (A challenging exercise in design schools is to eliminate the perception of depth through color.)

Modern elements tend to be simpler than their traditional counterparts and offer more contrast on the page. Text, for example, is set in compact blocks so that it contrasts with the space of the page. Illustrative and diagrammatic elements are more compact as well; they tend to be simpler than their traditional counterparts; solid colors and simple shapes offer greater contrast and flexibility in resizing than the detailed drawings so characteristic of the traditional page. A circle or square can change size radically without losing its communication value.

On the traditional page there are few elements other than text, and the page structure is simple. The modern page may include a wide diversity of elements other than text. These tend to be either photographs or diagrams rather than pictorial illustrations. When pictorial elements appear, details are typically eliminated through a process of simplification called *abstraction*.

Simplified modern elements offer the most versatility for scaling and positioning if they are stripped of details that limit their potential range of sizes, such as typography, texture, and fine-line details.

Resizing images is a relatively new capability brought about by photoreproduction processes. Because of photoreproduction, illustrative and diagrammatic elements are often created in a size unrelated to the size that will appear in the layout.

Today's diverse technologies, existing in a design climate receptive to new approaches, means that designers are provided with more opportunities than ever before to control the size, shape, format, and visual quality of the elements with which they work. With more opportunity, however, comes more responsibility; with more possibilities for success come more possibilities for failure. It is the overall design concept and the structure of the page that enable the designer to make meaningful decisions about elements rather than arbitrary ones.

The rectilinear face and de Stijl-inspired type on this Oskar Schlemmer poster from 1916 reflect the simplicity of form and compactness of typography so characteristic of the modern style.

The field of graphics has been significantly changed in this century by the introduction of two technological advances— photographic processes and digital processes. Introduced at opposite ends of this century, both have changed forever not only the results we achieve but the way in which we achieve them. Both processes make possible not only our ability to create elements with ease, but the ability to radically alter these elements once they have been created.
The traditional style had emerged from a technology in which elements made from wood or metal were inked and printed directly on paper. Because creating these elements was ponderous and labor intensive, nontypographic elements were used sparingly—typography was commonly the only element used.
A child of diversity, the modern page relies on a wide range of technologies for creating and modifying elements and for being reproduced. Improvements in paper and printing technologies encourage the use of large flat areas of ink, photographs, diverse illustration media, and a wider range of colors. Text no longer dominates the printed page.

Photoreproduction, broadly defined, is the conversion of black-and-white camera-ready art to photostats, films, and printing plates. Virtually anything we can see can be photographed; virtually any photograph can be converted to a printing plate.
Conventional photographs produced in a darkroom are *continuous* tone images—they include an unlimited range of gray shades. In photoreproduction, these gray shades are converted to *halftones*—patterns of large and small dots, either black or white, that the viewer's eye blends into shades of gray through the principle of *simultaneous contrast*. The halftone image itself has become a graphic element, often enlarged so much that the dots become pattern rather than image.

The halftone, initially developed as a way of printing continuous tone images, is often used as a graphic element as well.

Digital processes offer most of the same capabilities as photographic processes; in addition, they offer a whole new set of capabilities. When digital technology is used in combination with photographic technology, we can create and modify images in ways that would have been prohibitively expensive if not impossible a decade ago.

Like photographic processes, digital processes reduce everything to black and white. Unlike photographic processes, what we see is made up of many tiny dots positioned by coordinates and numbers (hence the term *digital*). The letters you are reading now are digital, as are most of the illustrations in this book; the dots are called *pixels*. The coarseness or fineness of the dots is its *resolution,* measured in dots per inch *(dpi).* These letters have a resolution of about 2500 dpi.

A decade ago computer users were limited to working with numbers and mathematical formulas. Today, readily available software programs allow us to be relatively unaware of the mechanics behind the images we create. We seldom (if ever) work with numbers to create images except by choice.

Photography came into its own as an art medium during the Bauhaus era not only as a means for recording the real world, but as an expressive and interpretive art medium. Experimentation with lighting, framing, *photomontage* (the assemblage of photographic and other kinds of imagery), *photograms* (the traces of objects placed on photographic paper during exposure), and other ways of combining and creating new imagery continue to inspire experimentation in other mediums as well.

The photographic image may have little in common with the world around us; although photographs are derived from real objects, the photographed object often takes on unreal and abstract qualities when seen by the camera and modified in the darkroom.

Today, in addition to the camera, we have a number of other devices that record the light and dark of what they "see." Electrostatic photocopiers, video cameras, and digital scanners provide new mediums by which we can contribute to the rich photographic tradition and set new directions in imaging as well.

An image today can be modified in an almost infinite number of ways through photographic and digital processes. Limits are set only by our imaginations.

Abstraction and simplification

The traditional view of the physical world was limited to what the human eye could see; that is, limited to that narrow band of energy known as light.

Science and technology have provided new ways to "see" the world beyond our vision. Microscopes and telescopes expand the range of the human eye; devices such as seismographs, oscilloscopes, and radar screens provide a visual record of the invisible—energy, processes, time, and motion. As the visual products of scientific technology, these images are not words, nor pictures of things, nor drawings of things. Rather, they are a new kind of visual language— images with specific shapes, colors, and textures of their own, which we learn to "read" as easily as we read words. These images provide new information in new forms, often communicating a concept or result better than words. They are indeed pictures worth a thousand words to those who understand them.

At the beginning of the twentieth century, in the face of evidence that the world was not merely what we see, the conventional "realistic" view in art no longer seemed appropriate. Artists began to respond to scientific evidence about the world by representing what they saw in new ways, one of which involved reducing objects to essentials through the process of *abstraction*.

In abstraction, extraneous details are eliminated, leaving only the essence of the object. When done well, such an image may actually communicate more clearly than if all of the detail were included.

An abstraction may be used as a generalization to represent a category of objects rather than a specific object. A pictorial image of Aunt Millie's cat, when abstracted, may become an image that represents all cats. Stick figures are abstractions, as are silhouettes. Many of the product logos we are familiar with are abstractions as well—the Michelin man made of tires, for example, or the Quaker Oats man's smiling face.

In reducing the modern page to essentials, elements on the printed page have also been simplified. Type has lost its serifs; traditional detailed pictorial illustration has been replaced by simple abstract images or photographs, which can also be pictorial or abstract.

Device-generated images are commonly used not only as visual records of data but also as graphic elements.

Both of these pointing hands are abstractions, but we tend to think of the detailed line drawing as realistic.

Nonobjective images are those that have not originated from an object. The squares in an organization chart, for example, are not intended to be pictures of desks or offices but simply to be neutral shapes that stand for objects. In thinking of them as nonobjective rather than as objects, we often draw and use them differently.

Symbols, logos, and icons frequently rely on nonobjective imagery because they are often representations of concepts or actions rather than pictures of things.

It is important that those who design symbols, icons, logos, charts, and diagrams be clear about what they intend the viewer to see as pictorial (realistic), as abstract, and as nonobjective.

When pictorial, abstract, and nonobjective elements are combined, an ambiguous message is often communicated to the viewer, who does not know what parts to interpret literally and what parts to view simply as shape. When part of a design is pictorial, the viewer often tries to "make something" of the other parts as well.

An ongoing pursuit in this century has been for the development of a visual language that could transcend spoken language.

Early in the century, artists such as Malevich communicated the concepts of the Russian Revolution to a highly illiterate populace using nonobjective symbols. Klee and Kandinsky, two instructors at the Bauhaus, also sought to express complex concepts nonobjectively. After World War II the pursuit of a visual language continued.

Earlier experiments combined the relatively new principles of visual perception with the characteristics of language, and research included the compilation of symbols from many cultures. Experiments after World War II were spearheaded by a diverse group that included anthropologist Margaret Mead and industrial designer Henry Dreyfuss.

Today we take for granted the widespread use of visual language in the form of symbols for travel, traffic control, and equipment operation. We incorporate the concept of visual language into logos and as icons for the page and the computer screen.

The symbols below are typical. They combine a simplified arrow, a common cultural symbol for direction, with a readily understood nonobjective symbol for an opening. Very similar symbols were used twenty years later to represent engaging and disengaging a clutch.

Even though this design is not intended to represent or be recognized as an object, it could represent something, such as a company, a product, or an idea.

These symbols for *entrance* and *exit* were developed by C. K. Bliss in the late 1940s.

Modern elements can be classified as graphic, typographic, photographic, illustrative, or diagrammatic. Elements are placed into these categories on the basis of their function. A photographic element, then, may function as a diagram; letterforms and photographs may function as graphic elements.

There is not only a wider diversity of elements on the modern page than on the traditional, but a wider diversity of ways to create them. Techniques are often combined.

On the traditional page elements must fit between or within margins. On the modern page, a more complex structure encourages a wider diversity of sizes and proportions. Flexibility is a desirable quality in a modern element because it allows more layout options. The less detailed an element, the more potential sizes it can be; the less pictorial an element, the more potential proportions it can assume.

The more flexible the element is, the easier the page will be to lay out and the more likely it will be that the layout is successful.

Typography is *visible language* that explains, instructs, and expresses thoughts and ideas through words. It continues to be the dominant element on the printed page. (See chapter 4.)

Typographic elements that are used for their graphic appeal, independent of their language value, act as *graphic elements;* that is, elements whose functions are to direct the eye and to create contrast. Graphic elements typically take the form of rules, bullets, overlines, and underlines, but anything included on the page for the principal purpose of directing the eye may also be classified as a graphic element. This includes illustrations, photographs, charts, diagrams, and color. Space can be included in this category as well because it is an active element that isolates, organizes, and directs.

Graphic elements provide interest and support hierarchy. They are not, by definition, essential to the message itself. Elements may serve more than one purpose, however. A photograph, for example, may be used both to catch and direct the viewer's eye and to communicate a message.

The large letterforms in this layout serve not as language but as graphic elements. We do not expect the viewer to "read" them.

Diagrammatic elements include charts, diagrams, and other structured graphics. Diagrammatic elements act as a visual language within a discipline. Most economists, for example, can read statistical charts as easily as a doctor can read a medical chart. By thinking of data graphics as visual language rather than as graphic elements, we will be more likely to consider their communication value and less likely to embellish them. It is as difficult to read an embellished diagram as it is to read embellished letterforms.

When we design elements that represent data we must differentiate between simplifying extraneous detail and eliminating information. Communication problems arise when the designer adds graphic complexity without adding information.

Communication problems are compounded by the overuse of instant chart and graph software to which embellishments are added as a sort of compensation for otherwise mundane design.

Statistical data are often distorted and their effectiveness diluted through meaningless embellishment. In the *Visual Display of Quantitative Information,* Edward Tufte observes that good information graphics are the result of simple design coupled with complex data. Pattern should be avoided because it adds complexity rather than clarity. Color should be added only when it has meaning.

The proportions of diagrams and charts can conform to layout grids by changing the proportions of the elements within the diagrams, the spaces between them, or both. We must take care, however, that the information does not become distorted in the process.

In the examples below the same data—one, one-half, and one-fourth—have been represented several ways. Each diagram or chart gives a slightly different impression of the data.

We can change the proportions of a bar chart by changing the proportions of the bars, the spaces between them, or both.

The data in a line graph are easily distorted when the proportions of the graph are changed.

Representing data by area may clarify the data, as shown by the circles, or obscure the data, as shown by the squares.

Photographic elements are created with a device that records the pattern of light and dark it "sees." Although the device used to create photographic elements is most often a camera recording on film, we can also include in this category images created by devices such as video cameras and digital scanners. These technologies for "seeing" contribute new imagery to the rich photographic tradition developed over the past century.

Advanced darkroom techniques and computers coupled with digital scanners allow a simple photographic image to be modified to the extreme—colors can be changed, blended, and intensified; flaws can be eliminated; textures can be imitated; diverse images can be seamlessly blended. As image modification becomes progressively less expensive and the technology progressively more accessible, the photographic image becomes limited only by the imagination and talent of the designer and the objective of the project.

Although the range of tools and techniques has expanded considerably in the past one hundred years, we continue to think of illustrative elements as those that are drawn, painted, or otherwise created with tool in hand. Traditionally, these have been pictorial depictions of the three-dimensional world; even diagrams and scientific data were characteristically pictorial.

On the functional modern page, illustration tends to be limited to technical, medical, and scientific illustration; in most cases, factual representation of the world has been delegated to photography. An exception is the editorial page, which tends to be expressive in character and on which illustration continues to be widely used.

With modern reprographic technologies we can copy, duplicate, enhance, color, and otherwise modify virtually any image, however it was created. This use of technology is blurring the distinction between illustration and photography and redefining both of these fields.

Distinctions between photographic and illustrative elements are blurring because of the new technologies used to create and modify them.

By 1920 those who were experimenting with typography had broken virtually every rule of traditional typography, as much for the sake of breaking rules as for communication or aesthetics. From this experimentation emerged a new-found freedom with typography that has since been codified into a new set of rules that are objective and functional in nature.

According to John Lewis, in the *Twentieth Century Book,* new (modern) typography developed from the same philosophical approach that Bauhaus director Walter Gropius applied to architecture.

A comparison between typography and architecture is appropriate: just as the traditional page and traditional architecture were modeled on classic forms, so the modern page and the modern building are designed for simplicity and function. The modern architect considers the functional needs of a house's future residents; the graphic designer considers the functional needs of the reader.

Both modern architecture and modern typography are neutral: the architect does not build a shoe store in the shape of a shoe, and the modern typographer does not set typography as an illustration of the message it is conveying with words.

During the Bauhaus era, experimentation with typography matured into a cohesive and practical style. Moholy-Nagy, a prominent figure at the Bauhaus, listed three primary considerations for typography that form the cornerstones of modern typography today:

1. Clarity is of overriding importance.
2. Communication should not be constrained by old styles of presentation or by preconceived aesthetic ideas.
3. Letters and words should not be forced into arbitrary shapes.

In *Die Neue Typografie,* Jan Tschichold further formalized this approach, providing the basis for what we now commonly term Swiss typography.

(This modern approach is described in more detail on the following pages. The reader who is unfamiliar with type terminology is advised to read the first chapter from book 1, section II, "Traditional Typography," before continuing.)

AA**AAA**A*AAA*
a*aaa*a*a*a*a*aa*a*

A modern type family offers sufficient variation for most projects. Shown here are the nine typefaces in the Frutiger family.

The modern typeface

The character of the modern typeface is quite distinct from that of the traditional. Unlike traditional typefaces, which have a thick-thin stroke, the modern typeface has a consistent stroke weight (although the stroke-to-height ratio is about the same, 1:10, after the Trajan model).

Modern typefaces are *sans serif,* typified by Helvetica and Univers. (These are not to be confused with the traditional category of "modern" that includes Bodoni.)

The modern sans serif typeface reflects the functional modern approach to design. Early modern sans serif typefaces were geometrically constructed from straight lines and circles. One typical example is Futura, designed by Paul Renner in 1930. Although it is beautifully simple in concept, it is inappropriate for large amounts of text because its letters have such similar shapes. Typeface designs, like other modern design elements, must strike a balance between unity and variety.

Helvetica and Univers, designed twenty-five years later, were drawn for optical balance rather than constructed geometrically. Their letterforms differentiate much more clearly to the reader.

Typical of the trend in typeface design since World War II, Helvetica and Univers have large x-heights in proportion to their ascenders and capitals. This not only helps create an even texture in languages that use extensive capitalization in text, such as German, but this allows smaller point sizes to be used without loss of readability because of size. Traditional typefaces, redesigned for modern technology, often assume these modern proportions as well.

Modern typefaces are designed as *families,* that is, sets of typefaces in different proportions and weights that are developed from a single master design. Univers, designed by Adrian Frutiger, offered twenty-one variations when introduced. In a type family, even the italics are designed from the master design, unlike traditional italic typefaces, which were calligraphic in origin and quite unlike their roman counterparts. These were often difficult to read. Modern italics are generally as readable as the roman typefaces in the same family.

abcdefg
hijklmno

abcdefg
hijklmno

Futura and Helvetica have been set as compactly as possible in the same point size. Helvetica creates a denser texture because of its squatter modern proportions.

Ez Ez Ez

If the x-height of Helvetica is to match the x-height of 48-point Goudy, the Helvetica must be set 10 points smaller. When Helvetica and Goudy are set in the same point size, Helvetica's x-height is much larger.

The ideal typeface for the modern page will have the following characteristics:
—Sans serif
—Standard 1:10 stroke-to-height ratio
—Clearly differentiated letterforms
—No unusual letter shapes
In choosing a modern typeface based on these criteria, two other factors to consider are the amount of diversity in the type family and how economically it uses space.

Any modern type family offers enough diversity so that hierarchical levels can be differentiated clearly. Three weights are generally sufficient if they are different enough from one another, but additional weights are sometimes useful.

In considering the way a typeface uses space, we should keep in mind that space is governed at least as much by kerning and leading as by the design of the typeface. Typefaces such as Helvetica and Univers are extremely similar in their use of space. Frutiger, the typeface you are reading now, is somewhat more compact. A condensed typeface, although even more compact, may be more difficult to read as its letterforms become more similar.

It is generally a better strategy to choose one typeface and work with it to achieve a result than to seek the solution to a design problem in the choice of a typeface. Any type that has been designed for readability will be effective if the kerning, leading, and other typesetting factors are in balance.

Compactness and contrast are two ways that modern typesetting differs from traditional, and these characteristics apply to setting display type as well as to setting text (see page 126).

For compactness and readability, display type is set in upper- and lowercase letters. Lowercase letters set more compactly and use less space. In setting type compactly, as much space as possible must be removed from between letters, up to but not beyond the point where letters touch and their separate forms begin to be obscured. Leading should be compact as well.

To maintain compactness, hierarchy is usually indicated by weight rather than by size. Bold headings not only use less space than those set in larger point sizes but also provide more contrast. Headings on text pages seldom reach display sizes.

In keeping with the less-is-more philosophy, display type should only be as large as necessary to serve its intended functions. If the display type is a dominant element, one of these functions may be as a graphic element. This might mean that the type would be extremely large; otherwise, display type relies on isolation rather than size for its effectiveness.

abcdefghijklmnopqrstuvwxyz
abcdefghijklmnopqrstuvwxyz
abcdefghijklmnopqrstuvwxyz
abcdefghijklmnopqrstuvwxyz

Univers Condensed, Futura, Frutiger, and Helvetica have been set to the same specifications. Each has a different color and texture and occupies a different amount of space.

The appropriate size for display type depends on a number of factors: the line breaks; the amount of contrast desired; the characteristics of the other elements on the page; the requirements of the page structure; and the layout as a whole.

Weight is more effective than size in terms of contrast; type that is both large and bold offers the most contrast. Large, bold type seems to "come forward," and it attracts the viewer's eye (depth illusion). Through contrast we can control the sequence in which information is seen, so information need not be arranged in sequence to be seen in sequence.

Our perception of the type size is influenced by what is being set (e.g., a long word versus a short word; many words versus a few) as well as by the other elements on the page (contrast illusion). When deciding on a consistent size to be used for a series of pages, then, the designer must consider both the longest and the shortest samples to find the best solution. The particular balance of size and weight chosen should reflect the relative importance of the element on the page.

Display type, like other modern type, is virtually always set flush left, ragged right. On rare occasions, when display type is a dominant graphic element on a page (e.g., the cover of a book), alignment is adjusted to suit the particular pattern of ascenders and descenders so that an even texture is created.

Line breaks play an important role in how display type looks and reads. The larger the display type the fewer line break options we have. In general, lines of type should be similar in length but not so similar that they look as though they should be justified. Extreme differences in line lengths hamper readability and create awkward shapes on the page. When possible, lines should break according to content—where breaks make sense. When working with a grid, grid fields set the maximum length of a line; lines need not fill that space, however, if it means that awkward shapes will be created.

Weight
Size

When deciding on size and weight, the choice should be in favor of compactness. Bold type offers more contrast and occupies less space on the page than large type.

The Nature and Art of Motion

The Nature and Art of Motion

Although the words *Art of* fit on the first line, the title's shape is awkward. Lines that are more similar in length are more readable and easier to work with.

The Nature and Art of Motion

When the type is used as a dominant graphic element rather than as part of a hierarchy, alignment can be adjusted to create an interesting shape.

Kerning, the adjustment of space between letters, is most commonly used to refer to *negative* kerning, the removal of space between letters.

Modern display type is almost always kerned because it provides more compactness. How much we kern should correspond to how open the letterforms are. An extended typeface can be kerned less than bold condensed type. Kerning adjustments should consider the spaces between the words as well as the spaces between the letters. This ensures an even texture, and helps the reader's eye follow along a line of type. Spaces between words must be wide enough to enable the reader to see words as separate groups, but not so wide that the words do not group by line. If the spaces between words on a line of type exceed the spaces between the lines, the reader's eye may group words on adjacent lines rather than along each line.

When it is not possible to kern, large display sizes should be avoided—the larger the type, the more critical is the kerning.

Leading can be used to refer to the distance from baseline to baseline. In display type, leading is often negative; that is, the space between baselines is less than the point size of the type. Compactness is limited by the pattern of ascenders and descenders, so some sets of words will set more compactly than others. Ascenders, descenders, capitals, and numbers often cause leading to seem irregular if they occur more frequently on one line than on another. Adjustments may be needed to balance leading optically.

Leading can be more compact on a short line than on a long one and more compact for a few lines than for many. As a rule, the more compact the leading, the more likely will be the need for adjustments.

A block of type should be surrounded by more space than the spaces we see within the type block, so that other elements do not inadvertently group with part of the type or cause the type to ungroup.

Leading, then, is a key grouping factor in layout because it determines how near the other elements can be placed to the type.

display type

display type

The only difference between these two examples is kerning. The space between the words was adjusted to correspond to the spaces within the words.

**Einstein
Galileo
Copernicus**

Capitals, ascenders, and descenders influence how we perceive the spaces between lines of type. The leading between these words is even, but the spaces we see are not.

Studies of readability began more than two hundred years ago with distance tests (e.g., "Can you read it from there, Fred?"), which had little to do with reading text, although the results were considered conclusive at the time.

We read not in a continuous flow, but in a series of jerky motions called *saccadic movement.* This movement is punctuated by *fixation pauses,* and it is during these pauses that reading actually takes place.

During a single fixation pause, an adult can read a line of text about thirty to thirty-five letters long, which is about 12 picas wide, depending on the typeface and size. (The line length you are reading now is about 14 picas.)

This means that it takes two fixation pauses to read this line, but there is considerable overlap between our fields of view in each. If we become conscious of our reading pattern, we may feel our eyes fixing at the beginning and end of a line of type as we read.

We can read a word or short phrase within this space as quickly as we can read a single letter. It is estimated that over 90 percent of reading time is devoted to fixation pauses of a quarter of a second each.

Rereading is called *regression* and tends to increase with the complexity of the material being read. The movement of our eyes from the end of one line to the beginning of the next is called a *return sweep.* Overly long lines of type often cause us to regress because we read the same line twice or skip a line during this return sweep.

Reading relies on the instant and accurate recognition of letterforms. Many of the readability studies that continue to be referred to today were done over thirty years ago, when the reader's relative unfamiliarity with sans serif type hindered recognition. Newer studies indicate that today's reader is familiar with both serif and sans serif type—readability depends more on the clear differentiation between letters and on grouping and texture than on the presence or absence of serifs.

There have been numerous attempts to combine upper- and lowercase alphabets into a single set of forms. Although typesetting and writing would be simplified, it is unlikely that readability would be enhanced.

für den neuen menschen existiert nur das gleichgewicht zwischen natur und geist· zu jedem zeit-

Jan Tschichold, 1929

MUSJK JM LEBEN dER VÖLKER AM 2. JULJ 20 Uhr dJRJGJERT JM OPERNhAUS WARShAUS bERÜhMTER dJRJGENT WERKE

Kurt Schwitters, 1927

Speaking of bird life in Palestine, it might interest and surprise many people to know

Reginald Piggott, c. 1960

Whatever its other functions, text is created for communication through reading, and readability must be the dominant concern of designers who specify or set text. It is not only pointless but absurd to write, edit, and set text that cannot be read.

When text is limited to a sentence or two, some freedom may be taken with readability parameters, but this should be the exception rather than the rule.

Every designer should understand the fundamentals of creating readable text because typography is the dominant element with which they work. Designers who find it difficult to incorporate readability into their work may find it useful to begin with readable text and to build their design around it. (This is an example of the modern approach of designing from the inside out rather than the outside in, as on the traditional page in which margins are created and then filled.) Readability is becoming an increasingly important factor in design as the population ages. Sacrifices made in readability for the sake of fashion a decade ago are no longer viable design options when communication through words is involved.

On the modern page, readable text type ranges between 8 and 11 points for a normal reading distance of about 15 inches. This range assumes that the typeface will have the larger x-height characteristic of modern typefaces such as Helvetica and Univers. Typefaces with traditional proportions should be set between 9 and 12 points.

Between forty and fifty characters per *average* line of type are recommended for readability. (The longest line, then, could have up to sixty characters.) Overly long lines cause regression unless they have wider leading; shorter lines tend to require additional eye movement, which may tire the reader. Leading should be from 1 to 4 points more than the point size of the type. A single point of extra leading may be sufficient when the line length is shorter. In general, shorter lines of type need less leading than longer ones. The exact measure of a line will vary with the typeface, point size, and kerning used.

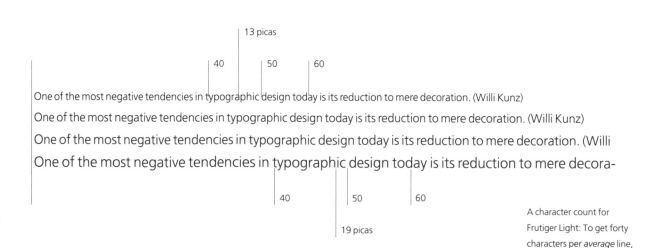

13 picas

40 50 60

One of the most negative tendencies in typographic design today is its reduction to mere decoration. (Willi Kunz)

One of the most negative tendencies in typographic design today is its reduction to mere decoration. (Willi Kunz)

One of the most negative tendencies in typographic design today is its reduction to mere decoration. (Willi

One of the most negative tendencies in typographic design today is its reduction to mere decora-

40 50 60

19 picas

A character count for Frutiger Light: To get forty characters per *average* line, the minimum line length for 8-point type is about 13 picas and for 11-point type, about 19 picas.

Modern text is always set flush left, ragged right. This not only ensures even spacing between letters and words but establishes a careful balance between unity and variety.

The *rag*, or ragged right margin, almost always requires minor adjustments: if the lengths of lines increase and decrease in a regular pattern, a shape may be created that is distracting to the reader and objectionable in the layout. Shapes can be eliminated by adjusting the line breaks as necessary. Dramatic changes in line length, however, are also distracting. Hyphenation allows us to modify the rag effectively. An even rag is difficult to achieve without some hyphenation, but more than two hyphens in a row may also interfere with readability. Adjustments to line length may need to be made over several lines until a satisfactory combination of line breaks is achieved.

Whenever possible, indents for indicating paragraphs should be avoided so that the unity of the left margin is not disturbed.

Modern text always uses upper- and lowercase letters according to the conventions of language. Readability studies have indicated that we read along the tops of letters rather than their entire shapes. Upper and lower case letters differentiate more clearly than type set in all capitals and space more evenly because they developed from writing. Capital letters were designed to be spaced widely apart in the manner of Roman inscriptions.

Because upper- and lowercase letters set more compactly, more letters fit into a given space than when the same text is set in capitals. Not only can we see more information in a single fixation pause, but we need to read fewer lines of type. Compare the next two sentences for compactness, texture, and readability:

"With all the new developments in the printing industry we need designers wedded to the pursuit of legibility." (John Ryder)

"WITH ALL THE NEW DEVELOPMENTS IN THE PRINTING INDUSTRY WE NEED DESIGNERS WEDDED TO THE PURSUIT OF LEGIBILITY." (JOHN RYDER)

Abound

AROUND

Lowercase letters usually differentiate better than capitals. Is the second word "abound" or "around"?

The most readable text type for the modern page is a medium weight, modern sans serif typeface with no outstanding characteristics, as described earlier in this chapter.

In general, the more unique or distinctive the letterforms, the more inappropriate they are for text. Text typefaces should seem so ordinary that the reader will be completely unaware of the typeface during reading.

This lack of distinction is called *transparency,* and it is a goal of all type designed for use as text. Designers of text typefaces can measure their success by how unaware the general reader is of their work.

To be transparent, letters within a typeface must differentiate clearly. This eliminates constructed typefaces such as Avant Garde and Futura, except for small blocks of text. Helvetica and Univers are readily available, but Akzidenz Grotesque, Frutiger, Franklin Gothic, and most other typefaces termed *gothics* or *grotesques* are also appropriate choices.

Some readers prefer serif typefaces for text. When serif typefaces are used they should meet the criteria for traditional typefaces as described in the *Traditional Typography* section of book 1. These typefaces are not at their best when set compactly, which poses a dilemma for the designer of the modern page. Readability must remain the primary concern.

An even, readable texture is the result of an appropriate combination of typeface, kerning, leading, line length, and point size. The evenness of the texture is as important to reading as the correct typeface or any other single factor.

Readability and texture will be compromised if there is too much kerning or not enough; if word spaces do not balance with kerning; if leading is either too loose or too tight; or if an inappropriate typeface is chosen.

There is a tendency to attribute problems with readability either to typeface or point size. It is not unusual for a client to insist that a typeface be made larger, even as large as 14 points, "for readability," then to go home and curl up with a book set in 9- or 10-point type. Clearly, then, the fault is not with the point size but with other factors, usually leading and kerning.

In typography, subtlety counts. With the ability to set type on the personal computer, the designer can become more familiar with these subtleties, creating and comparing text samples until an optimum combination is achieved.

Hierarchy

Systems

On the traditional page, capitalization and changes in type size are the most common ways to indicate changes in hierarchy. On the modern page, hierarchical levels are differentiated by bold type and changes in leading. This strategy allows maximum contrast, reinforces grouping, and maintains the compactness necessary for layout flexibility. Whatever the strategy, text must have a consistent texture if changes in hierarchical level are to be effective.

Following the axiom of less-is-more, changes need only be dramatic enough to communicate to the reader. A minimal change for hierarchy, then, could consist of simply using bold type in the same point size and leading as the text. By adding leading, another level is achieved. It is only when we are several steps up the hierarchical ladder that we need to consider increasing the point size.

Graphic elements help differentiate levels in a hierarchy as well, but should be reserved for elements that appear infrequently. If graphic elements appear too frequently, they lose their impact and may fragment text and distract the eye rather than enhance communication by directing the viewer's eye. Graphic elements generally provide enough contrast that little or no change in the point size of the type is required.

We can define typographic *systems* as preplanned specifications that apply to all printed pieces within a group, such as a brochure series. A well-designed system anticipates the wide range of needs that will arise and solves most potential typographic problems in advance. This significantly reduces the time it takes to complete a project and helps to ensure consistent quality. The systems approach was once reserved for large companies that needed to standardize the efforts of many people; a system ensured that each piece produced would represent the company rather than an individual within it. Small organizations can also benefit from this approach, particularly since desktop technology has become widespread. A graphic designer can establish a typographic style guide to be used with desktop technology by layout artists within the organization. This can significantly reduce the overall cost and production time for typesetting, so more of the printed pieces within an organization can be typeset rather than typed.

As those using desktop technology begin to understand typesetting, the overall quality of the work produced with this equipment will improve.

Overline

Overline with step rule

Reverse bar

Color or tint bar

The modern style developed from experimentation and the application of visual perception principles in reaction to the dogmatic traditional style, which seemed to have no basis other than convention. Swiss design evolved from this explosion of ideas and experiments, solidifying into a coherent style of modern communication typography that has seemed to many to have become as dogmatic as the style it sought to replace.

Despite this, typographic experimentation within the field has continued, not only unhampered by the restrictions of Swiss design, but often inspired by its strict structural framework.

Typographic experimentation continues not only in advertising (where impact commonly takes precedence over readability) and in schools (where experimentation is commonly used to teach principles), but also within the day-to-day world of graphic design, where impossible deadlines, budgets, and other business concerns combine to stifle creativity.

As is the nature of experimentation, not all of the results are good. Nevertheless, experimentation indicates that a healthy and progressive design environment exists. Experimentation within a style allows designers to test the limits of the principles on which that style is based.

It may be that it is this constant testing and experimentation that will allow the modern style to survive new generations of technologies and new generations of designers.

Typographic elements, used as expressions of sounds rather than as neutral language in this brochure for high-fidelity speakers, is an innovative (and economical) alternative to the more typical approach of using product photographs. This expressive use of typography by Mitchell Mauk echoes the experiments of the Dadaists over sixty years ago.

5 **Structure**

Structure is a key difference between traditional and modern pages. On the traditional page the margins define a box that is filled from top to bottom in a *linear* (sequential) manner. Margins are constructed from the proportions of the page. On the modern page, structure usually consists of a network of fields and intervals called a *grid.* The grid serves as an organizational framework by which the proportions, sizes, and locations of elements are determined. Structures such as grids help reduce the number of arbitrary decisions made during layout.

There have been numerous experiments in subdividing two-dimensional space. Formal structure was explored in design movements such as de Stijl, of which Mondrian was a leading force. The architect LeCorbusier introduced the *Modulor* in 1946—a modular system of dividing space based on the geometric relationships between those spaces. LeCorbusier is reported to have asked Albert Einstein for his opinion of the system and received the reply that it provided "a range of dimensions which makes the bad difficult and the good easy." This is the prime objective of all grid systems.

Today, most printed pieces such as magazines and newspapers are based on a grid. Grid systems are objective by intent and provide a rational basis for layout decisions; they help establish proportional relationships between elements and ensure an overall consistency. Grids are often assumed to be essential, but are sometimes used unnecessarily or inappropriately and become more of a hindrance than a help.

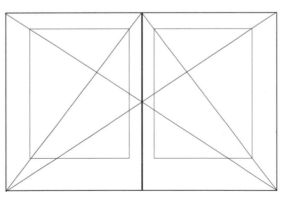

Traditional page structure consists of margins that are filled with elements in a linear fashion.

The modern grid is a structure on which we arrange elements according to modern design principles.

We draw lines on the page either as guides for positioning elements or to subdivide space. This concept of subdividing space is all around us: our homes are divided into rooms, our kitchen drawers are divided for utensils, and we may use segmented boxes to store and transport small items. We may need to modify these subdivided spaces for a specific use because they were designed for general use. When planning how a space will be divided, the way in which the space is to be used is a primary consideration.

In the three examples shown here, nine numbers have been arranged using three different approaches. The first two are simple networks of lines that have evolved into the layout grid commonly used today. The third example is a layout grid consisting of fields and intervals; it combines the properties of the first two approaches. By understanding the differences between these approaches we will better understand how and when to use a grid.

Segmentation is the division of the page into smaller areas, each of which is the equivalent of a tiny page with no internal structure. Within each area, elements are placed at random; the segment lines offer no guide to exact placement. The lines creating the segments are simply *dividing* lines that define areas, just as fences in a meadow define fields.

Because segment lines define the edges of an area, each area, or segment, can be filled. In the example below, every other segment is filled; if all the segments were filled, the edges of the areas would disappear. By placing one element per segment, a relatively even distribution is achieved.

Of these three sets of examples (pages 132-33), the first only defines areas; the second only provides positioning guides for the placement of elements; the third does both.

Unlike segment lines, the positioning guides shown below do not define areas. Instead, the vertical and horizontal lines intersect to provide specific *x-y* coordinates for the positioning of elements.

In the example below, each number is positioned at the point where a vertical line and a horizontal line meet. In this example, elements have been aligned to this point by their bottom right corners. They could also have been centered on each intersection or aligned by their top left corners—what is important is that they were all aligned in the same way.

Because the positioning guides below were drawn closely together, the elements aligned to them appear to be grouped. Each new arrangement of positioning guides will yield a different layout result.

The grid shown below both segments and provides specific positions for elements. This is the most common type of layout grid. Areas, or *fields,* are separated by strips of space called *intervals.* Both the fields and the intervals are consistent sizes. The corners of the fields act as the intersections required for positioning, and the edges of the fields define areas.

No margins have been added to any of these examples. Unlike on the traditional page, margins are not part of the essential structure, but are determined instead by the design and production limitations.

134

On the traditional page, margins are the primary structure. On the modern page, margins are subordinate to the structure—usually a grid.

Establishing a structure for the modern page begins with defining the space on the page that must be reserved for production requirements such as printing, binding, and trimming. The inside margin of a bound document, for example, must be wide enough to compensate for the space actually used by the binding, as well as the space lost to the curve of the page. In general, the thicker a document, the wider the inside margins must be, unless a mechanical binding is used.

We can print either on pages already cut to size or on large sheets that are cut to size after printing; the specific requirements of the job and the size and type of press used will determine which of these alternatives is appropriate. If printing is on the final page size, space must be left at one end of the page so that the press can grip the paper.

Typical minimum margins are shown in the diagram below. Even when a page will have no other structure, it must respect the minimum margins dictated by production, except for those elements that are intended to print to the edge of the page, or *bleed*.)

Minimum margins are usually only a point of departure for the further development of page structure. Minimum margins only define the size and shape of the space in which the page structure can be developed.

It is critical that layout structure be developed from the requirements of the elements and the design, and that final margins be determined after this structure is in place. This is a critical step in structuring the modern page. Unlike the traditional approach to page structure, in which margins are developed first, modern structure determines final margins last. It is interesting to note that the layout programs on personal computers tend to assume a traditional approach and require that margins be established first.

Typical minimum margins
for a page that will be
bound and trimmed are
3/4 inch for the inside
(bound) margin, and 1/2
inch for the top, bottom,
and outside margins.

Developing a basic grid

A basic layout grid subdivides the page into fields and intervals within the space defined by minimal margins. The grid is derived from the space provided on the page rather than from the specific elements themselves. In this sense, it could be considered more tradition-al than modern.

The basic grid has only limited usefulness because the number of fields and their pro-portions are decided arbitrarily. It is just such arbitrary decisions that often cause problems during layout.

When more than a few paragraphs of text will be used per page, when communication through that text is essential, or when a do-minant element has specific proportional requirements, the grid should be developed around those specifics rather than arbitrar-ily—form must follow function.

Generally, a grid can be developed from the designer's sketches so that the design deter-mines the specifications of the grid. Once a grid is established it is used in turn to deter-mine the specifics of the layout.

The grid helps us make final decisions about size, proportion, and placement. The num-ber of fields in the grid determines how flex-ible it will be to use. Whereas too few fields do not allow enough flexibility, too many fields may not provide enough constraint. The appropriate balance is decided by the design and by the kinds of elements that will be included.

It is not necessary or desirable to fill all of the fields; the fields we leave empty are as im-portant to the layout as the fields we use. On the grid for this book, an empty band of fields across the top of the page makes it easy and predictable to find the beginning of the text and assures a minimum level of con-trast between elements and space, no mat-ter how much of the rest of the page is filled.

This layout grid with forty-eight fields is an arbitrary subdivision of the page within minimum margins. Its usefulness may be limited because elements may or may not fit the fields.

Basic grids are relatively easy to develop and may be convenient for projects that do not contain much text; most projects, however, use text extensively. Although readable text fits neatly into some grids, it is as likely that text parameters will need to be compromised when the grid has been established arbitrarily.

Typographic grids develop from the requirements of text and assure us that the text will be readable. These, too, are developed from the designer's sketches, but they begin with the text specifications rather than with the subdivision of space.

The measurements of the fields and intervals are derived directly from the typeface, point size, kerning, line length, and leading of the text to be used (see workbook topic 9).

A typographic grid usually looks much like any other grid of fields and intervals. If text is the only element on the page, however, it may look more like the example below. This is because text has its own internal structure; very little additional structure is needed.

The grid shown below contains positioning for text and headings only. It consists of two large fields for text, a space interval separating them, margins, and a positioning guide for where the text should begin on the page. All other structure comes from text specifications such as leading.

This grid is designed to organize only text. The two grids on the next page are derived from this one and require no substantial changes to the structure established here.

This is a minimum structure for text. It provides positioning points for headings and columns of text only.

When a layout is to include elements in addition to text, additional fields are created within the minimum text structure already established. Both of the grids below build on the framework established on the previous page, and they provide enough flexibility for most applications.

While the initial text structure on the previous page provided only two fields, the first grid below provides twenty-eight fields.

The space between the heading and text that was established in the first structure has been retained, independent of the pattern of fields and intervals. This space is not a field and elements other than the heading will not be placed in it.

The second grid below provides thirty-six fields and was also derived from the basic text structure on the previous page. Because fields begin the top left corner, the width of the space between heading and text has not been preserved.

In the minimum text structure this space was determined *subjectively* from the designer's sketch; that is, the space was determined by the designer's sense of visual balance rather than by measurement. In the grid below the space between heading and text is determined *objectively* by the spacing of the fields and intervals; that is, it is determined by a measurement system rather than by a personal sense of balance.

If we were to use this grid for a layout, the text would either be nearer to or farther from the heading than in the original structure.

These two grids use the same text structure as on the example on the previous page, but they provide a network of fields and intervals for positioning other elements as well.

Layout is the arrangement, or *composition,* of elements in two-dimensional space. Layout is a step in the process of creating a printed piece, but it is not the first step. The design process as a whole begins with the first ideas about a project and does not end until the piece is produced and in the hands of the client.

The design process can be divided into three key phases: design, layout, and production, as shown below. Each step in each phase must occur before the next step can begin. Before layout can begin, design decisions must be made about what elements will be included, the nature of those elements, the size and shape of the space in which they will be arranged, the relationships between the elements, and the relationships between elements and space.

All of the steps in the process will occur whether it is by default or with purpose. The objectives of a piece—why it is being printed, who the audience is, how it will be distributed and used, and so on—will either be determined as a whole by the designer or indirectly and in a fragmentary manner during the process of layout.

Once objectives have been established, the designer develops ideas within the context of the objectives, first as small sketches called *thumbnails,* and later as more comprehensive sketches, or *comps.*

The final design becomes the model on which layout decisions are based, and the objectives established at the beginning of a project become the objectives for the layout as well as the design.

When a design is contradictory or ambiguous, it raises questions and creates conflict; when a design is well conceived and well planned, layout is a relatively simple process.

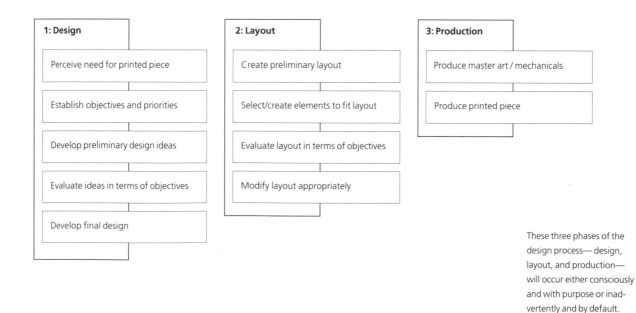

1: Design

Perceive need for printed piece

Establish objectives and priorities

Develop preliminary design ideas

Evaluate ideas in terms of objectives

Develop final design

2: Layout

Create preliminary layout

Select/create elements to fit layout

Evaluate layout in terms of objectives

Modify layout appropriately

3: Production

Produce master art / mechanicals

Produce printed piece

These three phases of the design process— design, layout, and production— will occur either consciously and with purpose or inadvertently and by default.

Communication is a two-step process—the viewer's attention must be *attracted* before a message can be *transmitted.* The most readable of type and the most sensible of layouts will not transmit a message unless the potential viewer stops to look at it.
The advertising field tends to overemphasize attraction. At the other extreme, attraction tends to be overlooked entirely in technical documentation and other such projects not concerned with "making the sale."
At both ends of the spectrum there is a point of absurdity—the advertisement, for example, in which so little emphasis has been placed on transmitting information that we cannot read the product name; or the technical manual in which so little emphasis has been placed on attraction that a potential reader, even if attracted by its cover, is encouraged to close it rather than to read it.
In both of these cases, the message has not been communicated.
Clear communication is the function of a printed piece; function, in turn, is a primary concern of the modern designer. Although this concern for communication is common to client, designer, and writer alike, it is the designer who must find a solution that satisfies both steps of communication.

Two messages are communicated on the printed page—one is *explicit* and one is *implicit.*
Explicit messages are communicated by the content of the elements themselves. Implicit messages are communicated by the manner in which those elements are arranged, and by the use of such nonmessage elements as graphic elements, color, and photographs used only for their graphic impact.
Advertising is noted for its use of the implicit message—the car ad that sells power or the perfume ad that sells femininity—but implicit messages are communicated in more subtle ways as well. The style, color, paper, visual hierarchy, and juxtaposition of elements carry a message to the viewer as well, and should be chosen with an implicit message in mind.
The designer's task is to create a framework in which the explicit message is reinforced, rather than contradicted, by the implicit message.

One of the key differences between the traditional page and the modern page is *linearity,* or the sequential organization of information from top to bottom on the page. Linearity is based on a *scroll* analogy in which information is perceived as a continuous, sequential flow. This analogy is so accurate a representation of the traditional page that it has been used as a model for word processing software. The scroll analogy explains why each traditional page is filled top to bottom before the next page begins; the pattern is broken only when text is broken into shorter scrolls called chapters.

Linearity often conflicts with the layout of the modern page. In modern layout, each page or spread is viewed as space (ground) on which elements (figures) are organized by principles such as grouping. In modern layout, these principles can be used to direct the viewer's eye.

In the scroll analogy, new pages often begin midword, midsentence, or midparagraph. Because the modern page is no longer seen as a segment of a scroll, and columns and pages no longer need to be filled, the nonlinear page can begin and end with complete thoughts.

On the modern page text is a grouped object uninterrupted by other elements. The linear structure of language is preserved within the text, but this structure no longer dictates the structure of the page.

In the two examples below a linear and a nonlinear layout are compared. Both use the same typographic style and both contain the same amount of information. On the linear page, left, the text flows from top to bottom in a single column; the placement of images is determined by the position of the text that refers to them. Sequence is given priority over structure or visual impact.

On the nonlinear page, right, the text is a grouped element uninterrupted by other elements. Although the photograph and diagram remain readily available to the reader, their positions and sizes were determined on the basis of structure and visual impact rather than on the basis of sequence.

On a linear page, priority is given to arranging all elements in sequence. On a nonlinear page, priority is given to organizing by modern design principles.

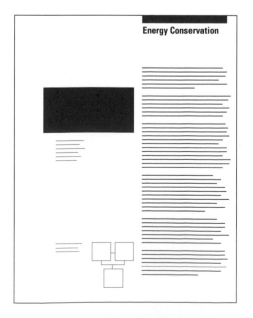

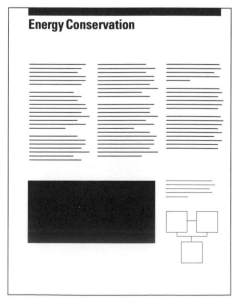

The traditional style has long been considered the writer's style; its structure evolved from and gives priority to the linearity of language and text. The modern style, then, might be considered the designer's style; modern design principles take precedence over linearity. This is a source of potential conflict with writers, who generally create text in a linear manuscript format, even when it is to be used on a nonlinear page. When the page is to be organized in a nonlinear way, the designer is often faced with the task of segmenting linear text appropriately. This is a task that is often better done by the writer. It is often beneficial, then, for the writer to be aware of the page structure in advance, and to be aware of the impact that nonlinear formats have on writing structure. One difference is that the writing no longer needs to provide the sole structure for the page as it did in the traditional style. Another difference is that text will no longer be interrupted by other elements.

If the text on a standard 8 1/2-by-11 page is set following guidelines for readability, it will probably be arranged in one of the ways shown below. The designer's preliminary sketches of the page structure can help the writer envision the format during writing and can provide a word count per page.
In considering the page structure in advance, the writer may structure of the text differently. Conversely, thinking about the text will often change the way in which the designer structures the page. Because writer and designer both play key roles in the development of printed communication, the best results tend to be produced when writer and designer collaborate rather than compete.

The potential arrangements of readable text on an 8 1/2-by-11 page are limited. Within these limits, however, is an almost unlimited range of design possibilities.

The design principles described in chapter 2 are the basis on which we make layout decisions on the modern page. Principles such as figure-ground reversal can be used to engage the viewer's attention. Grouping creates and clarifies relationships between elements. Order, pattern, and unity are imposed on the page by the use of a grid and by the consistency of the text. Contrast and asymmetry add variety for balance.

Text almost always plays a passive role on the page; if it does not, readability may be impaired. This means that it is the other elements on the page, including the space, that create visual interest.

Contrast is a primary tool by which the designer establishes a visual hierarchy and directs the viewer's eye. Contrast and asymmetry together encourage diagonal eye movement. Contrasting scale may imply depth, which reinforces the visual hierarchy by causing some elements to advance in space and others to recede.

The same elements—a circle, a square, and two columns of text—appear in each of the layouts below. Modern design principles are applied differently in each because the size and relative positions of the circle and square change in each.

In the first layout, for example, the square is so large that the layout loses its potential for asymmetry; space is inactive. The third layout also lacks asymmetry; because the elements are so similar in size, it lacks contrast as well. Both the first and the third layouts are passive and are therefore inappropriate for the modern style. The same relative positions for the square and circle are used in the fourth and fifth layouts; the fourth uses scale to create contrast. In the sixth layout, space becomes a more active and dominant element.

In the second and fourth layouts, there is an illusion of depth; this helps to make these layouts more dynamic.

Layout is affected by subtle changes—modifying the position or scale of an element only slightly can transform a passive layout into a dynamic one; the converse is true as well.

Contrast and asymmetry in combination create the most visually arresting page.

Each of these layouts should be viewed separately rather than as part of a group of layouts so that each composition can be evaluated individually.

Some elements, such as photographs, are virtually always considered a single object. Other elements, such as text and charts, are comprised of separate elements that we treat as a group during layout. These have an internal structure independent of the structure of the page; text, for instance, is structured by words and leading. In placing a group, we do not interfere with this internal structure.

How we group determines how we place elements on the page. If we think of five photographs as separate objects, for instance, we position them one at a time on the grid. We can also treat them as a group; as such, we would arrange them independent of the grid. The group, with its own internal structure, would align to the grid only as a single object.

Grouping is a key factor not only in creating the layout but in how it will be perceived. In evaluating a layout we must look for inadvertent as well as intentional groupings. The viewer will inevitably group elements by proximity unless there are other visual clues, such as similarity, that offer a different grouping interpretation.

Consider how grouping works on the page you are reading now, for example. The subhead is a separate object, even though it is similar to the text, because it does not group by proximity with the text. The illustrations at the bottom of the page are seen as a group because of similarity and proximity, so the caption relates to this group rather than to only the illustration on the right.

Sometimes grouping is ambiguous; such ambiguity should always be intentional. In each of the six layouts on the left, for example, it is unclear whether we are to group the circle and square together, or group one of them with text, or view each as a separate object. How we group determines how we interpret what we see. This is one of the key principles in Gestalt psychology.

Elements may be placed either as separate objects or as a group. The group must have its own consistent structure. If placed separately, structure is derived from the grid.

144

Each project varies in a number of ways, any of which could affect the design and the layout decisions made: the number of elements that have already been created; the nature of the elements that need to be created; the amount of text and images that must fit on the page; the relationships between those elements.

Because so many variables are involved, it is common for a designer to create a new grid for a new project. Because so many projects have the same general kinds of elements and requirements, however, it is not uncommon for a designer to use or modify an existing grid. The designer who uses grids regularly may have developed an array of grids that suits his or her style and needs. This is a particularly efficient practice for designers who work with desktop technology or other typesetting equipment.

In addition to the grids the designer creates, ready-made grids are available, primarily as *templates* to be used with desktop technology. Templates offer both grid and type specifications, but may or may not suit the requirements of the project at hand.

It is often during the process of creating a grid that many of the details of a design are considered and clarified, and potential layout problems are resolved. In creating the grid, the assumptions made during the design phase are confirmed or challenged. Because of these factors, grid development remains an important step in the design of a printed piece. Particularly for the beginning designer, ready-made templates leave many questions unanswered and may thus encourage arbitrary decisions. Ready-made design may be useful as a point of departure, however, and inspire layout and design ideas that would not otherwise have arisen.

Each of these layouts uses a modified version of the typographic grid shown. Fields are added or subtracted according to the needs of the project. Each follows the guidelines presented above; each is different in character.

A grid that has been designed appropriately provides the designer with a fast and easy way to create interesting and effective layouts. When the grid satisfies the needs of the project there is seldom a need to deviate from it. The urge to deviate from it is another matter—it may imply that the grid is being viewed as a restriction limiting the freedom of the designer rather than as a framework in which creativity can take place. This is a conflict that must be resolved before a grid can be used effectively.

Once an appropriate grid has been established, layout is a matter of fitting information into the space allocated for it, so that the reader perceives the pattern and logic of the organization. The single overriding rule for using grids is to use them consistently. Consistency provides a background of order, pattern, and unity.

The guidelines presented here act as a checklist for making layout decisions when working with a grid.

—Place and scale elements consistently according to the grid.

—Make elements only as large as necessary for communication unless they are also being used as graphic elements.

—Establish a visual hierarchy between the elements—everything cannot be dominant.

—Hang elements from the tops of fields; align elements to the left edges of fields. Place text as a group so that it is uninterrupted by other elements.

—Be systematic; for example, place similar elements in a consistent position from page to page in a multiple-paged document or series of pages.

—Limit text to about half of the fields on a page whenever possible.

—Leave about one-third of the fields on a page empty to help ensure layout flexibility.

—Use contrast, asymmetry, and other design principles to avoid creating a passive page.

146

When the designer is presented with too much information for the space allocated, design principles cannot be used to advantage and both aspects of communication are impaired: the page may not attract the viewer because it lacks visual interest; information cannot transmit its message effectively if elements are forced into inappropriate groupings because there is so little flexibility on the page. Once adjustments have been made so that it is set as compactly as possible, only two solutions remain: to decrease the information by editing or to increase the space on which the information appears.

When the length of a document is fixed (e.g., a four-page brochure, a forty-eight-page catalog) the information may need to be edited. This may involve eliminating such elements as photographs as well as editing the text.

When a preliminary layout is created early in the design process using a preliminary draft of the text, problems of fit become apparent immediately. This stage in the process is a good time to edit copy to fit the space allocated for it. Reviewing the layout and the text together also provides the writer with useful information about how the words will appear on the page.

When the layout and text are not compared for fit until the manuscript has reached its final draft, changes and editing are considerably more difficult and more expensive.

On a crowded page we cannot take advantage of modern design principles. The message is more likely to be read if we edit the text or expand the space.

If the length of the document has been decided arbitrarily and the information has already been edited, and when it is appropriate to place more emphasis on the first step in communication than the second, then the only option remaining is to add space. If the document must retain a standard 8 1/2-x-11 page size, this means doubling the amount of space for the information.

The layout below contains the same amount of copy as the first layout, but it is in twice as much space. There is space to make elements such as photographs and headings larger. The reader may perceive that there is less to read. (This is an example of the contrast illusion at work—the space is larger so the amount of text seems smaller.)

Magazine designers often use expanded space at the beginning of an article to make it more appealing, then they compensate for the loss of space by packing the remainder of an article into the back of the magazine. It is likely that readers will never finish reading such articles.

When the options have all been explored—when the space has been expanded as much as the budget will allow, the designer has explored alternative page structures and typesettings to gain space, and the writer has edited the copy so that it is as compact as possible, and content and space still do not balance—options outside the realm of design must be explored as well. These include options such as revising the budget and finding additional sources of revenue. These decisions affect the potential success of a printed piece as much as the design itself.

In exploring options, not only must the printed piece in question be examined, but also the context in which it will exist. Priorities must be established that take into consideration such factors as the image the company wants to project and the reasons for producing the piece. Once these objectives have been clarified and given priority, other decisions tend to fall into place.

Park systems

The objective approach

Design can be approached either *subjectively* or *objectively*. In the subjective approach, the designer works somewhat like an artist in that decisions tend to be made spontaneously and are based on his or her personal taste. In the objective approach, design is seen as a problem-solving activity, as well as the visual arrangement of objects. In this sense, design has more in common with architecture than with art.

Whatever the approach, however, successful results depend to a great extent on the visual awareness and sensitivity of the individual making the decisions. In this sense, no design is purely objective.

During the design process, subjective decisions are inevitable and desirable. In developing ideas, for example, the designer must respond subjectively to the goals of the project, which were established objectively. Once a structure has been developed objectively, layout decisions are subjective within that framework.

Although many of the art and design movements that spawned it were subjective in nature, modern design has evolved into an objective style, incorporating principles of functionalism and Gestalt psychology. Swiss design in particular has come to represent an objective approach to graphic design, in which modern design principles have been systematically and objectively applied. In the Swiss style, communication is seen as a common goal that is achieved by the systematic application of modern design principles. Within the seemingly rigid structure of Swiss design, a wide variety of alternative solutions can be found for any design problem. Swiss design emphasizes typography; typography, as visual language, requires a systematic and practical approach.

Objective structure, principles, guidelines, and style offer a broader and more reliable basis for design than the subjective approach. Within this objective framework, success is not as dependent on the state of mind of the designer. Only within the objective approach can systems be developed that can be used consistently by a variety of layout artists and designers.

On this mailer for an exhibit of Japanese ceramics and textiles, designer Russell Leong worked objectively to develop the basic concept, that of using a circular red image in a white field to suggest the Japanese flag. The concept and design style are objective; specifics, such as the exact size of the image and its level of abstraction, require subjective design decisions.

In using asymmetry and applying such design principles as contrast between elements and between elements and space, we ensure a dynamic page. The grid is an objective structure that provides the framework for unity; the elements then provide the variety needed for balance and visual interest.

Without the grid the designer must have an inner sense of rhythm—a subjective sense of grid—that can be applied to the arrangement of an assortment of objects, so that the viewer clearly perceives the pattern to the arrangement intended by the designer.

Laying out the unstructured page is a keenly subjective process that has only the individual's awareness as a basis on which to make decisions. This is the "art" part of design, which can only be taught indirectly and which some may never learn. Even with all the theory at our fingertips, we still may not be able to fit the pieces together in a satisfactory way.

A designer, asked for a copy of a brochure she had designed because of its outstanding use of a grid, replied, "Grid?" Her structure is a built-in awareness of space, proportion, organization, and design principles that has been developed through years of training and practice.

In the final analysis, there is no substitution for visual awareness, and it seldom develops without nurturing, training, and practice. It is only after our visual awareness has become a well-developed skill that we can produce consistently good work without objective structure.

A trapeze artist cannot freely experiment when learning new skills without a safety net to rely on. The designer's safety net is the grid; the grid provides a safe environment within which the designer can experiment. In both cases the safety net helps avoid potential disaster. Once a sufficient skill level has been developed, the designer (or the trapeze artist) may choose to eliminate the net. In both cases, there is a temptation to remove the net too soon.

150

In this 1947 newspaper ad, designer Carlo Vivarelli used an abstract element, a circle, to represent an insulation product. White circles overlap to form irregular, black negative shapes, creating interest with figure-ground differentiation. The white figures merge, becoming background for text.

Headings are reversed out of black rectangles. The rectangles add emphasis to headings; these would need to be set in a much larger and bolder typeface to gain the equivalent amount of contrast. Rectangles offer contrast in shape as well as in value.

DIE KUNSTISMEN

1924
1923
1922
1921
1920
1919
1918
1917

HERAUSGEGEBEN VON EL LISSITZKY

1916
1915

UND HANS ARP

1914

LES ISMES DE L'ART

1924
1923
1922
1921
1920
1919
1918
1917

PUBLIÉS PAR EL LISSITZKY

1916
1915

ET HANS ARP

1914

THE ISMS OF ART

1924
1923
1922
1921
1920
1919
1918
1917

PUBLISHED BY EL LISSITZKY

1916
1915

AND HANS ARP

1914

EUGEN RENTSCH VERLAG
ERLENBACH-ZÜRICH, MÜNCHEN UND LEIPZIG

1925

Die Gegenwart ist die Zeit der Analysen, das Resultat aller Systeme, die jemals entstanden sind. Zu unserer Demarkationsgrenze haben die Jahrhunderte die Zeichen gebracht. In ihnen werden wir Unvollkommenheiten erkennen, die zur Getrenntheit und Gegensätzlichkeit führten. Vielleicht werden wir davon nur das Gegensätzliche nehmen, um das System der Einheit aufzubauen. **MALEWITSCH.**

KUBISMUS

Das, was den Kubismus von der älteren Malerei unterscheidet, ist dieses: er ist nicht eine Kunst der Nachahmung, sondern eine Konzeption, welche strebt sich zur Schöpfung herauszuheben. **APOLLINAIRE.**

Statt der impressionistischen Raumillusion, die sich auf Luftperspektive und Farbennaturalismus gründet, gibt der Kubismus die schlichten, abstrahierten Formen in klaren Wesens- und Maßverhältnissen zueinander. **ALLARD.**

FUTURISMUS

Die Futuristen haben die Ruhe und Statik demoliert und das Bewegte, Dynamische gezeigt. Sie haben die neue Raumauffassung durch die Gegenüberstellung des Inneren und Außeren dokumentiert.
Die Geste ist für uns nicht mehr ein festgehaltener Augenblick der universalen Bewegtheit: sie ist entschieden die dynamische Sensation selbst und als solche verewigt. **BOCCIONI.**

EXPRESSIONISMUS

Aus Kubismus und Futurismus wurde der falsche Hase, das metaphysische deutsche Beefsteak, der Expressionismus gehackt.

Le temps actuel est l'époque des analyses, le résultat de tous les systèmes qui aient jamais été établis. Ce sont des siècles qui ont apporté les signes de notre ligne de démarcation, nous y reconnaîtrons les imperfections qui menaient à la division et à la contradiction. Peut-être que nous n'en prendrons que les propos contradictoires pour construire notre système de l'unité. **MALEWITSCH.**

CUBISME

Ce qui distingue le cubisme de la peinture précédente c'est qu'il n'est pas un art de l'imitation, mais une conception qui tend a s'élever en création. **APOLLINAIRE.**

Au lieu de l'illusion impressioniste de l'espace basée sur la perspective de l'air et le naturalisme des couleurs, le cubisme donne les formes simples et abstraites en leurs relations précises de caractère et de mesures. **ALLARD.**

FUTURISME

Les futuristes ont démoli la quiétude et la statique et démontré le mouvement, la dynamique. Ils ont documenté la nouvelle conception de l'espace par la confrontation de l'intérieur et de l'extérieur. Le geste pour nous ne sera plus un moment fixé du dynamisme universel: il sera décidément la sensation dynamique éternisée comme telle. **BOCCIONI.**

EXPRESSIONISME

C'est du cubisme et du futurisme que fût fabriqué le hachis, le mystique beefsteak allemand: l'expressionisme.

The actual time is the epoch of analyses, the result of all systems that ever were established. Centuries brought the signs to our line of demarcation. In them we shall recognise the imperfections that led to division and contradiction. Perhaps we hereof only shall take the contradictory to construct the system of unity. **MALEWITSCH.**

CUBISM

What distinguishes cubism from precedent painture is this: not to be an art of imitation but a conception that tends to rise itself as creation. **APOLLINAIRE.**

Instead of the impressionist illusion of space based on the perspective of air and the naturalism of colour, cubism offers the simpel and abstracted forms in their precise relations of character and measure. **ALLARD.**

FUTURISM

Futurists have abolished quietness and statism and have demonstrated movement, dynamism. They have documented the new conception of space by confrontation of interior and exterior. For us gesture will not any more be a fixed moment of universal dynamism: it will decidedly be the dynamic sensation eternalised as such. **BOCCIONI.**

EXPRESSIONISM

From cubism and futurism has been chopped the minced meat, the mystic german beefsteak: expressionism.

Multiple languages establish a rhythm on this title page and text page. In the United States, where multiple languages are less common, a similar rhythm is sometimes established through the repetition of a word or element.

The years are printed out and repeated to create a pattern that is more interesting visually than if the years were set conventionally, showing only the first and last years separated by a hyphen.

On these pages, designed by El Lissitzky in 1925, bold bars differentiate information and divide space but tend to overpower the text. Implied lines, created by grids consisting of fields and intervals, allow the information to dominate.

All of these covers by designer Randy Moravec use the structure shown on the next page. Using a structure assures unity; variety is introduced through the addition of a graphic element. Each graphic element also shows a careful balance between unity and variety.

Each cover reflects a specific topic: a network of lines is used for the cover of a packet distributed to a dealer network; a brochure for an accounting product uses a graphic showing freely flowing paper; a pattern of rotating circles, printed in silver varnish, represent coins on a pricing guide.

Accounting Plus

Systems Plus, Inc. is committed to the design and production of the highest quality software. We have structured our customer support department with the goal of helping you to achieve the maximum benefit and usage of our products. Please read this Customer Support Service agreement to understand the services available to you after you register your software and your computer hardware.

Software Registration

To qualify for any customer support service program you must fill out the Software Registration Card and mail it to Systems Plus Incorporated 500 Clyde Avenue, Mountain View California 94043. On occasion, Systems Plus may modify the current version of its products to incorporate changes in current features or the resolution of minor program errors or programming "bugs"

New Product Versions

New product versions incorporate new features and enhancements. Registered owners will be notified of product upgrade by mail. The new features and enhancements to the product will be described in The Balance Sheet. The cost of a new Product version is determined at the time of release and may be purchased by contacting your dealer or calling our sales department at (415)969-7047

Systems Plus Incorporated

Please fill out the following information before installing the software. Upon receipt of this registration card by Systems Plus, you will become a registered Accounting Plus owner have read the Systems Plus Software License Agreement and agree to abide by the terms contained there in

What brand of computer hardware is the software installed on? Please fill out a little information to help us serve you better in the future. How did you hear about Accounting Plus? Magazine Advertisement or article Computer software salesperson| Product literature What industry journals or periodicals do you read?

On text pages, the square used for cover graphics is divided into two columns. Because text is generally the only element used in these brochures, no grid structure was necessary, and positioning guides are provided as reference for the occasional placement of elements such as photographs.

This page structure is used for both brochure covers and inside pages. On the cover it not only provides positioning guides for the title and logo, but also defines a square area for a cover graphic. Using a single structure simplifies layout and unifies a range of printed pieces that might otherwise be seen as unrelated projects rather than as interrelated parts of a company image.

This logo by designer Randy Moravec was the point of departure for the development of the page structure and cover graphics shown here. Unity is established through the repetition of a single shape; variety is introduced by a progressive change in line weight. The logo was designed for a company that refines and markets new products.

Designed in the 1950s by
Siegfried Odermatt, these
catalog pages have a flex-
ible structure that can in-
corporate a wide variety of
items. The designer used
contrasting scale to create
visual interest by making
many objects small so that
one could be large. Photo-
graphed from the top or
side rather than in perspec-
tive, the objects take on an
abstract, sculptural quality.

This unstructured composition by Russell Leong relies entirely on design principles to control and direct the eye. Elements such as the surfboard silhouette in the bottom left corner and the mouse in the top right direct the eye back into the composition.

The emphasis is on attracting the eye rather than on transmitting a message; to discover message and meaning, the viewer must interact with the design. During this process, the viewer also gains insight into the reasons for and relationships between elements.

WESTERN

BOOKS

1950

THE NINTH EXHIBITION OF BOOKS
PRODUCED BY WESTERN PRINTERS

THE ROUNCE AND COFFIN CLUB

LOS ANGELES, CALIFORNIA • 1950

1 When invited to do this introductory bit of writing, I had the good grace to speak an appreciative thank you, but I lacked the courage to add a polite negative. After fifty years in the game, playing all the positions from bat-boy to pitcher, with an average record of home runs and strikeouts, followed by twenty years of looking on from the bleachers, and being only human, I was thrilled when invited onto the field and given an opportunity to again mingle with the players. And now, with only a few old score cards and a few daydreams, I am typing something that only by courtesy can be called a foreword.

No mention need be made of "Western Books" listed in the catalogue. They are being exhibited and worthily speak for themselves, some with imagination, others in an honest and direct expression of publisher's intent. I thoroughly enjoyed being a member of the jury responsible for their selection.

Now, what am I to write? Being a product of the horse and buggy era when, attired in tight-fitting trousers, a tight-fitting hip-length jacket, a starched collar, white shirt, and a straw hat, I rode a high bicycle through the tangled traffic of two-team percheron-drawn beer trucks and heavy-loaded drays, horse-drawn streetcars, market and milk wagons and a sparse sprinkling of carriages on the granite-cobbled streets of downtown Chicago on my daily trips to and from work, I belong to the Turkish cozy-corner, gilt-framed-chromo-on-the-wall, portrait-on-a-bamboo-easel, silk-throw-on-the-piano Victorian period known as the "Mauve Age." Obviously a back-number and old-fashioned it is equally obvious

FOREWORD by WILL BRADLEY

The title spread of this booklet (top) is nonlinear and asymmetrical. Only typographic elements were used. Set in all caps in a geometric sans serif typeface, words assume rectangular shapes whose color and texture are largely determined by the weight of the type. On the bottom spread, text was set traditionally and assumes a rectangular shape as well. Elements were placed below rather than above center, as in the traditional style. Compare this booklet with the 1959 version shown on page 92.

The modern style evolved in response to the dramatic changes taking place in the early decades of the twentieth century. New theories in science, art, and architecture gave rise to new philosophies. This period was marked by social upheaval and political unrest; the old ways of doing things were viewed as ineffectual in a modern world, and modern problems seemed to demand modern solutions. Many styles and the philosophies that spawned them were reactionary and short-lived; nevertheless they inspired others to experiment and question as well.

The Bauhaus, a design school established in Germany in 1919, became a focal point for many of these philosophies. At the Bauhaus, diverse philosophies merged into a coherent theory of design that has become the basis for much of the art and design done today. The Nazis closed the Bauhaus in 1933.

By the end of World War II many of the architects and designers from the Bauhaus had emigrated to Switzerland and the United States. By the late1950s the Swiss style of graphic design became a dominant style, characterized by an emphasis on communication, modern design principles, and neutrality.

A functional style, it can be broadly applied to all areas of visual communication and graphic design. The modern style stresses a systematic and objective approach to typography and grids that helps to ensure consistency, whether on a page, within a multiple-paged document, or within a series of documents.

Modern typography is characterized by sans serif type set flush left ragged right in upper- and lowercase letters. Text is set compactly into columns that allow from forty to fifty characters per average line.

The modern page is most often based on a regular grid of fields and intervals that subdivide the page into proportionally related segments. A grid not only helps to ensure an overall unity between the elements and the space on the page, but also reduces the number of arbitrary decisions that are made during layout.

Elements are scaled to fit this grid, and each element is only as large as it needs to be to function. By keeping elements compact, the designer gains the space necessary for flexibility during layout. Flexibility is needed so that the page can reflect modern design principles such as asymmetry, contrast, non-linearity, simplification, and space. The application of these modern design principles helps to attract potential viewers and to present information in a dynamic rather than static way.

In addition to providing a rational approach to basic layout and design, the modern style acts as a point of departure for subjective experimentation in which modern principles are applied to the page. The modern style provides a good basis by which to develop the visual sensitivity necessary for successful subjective design.

Workbook

3

This workbook offers supplemental information, explanations, exercises, and references that will clarify and reinforce the concepts and information presented in the other sections of this book. Topics fall into several categories: construction, grids, layout, typography, and templates. Each topic includes an explanation, exercises, and illustrations. A general reference to the relevant parts of books 1 and 2 is provided below.

Exercises help develop a greater awareness of style, layout, and typography, and they help develop analytical design skills. They are general enough to provide a challenge to those working in graphic design as well as to those just beginning their graphic-design education.

The exercises do not require that the reader have any specific technology, such as a desktop computer or typesetting equipment. Exercises, however, are structured so that those with the appropriate hardware and software can take advantage of these resources.

A work disk is included as well. Those using the disk should open and read the *Read me first* file before working with the other files on the disk—it offers important information and notes about procedures. The disk contains templates and samples relating to the topics presented. The page samples on the disk are from the workbook and can be analyzed, modified, reviewed, adapted, and otherwise used as a point of departure. For the patient and inquisitive person, disk samples also reveal how specific results were achieved. Templates are not only useful for many of the exercises but serve as a point of departure for other projects.

About the disk

Files on the enclosed disk were created on a Macintosh SE, using system software 6.0.2, finder 6.1, and Aldus PageMaker 3.02. Files in the *Templates* folder use standard Apple LaserWriter Plus fonts. Files in the *Samples* folder require downloadable Adobe fonts.

	Topic	Book 1	Book 2	Disk
1	Introduction			
2	Construction basics	Structure		Read me first
3	Constructing margins by spread	Structure		Traditional 1 and 3
4	Constructing a golden rectangle	Design Principles		
5	Constructing single page margins	Structure		Traditional 2
6	Constructing positioning guides	Structure	Structure	
7	Setting up a basic grid		Structure	
8	Setting up a typographic grid		Structure	Modern 1-3
9	Layout variations on a grid		Layout, Principles, Typography	Page samples
10	Using traditional structure	Structure, Typography	Typography	
11	One ad six ways	Layout, Typography	Layout, Typography	Ad samples
12	Modern graphic elements		Typography, Principles	
13	Recreating a classic page	Typography		Classic page
14	Making text more compact	Layout, Typography	Layout, Typography	
15	Templates			

Geometric construction requires no math, only the use of a straightedge and compass or any software with the equivalent drawing tools. The construction methods presented on the following pages use the principles shown here. It is useful to review and understand these basics before beginning the workbook exercises.

Subdividing with diagonals

The diagonals of a rectangle intersect at the center of the rectangle. Using diagonals to find a center is often faster and more accurate than measuring, particularly when the measurement requires rounding off. Vertical and horizontal lines drawn through the centerpoint of a rectangle cut each edge length in half, which creates four equal parts. Making a 50 percent photostat or printout of the original rectangle yields the same result: lengths are halved and the area is one fourth of the original. The diagram below demonstrates this principle.

100%

50%

Scaling with diagonals

Rectangles whose corners meet the same diagonal have the same aspect ratio, as shown in the diagram below. Diagonals, then, can be used to compare proportions of rectangles, even when they are considerably different in size. In layout, we must often block out an area to represent a photograph or illustration whose original size is different. By finding the diagonal of the original, we can draw a rectangle any other size and be assured that the proportion we use in our layout is correct. A pantograph works on this principle.

1. Draw a rectangle, then draw its diagonals. Subdivide the rectangle into fourths, then into sixteenths. Are the diagonals of the small rectangles at the same angle as the diagonals of the original rectangle?
2. Find a rectangular illustration with a border. Trace a rectangle that is one fourth of the area of the original, using diagonals. Make a 50 percent photocopy or photostat of the original illustration. Is the copy the same size as the rectangle you traced? Measure to see which is more accurate.

Traditional page margins are constructed by using two sets of diagonals, the diagonals of the spread (the two facing pages) and the diagonals of the pages. A typical sequence for constructing traditional margins is shown below. These yield a live area that is half the page area and that retains the proportions of the page. This area, used as live area, can be increased or decreased as necessary simply by redrawing margins along page and spread diagonals.

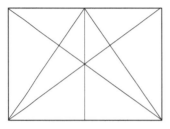 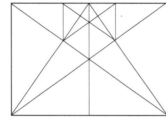 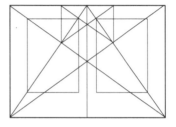

Step 1:
Draw the page sizes, then draw the diagonals for the page and the spread. Notice that the spread diagonals meet exactly at the center. Another interesting feature is that the points at which the page and spread diagonals intersect divides the spread into thirds—a fast and easy way to subdivide any rectangle into thirds without measuring.

Step 2:
Draw vertical lines from the intersection of the page and spread diagonals to the top edge of the spread. Draw diagonal lines from the tops of these vertical lines to the bottoms of the vertical lines on the opposite page.
Where this new diagonal intersects the page diagonal marks the starting point for drawing the margins.

Step 3:
Draw the margins as horizontal and vertical lines as shown, beginning with the top inside corner. The bottom inside corner is determined by where the inside and bottom margin lines intersect. The width of the margins can be adjusted slightly so long as the corners touch the diagonals as shown.

Exercises

1. Follow the sequence shown to construct traditional margins on a 14-by-11 spread (page size 7 by 11). Do the same for an 11-by-7 spread (page size 5 1/2 by 7). Are the margins on the small spread half the widths of the margins on the large spread? If not, why not?
2. What guidance does a traditional constructed page offer for placing and scaling elements? What additional guidance might be useful?
3. Look through library books for examples of traditional constructed margins. Make photocopies of several and draw in the construction lines. When were these books published?
4. How do we know that live areas produced by this construction technique retain page proportions?

The golden rectangle is a classic proportion commonly used in the traditional style. It has a ratio of 1:1.618, a number more easily constructed than measured. One of several methods for constructing the golden rectangle is shown here.

This proportion can be applied not only to illustrations and blocks of text, but also to the proportion of the page (below left) or the spread (below right). When the golden rectangle is used as the proportion for the spread the pages are squarish.

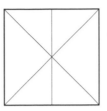

Step 1:
Draw a square, then divide it in half using diagonals. The height of the square determines the height of the golden rectangle.

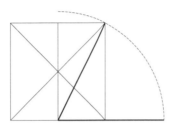

Step 2:
Draw a diagonal across half the square. Use this as a radius to extend the base of the square as shown. This marks the width of the golden rectangle.

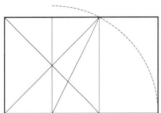

Step 3:
Complete the rectangle as shown, so that the height is the height of the original square and the width is the length described by the radius drawn.

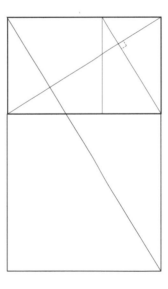

Diagonals:
Draw the diagonal of the golden rectangle; draw the diagonal of the small rectangle that was added to the original square. Add a square below the golden rectangle that is the width of the golden rectangle, as shown. There are now three golden rectangles, one horizontal and two vertical. The diagonal of the horizontal golden rectangle is at right angles to the vertical golden rectangles; the diagonals of the vertical golden rectangles are parallel.

Things to observe:
—The proportion of the rectangle that was added to the original square is also a golden rectangle.
—The square drawn below the golden rectangle, plus the golden rectangle that was constructed, creates another golden rectangle. Each time you add a square to the long side of a golden rectangle you create another golden rectangle.
—The diagonals for the largest and smallest golden rectangles are parallel; because they have parallel diagonals, we know they have the same proportions.

1. Construct a golden rectangle on tracing paper and draw its diagonal. Collect at least 10 common objects such as books and playing cards and compare them with the golden rectangle. How many of the objects you chose used this proportion?
2. Create a dummy booklet in which the spreads are golden rectangles. Create a dummy booklet in which the pages are golden rectangles. Which do you prefer and why? Which is the closest to the standard page proportions used today?

Unlike pages in a spread, single pages are unbound; on a traditional single page, side margins must be symmetrical. Two sets of diagonals are required for constructing margins; two methods for establishing a second set of diagonals are shown here.

Method 1: Adding a square

A second set of diagonals is created by adding a square to the page that is the same width as the page itself and aligns with the top of the page. All we can see of the square in the diagrams shown here is its bottom line and its diagonals. The same basic construction is used for both variations. Unlike margins for a spread, which are constructed in place, single page margins require two steps: in the first step the size and shape of the live area is determined; in the second step the rectangle representing the live area is positioned on the page so that its top corners align with the diagonals of the square.

Procedure for variations 1 and 2:

1. Draw the page diagonals. Draw the square and its diagonals.
2. Mark off an area to use as live area, based on the intersection of two of the diagonals. In the first variation above, the intersection of the page diagonals is used. In the second variation, the intersection of page diagonals and square diagonals is used.
3. Trace the live area defined onto a clean sheet of paper, reposition it over the construction drawing so that its top corners touch the diagonals of the square, and tape it into position.
4. Trace the page and margins onto a new sheet of paper and use it as a guide when setting up camera-ready art, or use it as an underlay for layout sketches.

Procedure for variation 3:

In this variation the margins are constructed in place. The bottom margin is the base of the square; side margins are determined by where the base of the square intersects page diagonals. The top margin is defined by where side margins meet square diagonals.

Method 2: Using a percentage of the page

The live area defined in this method of constructing single page margins derives from the percentage of the page to be used. In each of the variations below the second set of diagonals is drawn to a different point along the vertical edge of the page. The distance from the bottom of the page corresponds to the area used for live area.

In the first example, the second set of diagonals is drawn to a point halfway up the edge of the page and the live area uses half the page area. In the last example, the second set of diagonals is drawn one-third of the way up the edge of the page and uses one-third of the page area. As in the other single-page margin construction shown, two steps are required. In the first step the size and shape of the live area is determined; in the second step the live area is positioned on the page.

Procedure for method 2:

1. Draw the page diagonals.
2. Determine the amount of page area to be used for live area by marking a corresponding length along the vertical edge of the page, measuring from the bottom. For instance, to use two-thirds of the page for live area, as shown in variation 2 (above), a point has been marked two-thirds of the way up the left edge of the page.

3. Draw the second set of diagonals. Draw a rectangle whose top left point is at the intersection of the two sets of diagonals as shown below.
4. Trace the page on a new sheet of paper. Trace the live area in position. Its top corners should fall midway between the two sets of diagonals, as shown. Use this as reference for camera-ready art boards or as an underlay for layout sketches.

Exercises

1. Construct one of the variations in method 1 on a 5-by-8 sheet of paper, and use it as an underlay to lay out a new ad for the Typography Workshop shown in workbook topic 11. Use the traditional style.
2. Using method 2, construct margins on a 5-by-8 sheet of paper so that 50 percent of the page is live area. Construct margins on a 5-by-8 sheet of paper so that 75 percent of the page is live area.
3. Use each of the constructions from exercise 2 as underlays to lay out a new ad for the Typography Workshop shown in topic 11. Use the traditional style.
4. Compare the results from exercises 1 and 3. Did the differences in margins affect your layouts significantly? Which was the most satisfactory, and why?

When we need to organize only a few elements, positioning guides may be of more use than margins on a traditional page and sufficient for structure on the modern. In the constructions shown below, a page has been subdivided into segments using diagonals. In the first example, the page has been halved with diagonals and then halved again so that the page is divided into four segments. In the last example, the page has been divided into twelve segments. Twelve segments tend to be sufficient for most projects.

A typical project requiring positioning guides is shown on the next page: four variations of a book cover, two traditional and two modern. All of these variations use the twelve-segment positioning guide indicated. In using positioning guides, traditional elements commonly sit on or center on the guides, and modern elements hang from them.

Exercises

Divide a 7-by-10 page into 12 segments using diagonals, and use it as an underlay for the following exercises:
1. Design the cover of a novel using only the author's name and the title of the book. Use either the modern or the traditional style.
2. Create 3 traditional variations of your design, using exactly the same elements in the same sizes but a different set of positioning guides for each.
3. Compare the results from exercise 2. Which subdivision of space do you personally find the most appealing? How much of this success do you credit to the structure, how much to the specific words used, and how much to your choice of type size and style? Which structure was the easiest to use?

4 segments 3 segments 6 segments 12 segments

THE TWENTIETH
CENTURY BOOK

JOHN LEWIS

THE
TWENTIETH
CENTURY
BOOK

John Lewis

The 20th Century Book

John Lewis

John Lewis **The Twentieth
Century Book**

A basic grid is a regular subdivision of space into intervals and fields. Intervals are usually between one and two picas wide. The number of fields is generally determined by the amount of flexibility needed in layout—the more fields, the more flexibility. The aspect ratio of the fields can be determined either by a specific element to be included on the page, such as a photograph, or decided arbitrarily.

1. Margins, fields, and intervals

Minimum margins are drawn first as a reminder of production limitations; the remaining space is divided into fields and intervals. Once the space is divided into a grid, elements are tailored to fit it. This grid has 20 fields that are 7 picas wide and 5 picas high, separated by intervals of 1 pica. The fields are arranged in 4 columns and 5 rows.

2. Fitting text to the grid

Based on an average line length of 40 to 50 characters per average line, there are 3 possible text settings for this grid. Increasing the number of grid fields will increase the number of possible line lengths, because the text can span the width of multiple fields. Leading and field height seldom fit neatly together as they do on a typographic grid.

Minimum margins

Helvetica Light, 10/13, 23-pica line length:
To choose a width of column which makes the text pleasant to read is one of the most important typographic problems. The width of the column must be proportioned to the size of the type.
—Josef Müller-Brockmann, *Grid systems*

Helvetica Light, 9/12, 15-pica line length:
To choose a width of column which makes the text pleasant to read is one of the most important typographic problems. The width of the column must be proportioned to the size of

Helvetica Light, 8/11, 15-pica line length:
To choose a width of column which makes the text pleasant to read is one of the most important typographic problems. The width of the column must be proportioned to the size of the type. —Josef Müller-

3. Using the basic grid

As with all grids in the modern style, elements align at the top and left of grid fields. When possible, elements should be drawn or cropped and scaled to fit the grid. In the example below, the first diagram was scaled to fit a single grid field; the second diagram is slightly smaller than a grid field—it was scaled to match the first diagram because of their similarity and proximity.

It is characteristic in the modern style to align the tops of text blocks and to leave the bottoms of the columns *ragged*; that is, to let information in columns end at a logical point rather than midthought. This is shown below. Were the bottoms of the columns aligned as well as the tops, a subhead would begin at the bottom of the first column.

1. Set up a basic 4-column grid on a standard 8 1/2-by-11 page. Show a range of possible text settings.

2. Set up a second grid on an 8 1/2-by-11 page that will accommodate 3-inch square photos. Determine settings for readable text on this grid, and create 3 layouts, each of which includes 2 square photos and about 250 words of text.

1

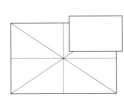

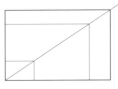

Construction Basics

Construction requires no calculation—only a straightedge and a compass or software with the equivalent drawing tools. Construction techniques are useful in layout and design, especially for the traditional style. Before beginning to do the constructions on the following pages, review these basics.

Subdividing with Diagonals

Diagonals subdivide a rectangle evenly, whatever its proportion. Diagonals intersect at the exact center of a rectangle. Using diagonals to find a center is often faster than measuring, expecially when a measurement is not evenly divided or requires rounding off.

Area vs. Length

By drawing vertical and horizontal lines through the center of a rectangle we divide each edge length in half, but divide the area into fourths. A photostat at 50 percent yields the same result—original lengths divided in half, and original area divided in fourths.

Comparing Proportions

Rectangles whose corners fall on the same diagonal have the same proportions. We can compare the proportions of rectangles, no matter how different they are in size, by using diagonals. This is useful in layout, since we often need to block out a space that represents a photograph. By first finding the diagonal of the original photo, we can then draw a rectangle in our layout that has the same diagonal. Pantographs work on this same principle, and they are used in layout for this same purpose.

Because text is the most critical element on the page and has the most specific requirements, it is logical that a grid be built around it. This approach to grids is consistent with modern design philosophy in that it allows form (the grid) to follow function (readability) rather than the other way around. Once a typographic grid is established, additional columns may be added for flexibility, but only as many as necessary.

The procedure for establishing a typographic grid may seem burdensome at first, but once grids are established for a range of text settings they can be modified and reused for different applications.

1. Set sample text

Find or develop sample text that meets readability requirements. It should have an even texture and color appropriate for the design, but it need not have an ideal line length. Use the text specimens provided by a typesetter if available or set your own. Text from magazines and brochures can be used as well if their text specifications can be determined.

2. Determine a line length range

Count characters in the specimen text as shown in the example below. Because we are seeking *average* line lengths, we determine the line length a little beyond 40 characters for a minimum line and 50 characters for a maximum line. Although 60 characters per line would be permissible on the basis of readability, longer lines are not as typical of the modern page, because they may require extra leading for readability. This means text will not be as compact.

Exercises

1. Find at least 6 examples of pages that you personally find readable. Once you have collected the samples, count the number of characters per line. Are there more or fewer characters per line than in the range specified here? Check your samples against the readability guidelines in book 2, chapter 4. How do your examples correspond to the guidelines?

2. Following the procedure presented here, create a typographic grid for an 8-inch square page, based on the text of your choice at its shortest possible line length. The grid should have from 25 to 35 fields. Also create a grid based on its longest line length.

3. Using one of these grids, redesign a traditional page from a book with a page size no larger than 6 by 9. The page should include at least one image in addition to the text. Include all of the information that appears on the original; work in the modern style.

4. Choose a page from a mail-order catalog that has a page size smaller than or equal to the page size you used for your grids. Use a grid you set up to create 3 layout variations of the catalog page. Include all of the information that is on the original, but modify it to suit your design.

|40 |50

Page structure provides a way of dividing space so that an infinite number of layout possibilities are reduced to a relative few. A structure of consistent subdivisions, consistently followed, provides an inherent balance between elements in a layout. The method we choose to use for creating structure affects, subtly or dramatically, the way the final page will look. Structure, no matter how simple or complex, is almost always apparent on the final page. Lack of structure is apparent as well. There are three key ways that we can subdivide the page. The simplest is segmentation, in which the page is subdivided into smaller areas. Within a segment there is no structure, and elements are placed at random within a segment. Segmentation assures a somewhat even distribution of elements. Segment lines are dividing lines. They do not provide specific positioning, but simply limit the area in which elements can be placed. Because segment lines define areas, these areas could be filled checkerboard style. While segmentation defines areas, it provides no exact position for elements. Positioning guides are another way to structure the page, and offer specific coordinates for positioning elements. Positioning guides, however, do not define space. The modern layout grid offers both segmentation and positioning. Segments called fields define space and are separated by intervals of space . The edges of the fields can act as positioning guides. It is most common to use the top left corner for positioning, but it is possible to use another corner as long as it is done consistently.

+50 characters: 16 picas

Helvetica Light, 8/12, FLRR

+40 characters: 12 picas

3. Establish the page frame

Determine the page size, then define minimum margins based on how the page will be used. The page shown below is a right-hand page; the left margin is an inside margin. The left-hand page would be a mirror image of this page.

4. Divide the vertical space

Fill the page with text. As shown below, text goes to the edge of the page—the minimum margins are drawn as reminders, not as final margins. Lines marking fields and intervals are drawn so that the top of a field touches the tops of ascenders and caps and the bottom of a field touches the bottoms of descenders. Fields usually contain 4 to 6 lines.

An interval is the distance from the tip of the descender in the line of type above the interval line to the top of the ascender in the line of type below it. Study the diagram below to see how this works. The interval, then, is determined by the specific text and leading settings used rather than by an arbitrary width. Changing the typeface, point size, or leading will change the heights of fields and intervals.

Page structure provides a way of dividing space so that an infinite number of layout possibilities are reduced to a relative few. A structure of consistent subdivisions, consistently followed, provides an inherent balance between elements in a layout. The method we choose to use for creating structure affects, subtly or dramatically, the way the final page will look. Structure, no matter how simple or complex, is almost always apparent on the final page. Lack of structure is apparent as well. There are three key ways that we can subdivide the page. The simplest is segmentation, in which the page is subdivided into smaller areas. Within a segment there is no structure, and elements are placed at random within a segment. Segmentation assures a somewhat even distribution of elements. Segment lines are dividing lines. They do not provide specific positioning, but simply limit the area in which elements can be placed. Because segment lines define areas, these areas could be filled checkerboard style. While segmentation defines areas, it provides no exact position for elements. Positioning guides are another way to structure the page, and offer specific coordinates for positioning elements. Positioning guides, however, do not define space. The modern layout grid offers both segmentation and positioning. Segments called fields define space and are separated by intervals of space . The edges of the fields can act as positioning guides. It is most common to use the top left corner for positioning, but it is possible to use another corner as long as it is done consistently. Page structure provides a way of dividing space so that an infinite number of layout possibilities are reduced to a relative few. A structure of consistent subdivisions, consistently followed, provides an inherent balance between elements in a layout. The method we choose to use for creating structure affects, subtly or dramatically, the way the final page will look. Structure, no matter how simple or complex, is almost always apparent on the final page. Lack of structure is apparent as well. There are three key ways that we can subdivide the page.

5. Determine field width

The grid on the page below is based on a 15-pica line length—the longest line that can be used to fit 2 columns on the page area shown within minimum margins. The grid on the next page is based on a minimum line length of 12 picas. Both use the text developed in step 1. Longer lines of type tend to create a horizontal stress on the page; shorter lines create a vertical stress.

6. Add columns as necessary

Once text requirements are met, additional columns can be created by subdividing text columns. In the example below, 4 columns have been created from a 2-column text grid; 1 column is just under 7 picas wide. In the example on the next page, 2 text columns were subdivided into 4 columns; the area within the minimum margins was wide enough to allow a fifth column to be added.

7. Adjust the aspect ratio

When a specific aspect ratio is desired, a grid can be adjusted by subdividing text columns or by adjusting the number of text lines per field. These options in combination will produce a wide range of aspect ratios. The aspect ratio of a single field is not the same as that of multiple fields, so the relative size of the desired aspect ratio should be considered when making these adjustments.

Structuring the page

Page structure provides a way of dividing space so that an infinite number of layout possibilities are reduced to a relative few. A structure of consistent subdivisions, consistently followed, provides an inherent balance between elements in a layout. The method we choose to use for creating structure affects, subtly or dramatically, the way the final page will look. Structure, no matter how simple or complex, is almost always apparent on the final page.

Lack of structure is apparent as well. There are three key ways that we can subdivide the page. The simplest is segmentation, in which the page is subdivided into smaller areas. Within a segment there is no structure, and elements are placed at random within a segment. Segmentation assures a somewhat even distribution of elements. Segment lines

Page structure provides a way of dividing space so that an infinite number of layout possibilities are reduced to a relative few. A structure of consistent subdivisions, consistently followed, provides an inherent balance between elements in a layout. The method we choose to use for creating structure affects, subtly or dramatically, the way the final page will look. Structure, no matter how simple or complex, is almost always apparent on the final page.

Lack of structure is apparent as well. There are three key ways that we can subdivide the page. The simplest is segmentation, in which the page is subdivided into smaller areas. Within a segment there is no structure, and elements are placed at random within a segment. Segmentation assures a somewhat even distribution of elements. Segment lines are dividing lines. They do not provide specific positioning, but simply limit the area in which elements

Comparing these grids

The 4-column grid (the grid on the previous page) can hold more words. Contrast and asymmetry are more difficult to achieve with a 4-column grid than with the 5-column grid below. The 5-column grid reserves space which will assure a minimum amount of contrast and asymmetry. The 4-column grid has fields with a horizontal stress, which will add to an overall horizontal feel to the page; the 5-column grid has a more vertical stress.

Leading restrictions

A typographic grid is based in part on leading. Leading must remain consistent throughout the text. No additional points of leading can be added between paragraphs. Instead, paragraphs can be indicated by a blank line between them, by the way in which lines end short, or by indents. Of these options, indents are the least modern. Grid, text, and leading are a whole, and one cannot be separated from the other.

Structuring the page

Page structure provides a way of dividing space so that an infinite number of layout possibilities are reduced to a relative few. A structure of consistent subdivisions, consistently followed, provides an inherent balance between elements in a layout. The method we choose to use for creating structure affects, subtly or dramatically, the way the final page will look. Structure, no matter how simple or complex, is almost always apparent on the final page.

Lack of structure is apparent as well. There are three key ways that we can subdivide the page. The simplest is segmentation, in which the page is subdivided into smaller areas. Within a segment there

Page structure provides a way of dividing space so that an infinite number of layout possibilities are reduced to a relative few. A structure of consistent subdivisions, consistently followed, provides an inherent balance between elements in a layout. The method we choose to use for creating structure affects, subtly or dramatically, the way the final page will look. Structure, no matter how simple or complex, is almost always apparent on the final page.

Lack of structure is apparent as well. There are three key ways that we can subdivide the page. The simplest is segmentation, in which the page is subdivided into smaller areas. Within a segment there is no structure, and elements are placed at random within a segment. Segmentation assures a somewhat even distribution of elements. Segment lines are dividing lines. They do not provide specific positioning, but simply limit the area in which elements can be placed. Because segment lines define areas, these areas could be filled checkerboard style. While segmentation defines areas, it provides no exact position for elements. Position-

Any grid can be used a variety of ways without breaking the basic rules for using a grid. Differences in the use of a grid arise because of the way in which the designer interprets emphasis, hierarchy, the relationship between elements, the grouping of elements, and the flow of information. All six lay-outs shown below and on the following pages use exactly the same grid and information (with the exception of the heading number, which changes in sequence with the variation.)

The first four variations are modern; the last two show traditional typography used on the same (modern) grid. Although the typeface is traditional, it is set to fit the grid. These are only a few of many layout variations possible with a single grid. An even wider diversity can be generated by making minor changes to the grid, such as altering the proportions of the fields.

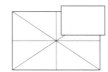
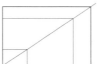

Construction Basics

Construction requires no calculation, only a straightedge and a compass or software with the equivalent drawing tools. Construction techniques are useful in layout and design, especially for the traditional style. Before beginning to do the constructions on the following pages, review these basics.

Subdividing with Diagonals
Diagonals subdivide a rectangle evenly, whatever its proportion. Diagonals intersect at the exact center of a rectangle. Using diagonals to find a center is often faster than measuring, expecially when a measurement is not evenly divided or requires rounding off.

Area vs. Length
By drawing vertical and horizontal lines through the center of a rectangle we divide each edge length in half, but divide the area into fourths. A photostat at 50 percent yields the same result—original lengths divided in half, and original area divided in fourths.

Comparing Proportions
Rectangles whose corners fall on the same diagonal have the same proportions. We can compare the proportions of rectangles, no matter how different they are in size, by using diagonals. This is useful in layout, since we often need to block out a space that represents a photograph. By first finding the diagonal of the original photo, we can then draw a rectangle in our layout that has the same diagonal. Pantographs work on this same principle, and they are used in layout for this same purpose.

Variation 1 (opposite)
The number and diagrams have dominance because they are isolated at the top of the page. The number acts as a graphic element, as well as being informational. Both the diagrams and the number are a single grid field high. The layout is nonlinear: the viewer can begin at the number and either scan across the top of the page or read down to the heading and across to the text.

Variation 2
This page has a diagonal emphasis that is achieved primarily because columns are broken so that they become progressively longer. The strong diagonal emphasis tends to direct the eye from the number at the top left to the diagrams at the bottom right rather than to the first column of text.

2 | Construction Basics

Construction requires no calculation, only a straightedge and a compass or software with the equivalent drawing tools. Construction techniques are useful in layout and design, especially for the traditional style. Before beginning to do the constructions on the following pages, review these basics.

Subdividing with Diagonals: Diagonals subdivide a rectangle evenly, whatever its proportion. Diagonals intersect at the exact center of a rectangle. Using diagonals to find a center is often faster than measuring, expecially when a measurement is not evenly divided or requires rounding off.

Area vs. Length: By drawing vertical and horizontal lines through the center of a rectangle we divide each edge length in half, but divide the area into fourths. A photostat at 50 percent yields the same result– original lengths divided in half, and original area divided in fourths.

Comparing Proportions: Rectangles whose corners fall on the same diagonal have the same proportions. We can compare the proportions of rectangles, no matter how different they are in size, by using diagonals. This is useful in layout, since we often need to block out a space that represents a photograph. By first finding the diagonal of the original photo, we can then draw a rectangle in our layout that has the same diagonal. Pantographs work on this same principle, and they are used in layout for this same purpose.

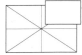 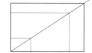

Variation 3

This layout is very linear in nature. The introductory text has been separated from the descriptions and placed in a box with the number and heading, both of which have been given considerably less emphasis than in the first 2 variations. The descriptions, as defined by the subheads, are fit into a single column.

An additional but perhaps unnecessary diagram has been added for consistency, and each diagram is aligned to the grid near the text that describes it. A conflict arises: if linearity is to be preserved, each diagram must align with appropriate text. If the grid is to be preserved, however, each diagram must align with the grid. This is an example of how linear layout conflicts with the structured modern page.

3 Construction Basics

Construction requires no calculation, only a straightedge and a compass or software with the equivalent drawing tools. Construction techniques are useful in layout and design, especially for the traditional style. Before beginning to do the constructions on the following pages, review these basics.

Subdividing with Diagonals: Diagonals subdivide a rectangle evenly, whatever its proportion. Diagonals intersect at the exact center of a rectangle. Using diagonals to find a center is often faster than measuring, expecially when a measurement is not evenly divided or requires rounding off.

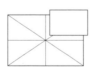

Area vs. Length: By drawing vertical and horizontal lines through the center of a rectangle we divide each edge length in half, but divide the area into fourths. A photostat at 50 percent yields the same result– original lengths divided in half, and original area divided in fourths.

Comparing Proportions: Rectangles whose corners fall on the same diagonal have the same proportions. We can compare the proportions of rectangles, no matter how different they are in size, by using diagonals. This is useful in layout, since we often need to block out a space that represents a photograph. By first finding the diagonal of the original photo, we can then draw a rectangle in our layout that has the same diagonal. Pantographs work on this same principle, and they are used in layout for this same purpose.

Variation 4
In this layout, the heading contrasts so much with the other elements and the page that it is likely to be the first element you see, even though it is last in sequence. The eye is also attracted to the bottom of the page because the diagram is located there.

In variation 3 a diagram was added; in variation 4, diagrams have been combined into a single diagram.
It is about the width of two grid fields. The wide left margin helps keep the layout asymmetrical even though the text, diagram, and heading are compactly grouped.

Construction requires no calculation, only a straightedge and a compass or software with the equivalent drawing tools. Construction techniques are useful in layout and design, especially for the traditional style. Before beginning to do the constructions on the following pages, review these basics.

Subdividing with Diagonals
Diagonals subdivide a rectangle evenly, whatever its proportion. Diagonals intersect at the exact center of a rectangle. Using diagonals to find a center is often faster than measuring, expecially when a measurement is not evenly divided or requires rounding off.

Area vs. Length
By drawing vertical and horizontal lines through the center of a rectangle we divide each edge length in half, but divide the area into fourths. A photostat at 50 percent yields the same result—original lengths divided in half, and original area divided in fourths.

Comparing Proportions
Rectangles whose corners fall on the same diagonal have the same proportions. We can compare the proportions of rectangles, no matter how different they are in size, by using diagonals. This is useful in layout, since we often need to block out a space that represents a photograph. By first finding the diagonal of the original photo, we can then draw a rectangle in our layout that has the same diagonal. Pantographs work on this same principle, and they are used in layout for this same purpose.

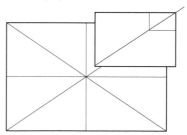

4 **Construction Basics**

Variation 5

At first glance this layout may not seem to use the same grid as the last 4. This is because traditional rather than modern typography and layout principles have been applied to the modern structure. The traditional typeface has been set on the same leading, but it is 1 point size larger to compensate for the smaller x-height.

Positions for the heading and text were determined by the grid. The diagrams have been placed by their relationships to the text rather than by the grid. Because each is one grid field high, and the height of the grid fields corresponds to the text leading, they fit easily into the text.

Contrast and asymmetry have been minimized, and details such as the small caps help give this layout a traditional flavor despite a modern structure.

Variation 6 (opposite)

This layout is based on the same grid as used for the previous layouts, and the same traditional typeface and size has been used as in variation 5. An even texture was difficult to achieve because text was justified on a short line length. The text and heading are positioned on the grid, but the diagrams have been centered within the text columns without regard for any other structure except the writing.

5 : Construction Basics

CONSTRUCTION REQUIRES NO CALCULATION, only a straightedge and a compass or software with the equivalent drawing tools. Construction techniques are useful in layout and design, especially for the traditional style. Before beginning to do the constructions on the following pages, review these basics.

Subdividing with Diagonals: Diagonals subdivide a rectangle evenly, whatever its proportion. Diagonals intersect at the exact center of a rectangle. Using diagonals to find a center is often faster than measuring, expecially when a measurement is not evenly divided or requires rounding off.

Area vs. Length: By drawing vertical and horizontal lines through the center of a rectangle we divide each edge length in half, but divide the area into fourths. A photostat at 50 percent yields the same result—original lengths divided in half, and original area divided in fourths.

Comparing Proportions: Rectangles whose corners fall on the same diagonal have the same proportions. We can compare the proportions of rectangles, no matter how different they are in size, by using diagonals. This is useful in layout, since we often need to block out a space that represents a photograph. By first finding the diagonal of the original photo, we can then draw a rectangle in our layout that has the same diagonal. Pantographs work on this same principle, and they are used in layout for this same purpose.

1. Evaluate each of these 6 variations on a scale of 1 to 10 (10 being the best) on each of the following criteria: visual interest; readability; appropriate hierarchy for the information; easiest to scan for information; easiest to associate text with appropriate diagram; best application of design principles.

2. Create your own set of at least 4 variations on the grid you developed for topic 9, exercise 2. Evaluate your variations on the criteria listed in exercise 1.

4. Collect a set of at least 12 variations for a single category (e.g., tables of contents, chapter openings in novels, technical specifications for cars or electronic products, etc.) Evaluate them in terms of structure and style.

5. Find related printed pieces (e.g., data sheet and product brochure). Determine whether they use a grid and whether it is the same grid.

6. Apply what you have learned about using grids from this series of exercises to the redesign of a page from a textbook or technical journal. Be sure to include all of the information presented on the original page.

6: CONSTRUCTION BASICS

Construction requires no calculation, only a straightedge and a compass or software with the equivalent drawing tools. Construction techniques are useful in layout and design, especially for the traditional style. Before beginning to do the constructions on the following pages, review these basics.

Subdividing with Diagonals: Diagonals subdivide a rectangle evenly, whatever its proportion. Diagonals intersect at the exact center of a rectangle. Using diagonals to find a center is often faster than measuring, expecially when a measurement is not evenly divided or requires rounding off.

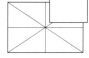

Area vs. Length: By drawing vertical and horizontal lines through the center of a rectangle we divide each edge length in half, but divide the area into fourths. A photostat at 50 percent yields the same result —original lengths divided in half, and original area divided in fourths.

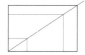

Comparing Proportions: Rectangles whose corners fall on the same diagonal have the same proportions. We can compare the proportions of rectangles, no matter how different they are in size, by using diagonals. This is useful in layout, since we often need to block out a space that represents a photograph. By first finding the diagonal of the original photo, we can then draw a rectangle in our layout that has the same diagonal. Pantographs work on this same principle, and they are used in layout for this same purpose.

The following two examples both use the same information presented in the previous six examples, but the page shape has been changed to more traditional proportions, and the structure has been changed to traditional constructed margins. These two examples show traditional and modern typography on a traditional structure; linearity is an integral part of such a structure.

Variation 1
This traditional typography has a characteristic light color and even texture, which is reflected in the diagrams, subheads, and headings. The only contrast on the page is provided by the wide margins and the initial cap marking the beginning of the text.

The unity achieved on a traditional page is fragile: if the texture is broken by uneven leading or spacing, if elements are too large or too bold, or if the diagrams are placed out of balance with the page's symmetry, for example, the effectiveness of the style is lost. No page structure exists for positioning elements except margins and text.

1 : CONSTRUCTION BASICS

CONSTRUCTION REQUIRES NO CALCULATION, only a straightedge and a compass or software with the equivalent drawing tools. Construction techniques are useful in layout and design, especially for the traditional style. Before beginning to do the constructions on the following pages, review these basics.

Subdividing with Diagonals: Diagonals subdivide a rectangle evenly, whatever its proportion. Diagonals intersect at the exact center of a rectangle. Using diagonals to find a center is often faster than measuring, expecially when a measurement is not evenly divided or requires rounding off.

Area vs. Length: By drawing vertical and horizontal lines through the center of a rectangle we divide each edge length in half, but divide the area into fourths. A photostat at 50 percent yields the same result—original lengths divided in half, and original area divided in fourths.

Comparing Proportions: Rectangles whose corners fall on the same diagonal have the same proportions. We can compare the proportions of rectangles, no matter how different they are in size, by using diagonals. This is useful in layout, since we often need to block out a space that represents a photograph. By first finding the diagonal of the original photo, we can then draw a rectangle in our layout that has the same diagonal. Pantographs work on this same principle, and they are used in layout for this same purpose.

Variation 2

Although the structure of this page remains traditional, the typography is modern, with characteristically tight leading and kerning. Headings are bold and the right margin is ragged. As the structure offers no guidance for the placing of diagrams, spacing between elements is adjusted by leading or simply by eye. The text is broken into groups by the extra space that has been added before the subheads. This space in conjunction with the bold type provide contrast on the page. Nevertheless, the subtle spacing and proportioning provided by a grid is missing; the page remains relatively passive.

1. Find at least 6 examples of traditionally structured pages, and determine whether the type used on them is modern, traditional, or a combination of the two.

2. Find a traditional page with traditional type and redesign it with modern type. Use the same structure and page size as on the original.

3. Find a page of modern type and redesign it with traditional type. Use the same structure and page size as the original.

4. After completing exercises 2 and 3, answer the following: Which is more space efficient, modern or traditional typography? Why? Which was easier for you to work with, modern or traditional? Was it easier because you liked it better, because you were already familiar with it, or because that style is just naturally easier to use?

1: Construction Basics

Construction requires no calculation, only a straightedge and a compass or software with the equivalent drawing tools. Construction techniques are useful in layout and design, especially for the traditional style. Before beginning to do the constructions on the following pages, review these basics.

Subdividing with Diagonals

Diagonals subdivide a rectangle evenly, whatever its proportion. Diagonals intersect at the exact center of a rectangle. Using diagonals to find a center is often faster than measuring, especially when a measurement is not evenly divided or requires rounding off.

Area vs. Length

By drawing vertical and horizontal lines through the center of a rectangle we divide each edge length in half, but divide the area into fourths. A photostat at 50 percent yields the same result— original lengths divided in half, and original area divided in fourths.

Comparing Proportions

Rectangles whose corners fall on the same diagonal have the same proportions. We can compare the proportions of rectangles, no matter how different they are in size, by using diagonals. This is useful in layout, since we often need to block out a space that represents a photograph. By first finding the diagonal of the original photo, we can then draw a rectangle in our layout that has the same diagonal. Pantographs work on this same principle, and they are used in layout for this same purpose.

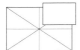 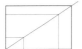

Each of the six ads shown here is a different solution for the same design problem. Each applies some of the characteristics of the modern and traditional styles. These ads represent only a few of the many possible typographic solutions.

Each of these ads can be described in typographic and layout terms, as well as from the point of view of design principles. Because such descriptions are independent of our subjective responses, they help us to analyze both what we create and what we would like to emulate. It is often through such analysis that we gain an understanding of how a design is structured and how to create (or recreate) a satisfactory design solution.

Exercises

1. In which of these ads has attraction been given precedence over readability? How and why?

2. Which of these ads would you classify as traditional? Which would you classify as modern? What key factors can help you decide?

3. Recreate one of these ads to fit an area with an aspect ratio of 3:5 or 5:3 (i.e., vertical or horizontal). How much does the shape of the space influence the design?

4. Design a seventh ad that is not like any of these, using the same information, size, and area shown here. In what ways does it differ? In what ways is it the same?

5. If you are working with the files on the disk and have the fonts indicated, copy one of the ads and do a series of variations as follows: change the leading; change the point size; change the line length; change the typeface. Which changes had the most impact? Which of these ads required the most fine tuning and minor adjustments to make it perfect?

TYPOGRAPHY WORKSHOP

A PRINCIPAL ELEMENT WITH WHICH GRAPHIC DESIGNERS WORK, TYPOGRAPHY FUNCTIONS BOTH AS THE VISUALIZATION OF LANGUAGE AND AS A DESIGN ELEMENT. THIS WORKSHOP OFFERS A PROGRESSIVE SERIES OF PROJECTS AND EXERCISES TO HELP STUDENTS DEFINE AND WORK WITH TYPOGRAPHY, INCLUDING STRUCTURED AND UNSTRUCTURED TYPOGRAPHIC LAYOUTS, EXPERIMENTAL LETTERFORMS, READABILITY ISSUES, AND TYPOGRAPHIC EXPRESSION. OFFERED BY THE UNIVERSITY OF CALIFORNIA SANTA CRUZ EXTENSION, THE WORKSHOP BEGINS OCTOBER 17TH. FOR MORE INFORMATION, PLEASE CALL THE EXTENSION OFFICE AT (408) 429-2971.

A principal element with which graphic designers work, typography functions both as the visualization of language and as a design element. this workshop offers a progressive series of projects and exercises to help students define and work with typography, including structured and unstructured typographic layouts, experimental letterforms, readability issues, and typographic expression. The workshop begins October 17th. For more information, call the University of California Extension at (408) 429-2971.

typography workshop

Top: Palatino
Bottom: Helvetica (lLight and Black)

Example 1 (top left)

Begins October 17 **Typography Workshop**

A principal element with which graphic designers work, typography functions both as the visualization of language and as a design element. This workshop offers a progressive series of projects and exercises to help students define and work with typography, including structured and unstructured typographic layouts, experimental letterforms, readability issues, and typographic expression. For more information, call (408) 429-2971.

University of California **Santa Cruz Extension**

Example 2 (top right)

Begins October 17th

TYPOGRAPHY WORKSHOP

A principal element with which graphic designers work, typography functions both as the visualization of language and as a design element. This workshop offers a progressive series of projects and exercises to help students define and work with typography, including structured and unstruct-ur ed typographic layouts, experimental letter-forms, readability issues, and typograph-ic expression. For more informa-tion, call the University of California Santa Cruz Extension at (408) 429-2971

◆

Example 3 (bottom left)

A PRINCIPAL ELEMENT WITH WHICH GRAPHIC

TYPOGRAPHY WORKSHOP

DESIGNERS WORK, TYPOGRAPHY FUNCTIONS

BOTH AS THE VISUALIZATION OF LANGUAGE

SANTA CRUZ EXTENSION

AND AS A DESIGN ELEMENT. THIS WORKSHOP

OFFERS A PROGRESSIVE SERIES OF PROJECTS

UNIVERSITY OF CALIFORNIA

AND EXERCISES TO HELP STUDENTS DEFINE AND

WORK WITH TYPOGRAPHY, INCLUDING STRUC-

BEGINS OCTOBER 17TH

TURED AND UNSTRUCTURED TYPOGRAPHIC LAY-

OUTS, EXPERIMENTAL LETTERFORMS, READABILITY

CALL [408] 429-2971

ISSUES, AND TYPOGRAPHIC EXPRESSION.

Example 4 (bottom right)

Typography Workshop

A principal element with which graphic designers work, typography functions both as the visualization of language and as a design element. This workshop offers a progressive series of projects and exercises to help students define and work with typography, including structured and unstructured typographic layouts, experimental letterforms, readability issues, and typographic expression.
The workshop begins October 17th. For more information, call University of California Santa Cruz Extension at (408) 429-2971.

Top: Univers Condensed
Bottom: Futura

Top: Janson
Bottom: Frutiger

Graphic elements serve not merely to decorate the page, but to direct the eye and to help us differentiate levels in a hierarchy. When adding graphic elements we must strike a balance between unity and variety—too much unity and graphic elements do not attract the eye; too much variety and they serve to distract the eye rather than to direct it.

All of the variations shown here have exactly the same type and layout; the only elements changed are the graphic elements. All of these graphic elements could be created with typesetting equipment, and they are only a few of many variations possible without modifying the size and position of the type itself. It is useful to think about the graphic elements when planning the type, however, so that appropriate leading is established.

Exercises

1. Evaluate each of these variations on a scale of one to ten (ten being the best) on how well the graphic elements reinforce the relative importance of headings, direct the eye, enhance communication, and use modern design principles. On the basis of this objective evaluation, which is best? Does this agree with your subjective judgment (taste)?

2. To which of these variations could you easily and logically add a third hierarchical level higher than those levels shown? Lower than those levels shown? To which of these variations would it be difficult or impossible to add more levels?

3. Which of the examples shown here could be readily adapted to a multiple-column page? Which ones could not?

4. Apply one of these variations to some other text. Compare it to the original, and look for differences in the width and length of the graphic element and the proximity of that element to the type. What changed? Was the change intentional, and if so, why?

5. Add a third hierarchical level to the same text you used in exercise 4 and add graphic elements to all three levels to reinforce the hierarchy. Use either one of the variations shown here or develop your own graphic elements.

Typography Workshop

A principal element with which graphic designers work, typography functions both as the visualization of language and as a design element. This workshop offers a progressive series of projects and exercises to help students define and work with typography, including structured and unstructured typographic layouts, experimental letterforms, readability issues, and typographic expression.

Enrollment

The workshop begins October 17th. For more information, call University of California Santa Cruz Extension at (408) 429-2971.

Typography Workshop

A principal element with which graphic designers work, typography functions both as the visualization of language and as a design element. This workshop offers a progressive series of projects and exercises to help students define and work with typography, including structured and unstructured typographic layouts, experimental letterforms, readability issues, and typographic expression.

Enrollment

The workshop begins October 17th. For more information, call University of California Santa Cruz Extension at (408) 429-2971.

Typography Workshop

A principal element with which graphic designers work, typography functions both as the visualization of language and as a design element. This workshop offers a progressive series of projects and exercises to help students define and work with typography, including structured and unstructured typographic layouts, experimental letterforms, readability issues, and typographic expression.

Enrollment

The workshop begins October 17th. For more information, call University of California Santa Cruz Extension at (408) 429-2971.

Typography Workshop

A principal element with which graphic designers work, typography functions both as the visualization of language and as a design element. This workshop offers a progressive series of projects and exercises to help students define and work with typography, including structured and unstructured typographic layouts, experimental letterforms, readability issues, and typographic expression.

Enrollment

The workshop begins October 17th. For more information, call University of California Santa Cruz Extension at (408) 429-2971.

Typography Workshop

A principal element with which graphic designers work, typography functions both as the visualization of language and as a design element. This workshop offers a progressive series of projects and exercises to help students define and work with typography, including structured and unstructured typographic layouts, experimental letterforms, readability issues, and typographic expression.

Enrollment

The workshop begins October 17th. For more information, call University of California Santa Cruz Extension at (408) 429-2971.

Typography Workshop

A principal element with which graphic designers work, typography functions both as the visualization of language and as a design element. This workshop offers a progressive series of projects and exercises to help students define and work with typography, including structured and unstructured typographic layouts, experimental letterforms, readability issues, and typographic expression.

Enrollment

The workshop begins October 17th. For more information, call University of California Santa Cruz Extension at (408) 429-2971.

The page shown below is an outstanding example of traditional typesetting. This is not due to any single characteristic, such as typeface or symmetry, but rather to the way in which all of the typesetting and layout factors have been combined.

The example on the next page, created with desktop technology, uses a typeface that is less Gothic in character; nevertheless, by copying the relative sizes and spacing of the elements as closely as possible, a very pleasing traditional page has been created.

Recreating outstanding work is a classic way of learning, reminiscent of art students who learn painting by copying the work of old masters. Copying is also an excellent way to learn firsthand about design and typography, whether modern or traditional. It provides insight and allows us to practice analytical skills. Copying teaches many of the things one cannot learn except through observation and practice. The more we observe, the more we see and the better our visual skills become.

Boccacio's *Life of Dante* by John Henry Nash (San Francisco, 1916).

LIFE OF DANTE

GIOVANNI BOCCACCIO'S ENCOMIUM ON DANTE OR "TRATTATELLO IN LAUDE DI DANTE" [COMMONLY KNOWN AS THE LIFE OF DANTE]. TRANSLATED FROM THE ITALIAN BY PHILIP HENRY WICKSTEED, M.A.

I

SOLON, whose bosom was reputed a human temple of divine wisdom, and whose most sacred laws still stand as an illustrious witness of ancient justice to the men of to-day, was often wont to say (as some affirm) that every Commonwealth must go or stand upon two feet, like as do we ourselves; of which, with ripe sagacity, he declared the right foot to be the allowing of no fault that had been committed to go unpunished, and the left the rewarding of every good deed; whereto he added that if either of the two feet were withdrawn by vice or negligence, or were less than well preserved, without doubt that Commonwealth which so fared must needs go halt; and if by ill chance it should be faulty in both the two, we must hold it as most certain that it would have no power to stand up in any fashion. Moved then by this so praiseworthy and so clearly true opinion, many excellent and ancient peoples did honour to men of worth, sometimes by deifying them, sometimes by a marble statue, often by illustrious obsequies, and sometimes by a triumphal arch, or again by a laurel crown, according to the deserts that had preceded. The punishments, on the other hand, inflicted on the guilty I care not to rehearse. Furthered by which honours and purgings, Assyria, Macedonia, Greece, and lastly the Roman Commonwealth, reached the ends of the earth with their achievements, and the stars with their fame. But the footprints which they left in so lofty examples have not only been ill followed by their successors of the present day, and most of all by my own Florentines, but have been so far departed from that ambition has got hold of every reward that belongs

Exercises

1. Compare the two pages shown here. In what ways do they differ? In what ways are they the same? Create a third version, using a modern typeface such as Helvetica or Futura. Be as accurate as possible with size and spacing. How does it compare to the others?
2. Recreate a page from a book or magazine, using the specifications given for the layout below.

3. Find an example of a traditional hierarchy in a book or brochure, determine the type specifications for the title, subtitle, and text, and apply those specifications to the page below. How does the new page differ?
4. Find an example of good traditional typography and copy it. What was the most difficult aspect to copy accurately? Do the same with a modern example. Which style was easier to do? Why?

Type specifications:
Goudy, set justified and unkerned on a 26-pica line length.
Title: 44/41
Subtitle: 12/14
Text: 11/14
Initial cap: 53/53

LIFE OF DANTE

GIOVANNI BOCCACCIO'S ENCOMIUM ON DANTE OR "TRATTATELLO IN LAUDE DI DANTE" [COMMONLY KNOWN AS THE LIFE OF DANTE]. TRANSLATED FROM THE ITALIAN BY PHILIP HENRY WICKSTEED, M.A.

❖

SOLON, whose bosom was reputed a human temple of divine wisdom, and whose most sacred laws still stand as an illustrious witness of ancient justice to the men of to-day, was often wont to say (as some affirm) that every Commonwealth must go or stand upon two feet, like as do we ourselves; of which, with ripe sagacity, he declared the right foot to be the allowing of no fault that had been committed to go unpunished, and the left the rewarding of every good deed; whereto he added that if either of the two feet were withdrawn by vice or negligence, or were less than well preserved, without doubt that Commonwealth which so fared must needs go halt; and if by ill chance it should be faulty in both the two, we must hold it as most certain that it would have no power to stand up in any fashion. Moved then by this so praiseworthy and so clearly true opinion, many excellent and ancient peoples did honour to men of worth, sometimes by deifying them, sometimes by a marble statue, often by illustrious obsequies, and sometimes by a triumphal arch, or again by a laurel crown, according to the deserts that had preceded. The punishments, on the other hand inflicted on the guilty I care not to rehearse. Furthered by which honours and purgings, Assyria, Macedonia, Greece, and lastly the Roman Commonwealth, reached the ends of the earth with their achievements, and the stars with their fame. But the footprints which they left in so lofty examples have not only been ill followed by their successors of the present day, and most of all by my own Florentines, but have been so

One of the more common reasons given for compromising style and design is to fit more text on the page. Traditional pages with overly narrow margins and modern pages with no white space are often the result. In addition to rethinking a layout when fit is a problem, text can also be modified in a number of ways to save space. Although the amount of space saved in a single column may seem minimal, it may make a considerable difference over the length of a document.

Each of the eleven paragraphs in this series reflect differences in text setting and show the relative effectiveness of each on the overall length. The specification noted at the top of each column is the only variable that has been changed; each text column has a different look because of that change.

Exercises

1. Which of these paragraphs is the most unlike the others? What is different about it? In which style would you classify it?

2. Read segments from each paragraph, then choose the 2 that you find the easiest to read. Which 2 are the most difficult to read? Which factor—typeface, kerning, leading, or point size—do you consider the most critical to readability based on these examples?

3. Copy a page from your favorite novel. Using the traditional style, set it at least 3 different ways, changing only 1 specification at a time. Which specifications did you find most appropriate to change?

4. Set the same page at least 3 different ways again, this time using the modern style. Which specifications did you find most appropriate to change?

5. In your judgment, which of the 11 columns of type in this series look the most like the typesetting in old books and which looks the most like modern typesetting technology?

Original:

The English visitor to Rome, if he has any familiarity with letter forms, cannot fail to be struck with the consistent quality of the architectural lettering which he sees on many of the late 16th, 17th and 18th century buildings. It is a letter which fits his preconceptions about roman lettering in a way that may not at first be easy to define. The proportions are close to those of the one ancient inscription with which he has more than a vague acquaintance: the tablet on the base of the column of Trajan in the same city. This will not strike him as unusual, for the teaching of lettering in England has for many years tended to suggest that the Trajan inscription is at once a representative and a supreme example of the inscriptional lettering of ancient Rome. It is only when he examines inscriptional lettering elsewhere in Italy and Europe that it may occur to him that it is only in 20th century England and 16th century Rome that the lettering on the Trajan column has been selected as a standard roman letter. (James Mosley)

This sample text is the point of departure. Each typesetting modification introduced in the 10 examples that follow will reduce the amount of space used by this text to a greater or lesser degree. Each will have some impact on the color, shape, proportion, texture, and readability of the text.

Specifications:
Janson text, 10/15, FLRR, unkerned, 15 picas wide, 31.25 picas deep.

Kerning:

The English visitor to Rome, if he has any familiarity with letter forms, cannot fail to be struck with the consistent quality of the architectural lettering which he sees on many of the late 16th, 17th and 18th century buildings. It is a letter which fits his preconceptions about roman lettering in a way that may not at first be easy to define. The proportions are close to those of the one ancient inscription with which he has more than a vague acquaintance: the tablet on the base of the column of Trajan in the same city. This will not strike him as unusual, for the teaching of lettering in England has for many years tended to suggest that the Trajan inscription is at once a representative and a supreme example of the inscriptional lettering of ancient Rome. It is only when he examines inscriptional lettering elsewhere in Italy and Europe that it may occur to him that it is only in 20th century England and 16th century Rome that the lettering on the Trajan column has been selected as a standard roman letter. (James Mosley)

Kerning reduces the spaces between letters so more letters fit on a line. The typeface, the length of the line, and the way in which words break will influence how much effect kerning has overall. Kerning that is too tight often impedes readability by obscuring the rapid and automatic recognition of the letters.

Specifications:
Janson text, 10/15, FLRR, kerned,
15 picas wide, 28.75 picas deep.

Leading:

The English visitor to Rome, if he has any familiarity with letter forms, cannot fail to be struck with the consistent quality of the architectural lettering which he sees on many of the late 16th, 17th and 18th century buildings. It is a letter which fits his preconceptions about roman lettering in a way that may not at first be easy to define. The proportions are close to those of the one ancient inscription with which he has more than a vague acquaintance: the tablet on the base of the column of Trajan in the same city. This will not strike him as unusual, for the teaching of lettering in England has for many years tended to suggest that the Trajan inscription is at once a representative and a supreme example of the inscriptional lettering of ancient Rome. It is only when he examines inscriptional lettering elsewhere in Italy and Europe that it may occur to him that it is only in 20th century England and 16th century Rome that the lettering on the Trajan column has been selected as a standard roman letter. (James Mosley)

Leading saves a significant amount of space but changes the color and texture just as significantly. Overly tight leading may interfere with readability. Shorter lines of type can be leaded more tightly than longer ones.

Specifications:
Janson text, 10/13, FLRR, unkerned,
15 picas wide, 27 picas deep.

Justification:

The English visitor to Rome, if he has any familiarity with letter forms, cannot fail to be struck with the consistent quality of the architectural lettering which he sees on many of the late 16th, 17th and 18th century buildings. It is a letter which fits his preconceptions about roman lettering in a way that may not at first be easy to define. The proportions are close to those of the one ancient inscription with which he has more than a vague acquaintance: the tablet on the base of the column of Trajan in the same city. This will not strike him as unusual, for the teaching of lettering in England has for many years tended to suggest that the Trajan inscription is at once a representative and a supreme example of the inscriptional lettering of ancient Rome. It is only when he examines inscriptional lettering elsewhere in Italy and Europe that it may occur to him that it is only in 20th century England and 16th century Rome that the lettering on the Trajan column has been selected as a standard roman letter. (James Mosley)

Justification reduces the length of a column by using all the space on every line of type. If a line length is too short, justification may cause an uneven texture or excessive hyphenation, both of which affect readability.

Specifications:
Janson text, 10/15, justified, unkerned, 15 picas wide, 30 picas deep.

Typeface:

The English visitor to Rome, if he has any familiarity with letter forms, cannot fail to be struck with the consistent quality of the architectural lettering which he sees on many of the late 16th, 17th and 18th century buildings. It is a letter which fits his preconceptions about roman lettering in a way that may not at first be easy to define. The proportions are close to those of the one ancient inscription with which he has more than a vague acquaintance: the tablet on the base of the column of Trajan in the same city. This will not strike him as unusual, for the teaching of lettering in England has for many years tended to suggest that the Trajan inscription is at once a representative and a supreme example of the inscriptional lettering of ancient Rome. It is only when he examines inscriptional lettering elsewhere in Italy and Europe that it may occur to him that it is only in 20th century England and 16th century Rome that the lettering on the Trajan column has been selected as a standard roman letter. (James Mosley)

Because typeface designs vary so much in their proportions, a change of typeface may significantly add or subtract from the overall length of text.

Specifications:
Goudy 10/15, FLRR, unkerned, 15 picas wide, 30 picas deep.

Point size:

The English visitor to Rome, if he has any familiarity with letter forms, cannot fail to be struck with the consistent quality of the architectural lettering which he sees on many of the late 16th, 17th and 18th century buildings. It is a letter which fits his preconceptions about roman lettering in a way that may not at first be easy to define. The proportions are close to those of the one ancient inscription with which he has more than a vague acquaintance: the tablet on the base of the column of Trajan in the same city. This will not strike him as unusual, for the teaching of lettering in England has for many years tended to suggest that the Trajan inscription is at once a representative and a supreme example of the inscriptional lettering of ancient Rome. It is only when he examines inscriptional lettering elsewhere in Italy and Europe that it may occur to him that it is only in 20th century England and 16th century Rome that the lettering on the Trajan column has been selected as a standard roman letter. (James Mosley)

Line length:

The English visitor to Rome, if he has any familiarity with letter forms, cannot fail to be struck with the consistent quality of the architectural lettering which he sees on many of the late 16th, 17th and 18th century buildings. It is a letter which fits his preconceptions about roman lettering in a way that may not at first be easy to define. The proportions are close to those of the one ancient inscription with which he has more than a vague acquaintance: the tablet on the base of the column of Trajan in the same city. This will not strike him as unusual, for the teaching of lettering in England has for many years tended to suggest that the Trajan inscription is at once a representative and a supreme example of the inscriptional lettering of ancient Rome. It is only when he examines inscriptional lettering elsewhere in Italy and Europe that it may occur to him that it is only in 20th century England and 16th century Rome that the lettering on the Trajan column has been selected as a standard roman letter. (James Mosley)

A smaller point size fits more characters per line. This example uses only one point size smaller, yet makes considerable difference in length. Because new designers, particularly those using desktop technology, tend to set or specify type considerably larger than it needs to be for readability, point size can generally be reduced without losing readability.

Specifications:
Janson text, 9/15, FLRR, unkerned, 15 picas wide, 27.5 picas deep.

The impact of changing the line length will depend on how many line breaks change, which depends on the text. Often changing the line length by only a few points will shorten a column considerably. Often the reader will not even be aware of such changes.

Specifications:
Janson text, 10/15, FLRR, unkerned, 16 picas wide, 28.75 picas deep.

Kerning and leading:

The English visitor to Rome, if he has any familiarity with letter forms, cannot fail to be struck with the consistent quality of the architectural lettering which he sees on many of the late 16th, 17th and 18th century buildings. It is a letter which fits his preconceptions about roman lettering in a way that may not at first be easy to define. The proportions are close to those of the one ancient inscription with which he has more than a vague acquaintance: the tablet on the base of the column of Trajan in the same city. This will not strike him as unusual, for the teaching of lettering in England has for many years tended to suggest that the Trajan inscription is at once a representative and a supreme example of the inscriptional lettering of ancient Rome. It is only when he examines inscriptional lettering elsewhere in Italy and Europe that it may occur to him that it is only in 20th century England and 16th century Rome that the lettering on the Trajan column has been selected as a standard roman letter. (James Mosley)

Typeface and leading:

The English visitor to Rome, if he has any familiarity with letter forms, cannot fail to be struck with the consistent quality of the architectural lettering which he sees on many of the late 16th, 17th and 18th century buildings. It is a letter which fits his preconceptions about roman lettering in a way that may not at first be easy to define. The proportions are close to those of the one ancient inscription with which he has more than a vague acquaintance: the tablet on the base of the column of Trajan in the same city. This will not strike him as unusual, for the teaching of lettering in England has for many years tended to suggest that the Trajan inscription is at once a representative and a supreme example of the inscriptional lettering of ancient Rome. It is only when he examines inscriptional lettering elsewhere in Italy and Europe that it may occur to him that it is only in 20th century England and 16th century Rome that the lettering on the Trajan column has been selected as a standard roman letter. (James Mosley)

The tight kerning and leading have squeezed all of the extra space out of the text, making the color considerably darker and the texture considerably denser. Such compactness is best set on a short line length.

Specifications:
Janson text, 10/12, FLRR, kerned, 15 picas wide, 23 picas deep.

A typeface with a smaller letter design can be set on tighter leading without the text seeming crowded or dark. Each combination creates a different color. Often changing the leading only a point will make a significant difference.

Specifications:
Goudy, 10/13, FLRR, unkerned, 15 picas wide, 26.25 picas deep.

Point size, leading, and justification:

The English visitor to Rome, if he has any familiarity with letter forms, cannot fail to be struck with the consistent quality of the architectural lettering which he sees on many of the late 16th, 17th and 18th century buildings. It is a letter which fits his preconceptions about roman lettering in a way that may not at first be easy to define. The proportions are close to those of the one ancient inscription with which he has more than a vague acquaintance: the tablet on the base of the column of Trajan in the same city. This will not strike him as unusual, for the teaching of lettering in England has for many years tended to suggest that the Trajan inscription is at once a representative and a supreme example of the inscriptional lettering of ancient Rome. It is only when he examines inscriptional lettering elsewhere in Italy and Europe that it may occur to him that it is only in 20th century England and 16th century Rome that the lettering on the Trajan column has been selected as a standard roman letter. (James Mosley)

All specifications:

The English visitor to Rome, if he has any familiarity with letter forms, cannot fail to be struck with the consistent quality of the architectural lettering which he sees on many of the late 16th, 17th and 18th century buildings. It is a letter which fits his preconceptions about roman lettering in a way that may not at first be easy to define. The proportions are close to those of the one ancient inscription with which he has more than a vague acquaintance: the tablet on the base of the column of Trajan in the same city. This will not strike him as unusual, for the teaching of lettering in England has for many years tended to suggest that the Trajan inscription is at once a representative and a supreme example of the inscriptional lettering of ancient Rome. It is only when he examines inscriptional lettering elsewhere in Italy and Europe that it may occur to him that it is only in 20th century England and 16th century Rome that the lettering on the Trajan column has been selected as a standard roman letter. (James Mosley)

When both the point size and the leading are changed at similar rates, the overall color remains similar to the original text.

Specifications:
Janson text, 9/13, justified, unkerned, 15 picas wide, 23.75 picas deep.

In combination, typesetting variables have dramatic effects. Each combination of specifications creates a different texture, color, and shape, which affects the appearance of the page. If the differences are extreme, the layout is affected as well. The paragraph above, for example, looks considerably different than the original and would cause the layout to look considerably different as well.

Specifications:
Times, 9/12, justified, kerned, 16 picas wide, 17.75 picas deep.

One of the folders on the disk that accompanies this book contains templates. A template consists of a page structure and type settings (styles) for several hierarchical levels. Page structure and type specifications for two of the traditional and two of the modern templates from the disk are provided here. The typefaces specified are commonly available on Apple laser printers; no additional (downloadable) fonts are required for their use.

Page structure specifications can be used for drawing the structure by hand or for setting up the templates with computer hardware and software not used for the disk. The reduced-size page structures shown in the workbook may be used as sketching underlays for exploring layout ideas and variations quickly. Exercises are included with each template.

Traditional 1

This template consists of constructed margins for an 11-by-17 spread, a central axis on each page, and six style specifications.

When looking at template specifications, you will find that in the modern style the type specifications are simple and the page structure is complex. In the traditional style, however, the page structure is simple, and complexity is introduced in the setting of the type, which provides much of the structure on the page.

Exercises

1. Using the traditional page structure shown here, redesign a page from this workbook. Include as much of the information shown on the original page as possible. Work in the traditional style and use the type specifications provided with the template. Did all the information fit on the page? How did you choose to organize the three types of information (text, exercises, and specifications) shown on this page? How useful was the page structure?

2. Create 3 variations of the page you redesigned in exercise 1. Do not change the margins or the style of the typography, only the layout. Change type specifications only as absolutely necessary. Add graphic elements if useful for organization. How different are your four layouts? Which do you think is the most successful in terms of style? In terms of communication?

3. Create another variation. Edit and reorganize the information as much as necessary to suit the style, but do not change the meaning or eliminate information. Modify the structure as necessary. Compare this to the first 4 layouts you created. How much change was necessary? Were aesthetic and communication qualities of your layout significantly improved?

4. Find at least 3 examples of pages that could be redesigned using this template. On what did you base your decision?

5. Find at least 3 examples of pages that could *not* be redesigned using this template. On what did you base your decision?

Traditional 1 template

Structure:
Constructed margins as shown in workbook topic 3.
Page size: 8 1/2-by-11 inches
Width of live area: 34.25 picas.

Type specifications:
All type set as unkerned Palatino.
Text: 11/17, justified, indented 1.5 picas, 6 extra points of leading between paragraphs.
Subhead 1: 14/17, small caps, centered, one blank line space before and after.
Subhead 2: 10/17, all caps, centered, 11 extra points of leading before and 6 extra points of leading after.

Caption: 9/13 italics, justified, first line indented 1.5 picas, right and left margins indented 3 picas
Head: 16/17 small caps, centered
Reference (i.e., footers): 9/17 italics, centered

Traditional 3

This page uses constructed margins on an 11-by-8 1/2 spread. Because the page size is small, this template will be most appropriate for projects that consist primarily of text. When a variety of nontext elements are included as well, it may be better to group them rather than try to integrate them with text. This template would be most appropriate for such projects as books; booklets, brochures, event programs, lists and tables; and simple catalogs that show only one or two items per page.

Because both Traditional 3 and Modern 3 are on a small page size that allows little flexibility, it is likely that if modern typography is used on the traditional structure, and vice versa, similar results will be achieved. Differences will come from the design principles that are applied, and to the relative linearity of the layout approach.

1. Using the page structure and type specifications provided here, redesign a chapter heading from *Alice in Wonderland* or from another children's book.
2. Create 3 variations of the page you redesigned, each using the same margins, text, and reference elements but with headings that reflect different approaches to the hierarchy of the chapter title and number.
3. Compare one of your designs with the original. Which one has the most words? Which one has the widest margins? Which one best represents traditional design principles?
4. How would you include an illustration and caption with your design? Would your approach vary from design to design? Why, or why not?
5. Redesign the first two pages of a chapter in a technical reference manual using one of the redesigned pages from either of the first two exercises, retaining the type specifications and page structure.
6. Find at least 1 example of a printed piece with a page of similar size that could *not* be adapted to this template. What would need to be changed? On what did you base your decision?

Traditional 3 template

Structure:
Constructed margins as shown in workbook topic 3.
Page size: 5 1/2 by 8 1/2
Width of live area: 22 picas

Type specifications:
All type is unkerned Times.
Text: 10/14, justified, indented 1 pica, with 4 extra points of leading between paragraphs.
Subhead 1: 12/14, italic, centered; 4 extra points of leading before and after.
Subhead 2: 10/14, italic, centered.
Caption: 9/10 italics, justified, first line indented 1 pica.
Head: 18/22, italic, centered.
Reference (i.e., footers): 7/10, all caps, widely spaced; footers flush left; page

196

Modern 1

On this six-column grid of 66 fields, a wide interval runs across the top of the page. This interval may be used for heads, subheads, and graphic elements, but text should not begin above the top grid field. Text, subheads, and heads run two columns wide; captions run one column wide.

The grid is set up for spreads—pages are mirror images of each other. True to the modern style, text is compact and sans serif; margins are minimal. The compactness of the text and the narrowness of the margins, however, must be balanced by open space. As a general rule, at least one-third of the grid fields should remain empty.

This template offers considerable flexibility, and is appropriate for a variety of applications, including brochures, data sheets, manuals, magazines, newsletters, catalogs, fliers, and instruction sheets.

1. This exercise will help you become more familiar with the subtle proportional relationships between fields and intervals, and can be done with both the modern grids. Create an asymmetrical composition of rectangles, using a grid as an underlay, by filling in one or more fields. Include only enough rectangles to imply where the grid lines are—leave as many fields empty as possible. Vary the sizes of the rectangles for scale contrast. (Because the grid is made up of vertical and horizontal lines, whole lines will be *implied* by sections of lines; our eye will group these sections using principles of continuation and closure.)

2. Choose a page from a do-it-yourself book and lay it out on this grid. Use the specifications shown to modify the type so that it matches the grid. How has the new structure affected organization? Communication? How could the information be edited or reorganized to take advantage of the page structure?

3. Collect a page from each of 3 different kinds of printed pieces that could be redesigned using this grid. (Magazines, catalogs, product brochures, and textbooks are examples of typical pieces to look for.) On what basis did you make your choices?

5. Choose one of the pages you collected in exercise 3 and create a new layout using the grid and type specifications provided in this template.

Modern 1 template

Grid specifications:
Page size: 8 1/2-by-11 inches
Inside margin: 4 picas
Field width: 6.75 picas
Text column: 14.5 picas
Interval width: 1 pica

Type specifications:
Helvetica, set FLRR, kerned, no indents. Paragraphs should be indicated by an extra line space return.
Text: 9/12
Subhead: 9/12 bold
Caption: 8/12 italic
Head: 11/12 bold

1. How many fields are on one page of this grid? How do you differentiate fields from margin?

2. Choose an 8 1/2-by-11 page from the *Modern 1* exercises and lay it out in an 11-by-8 1/2 spread using this grid. Does the spread have the same balance of space as the page?

3. Choose one of the spreads from the exercises with the *Traditional 3* template, and do a new layout using the *Modern 3* layout.

4. Find a page from a booklet, product data sheet, or book page and redesign it using this grid. Explore at least 6 layout variations before deciding on a final layout. Did the nontext elements need to be rescaled to fit the grid?

5. Compare your layout to the original: Does your final layout have more or less white space than the original? Does the text for this grid use more or less space than on the original? Which layout utilizes modern design principles best? How and why?

6. Mock up a page that uses a heading, text, and two subheads. Make enough photocopies to produce at least 3 variations on graphic elements that enhance and reinforce the hierarchy. Use a different graphic element on each and compare them to a variation that has no graphic elements added. Which is the most effective and why?

7. Find at least 6 other printed pieces that could be redesigned using this grid. On what basis did you decide?

8. Find at least 3 printed pieces that could *not* be redesigned using this grid. On what basis did you decide?

Modern 3

This six-column grid, set up as a spread, is for a 5 1/2-by-8 1/2 page size. Pages are mirror images of one another. Text, subheads, and heads run across four columns; captions run across two columns. Because the small page size limits flexibility, this template is more appropriate for simple, relatively linear printed pieces such as books and documentation. It may be useful for simple catalogs and brochures as well.

Although layout flexibility is limited by the size of the page, there is a considerable difference between using this template and the *Traditional 3* template. Adherence to modern design principles keeps the gridded page asymmetrical and elements in contrast. Because this is such a traditional page size, however, there is a temptation to think of the page in a traditional way.

Modern 3 template

Grid specifications:
Page size: 5 1/2-by-8 1/2 inches
Inside margin: 4 picas
Field width 3.75 picas
Text column: 18 picas
Interval width: 1 pica

Type specifications:
Helvetica, set FLRR, kerned, no indents. Paragraphs indicated by an extra line space return.
Text: 10/14
Subhead: 10/14 bold
Caption: 8/14
Head: 13/14 bold

Bibliography

Jeffrey Abt
The Printer's Craft
University of Chicago Press, 1982

Rudolf Arnheim
Art and Visual Perception
University of California Press,
Berkeley, 1969

John Benson and Arthur Carey
The Elements of Lettering
John Stevens, Rhode Island, 1940

Joseph Blumenthal
Art of the Printed Book, 1455-1955
David R. Godine, Boston, 1973

Sir Cyril Burt
A Psychological Study of Typography
Cambridge University Press
London, 1959

Rob Carter, Ben Day, and Philip Meggs
**Typographic Design: Form
and Communication**
Van Nostrand Reinhold, New York, 1985

James Craig and Bruce Barton
Thirty Centuries of Graphic Design
Watson-Guptill, New York, 1987

Carl Dair
Design with Type
University of Toronto Press, 1967

Maurice de Sausmarez
**Basic Design: The Dynamics
of Visual Form**
Van Nostrand Reinhold, 1964

Theodore L. DeVinne
Manual of Printing Office Practice
Battery Park Books, New York, 1926

Donis A. Dondis
A Primer of Visual Literacy
MIT Press, Cambridge, Mass., 1973

W. A. Dwiggins
Layout in Advertising
Harper & Brothers, New York, 1928

Adrian Frutiger
Type Sign Symbol
ABC Verlag, Zurich, 1980

Edward M. Gottschall, ed.
Advertising Directions 4
Art Directions Book Company
New York, 1964

Frederic W. Goudy
**The Alphabet and Elements
of Lettering**
Dover, New York, 1963

Graphic Arts
Garden City Publishing, New York, 1929

R. L. Gregory
The Intelligent Eye
McGraw-Hill, New York, 1970

Robert Harling, ed.
Typography 4, Autumn 1937
Harry Carter, *The Optical Scale in
Typefounding*

Armin Hofmann
Graphic Design Manual
Van Nostrand Reinhold
New York, 1965

H. E. Huntley
The Divine Proportion
Dover, New York, 1970

Allen Hurlburt
**Layout: The Design of the
Printed Page**
Watson-Guptill, New York, 1977

Allen Hurlburt
The Grid
Van Nostrand Reinhold
New York, 1978

R. S. Hutchings, ed.
Alphabet, International Annual 1964
James Mosley, *Trajan Revived*

International Typographical Union
ITU Lessons in Printing
Design for Printers—Job Unit IV
Elements of Composition—Job Unit I
Indiana, 1945

Johannes Itten
**Design and Form: The Basic Course
at the Bauhaus**
Reinhold, New York, 1964

W. Pincus Jaspert, W. Turner Berry,
and A. F. Johnson
The Encyclopaedia of Type Faces
Blandford Press, Poole, 1953

Herbert Jones
Type in Action
Sidgwich and Jackson, London, 1938

Wassily Kandinsky
Point and Line to Plane
Solomon R. Guggenheim Foundation
Museum for Non-Objective Art,
New York, 1947

Gyorgy Kepes, ed.
Sign, Image, Symbol
George Braziller, New York, 1966

David Kindersley
**Optical Letter Spacing for
New Printing Systems**
Wynkyn de Worde Society
London, 1976

Wolfgang Köhler
Gestalt Psychology
Liveright Publishing, New York, 1947

Robert Lawlor
Sacred Geometry
Thames & Hudson, London, 1982

John Lewis
The Twentieth Century Book
Reinhold, New York, 1967

John Lewis
Typography: Basic Principles
Reinhold, New York, 1963

London Times
Literary Supplement
October 13, 1927

Manfred Maier
Basic Principles of Design
Van Nostrand Reinhold
New York, 1977

Philip B. Meggs
A History of Graphic Design
Van Nostrand Reinhold
New York, 1983

Sean Morrison
A Guide to Type Design
Prentice-Hall, New Jersey, 1986

Stanley Morison and Kenneth Day
The Typographic Book, 1450-1935
University of Chicago Press, 1963

Josef Müller-Brockmann
Grid Systems
Arthur Niggli, Switzerland, 1981

Josef Müller-Brockmann
A History of Visual Communication
Arthur Niggli, Switzerland, 1971

Alexander Nesbitt
**The History and Technique
of Lettering**
Dover, New York, 1950

Nicholas Pastore
**Selective History of Theories of
Visual Perception: 1659-1950**
Oxford University Press, 1971

Robert O. Paxton
Europe in the Twentieth Century
Harcourt Brace Jovanovich
New York, 1975

Dan Pedoe
Geometry and the Visual Arts
Dover, New York, 1976

Paul Rand
A Designer's Art
Yale University Press, New Haven, 1985

Irvin Rock
Perception
Scientific American Library
New York, 1984

Bruce Rogers
Paragraphs on Printing
Dover, New York, 1979

Emil Ruder
Typography: A Manual of Design
Hastings House, New York, 1981

John Ryder
The Case for Legibility
Moretus Press, New York, 1979

Penny Sparke
Design in Context
Quarto, London, 1987

Herbert Spencer
Pioneers of Modern Typography
Lund Humphries, London, 1969

Herbert Spencer
The Visible Word
Visual Communication Books,
New York, 1969

Herbert Spencer, ed.
Typographica 3, June 1961
Ken Garland, *Typophoto*

Herbert Spencer, ed.
Typographica 12, December 1965
Ann Gould, *Art on the Assembly Line*

Herbert Spencer, ed.
Typographica 13, June 1966
Eckhard Neumann, *Aesthetic pattern
programmes*

Sallie B. Tannahill
**P's and Q's: A Book on the Art
of Letter Arrangement**
Doubleday Doran, New York, 1945

John Trevitt
Book Design
Cambridge University Press
England, 1980

Edward R. Tufte
**The Visual Display of
Quantitative Information**
Graphics Press, Connecticut, 1983

Mark Verstockt
**The Genesis of Form:
From Chaos to Geometry**
Muller, Blond & Whilte, London, 1987

Paul C. Vitz and Arnold B. Glimcher
Modern Art & Modern Science
Praeger, New York, 1984

Frank Whitford
Bauhaus
Thames and Hudson, London, 1964

Jeremy Wolfe
**The Mind's Eye: Readings from
*Scientific American***
W. H. Freeman, New York, 1986

Index

This book was designed, written, and produced using an Apple Macintosh SE and Aldus PageMaker, a page layout program.

The book was written in its final format—no preliminary manuscript was prepared. Most of the typographic examples were created directly on the page as needed. Draft versions of the book were printed on a laser printer. Mechanical art was printed by a Linotronic 300.

Book 1 was set in Caslon 540; book 2, book 3, and front and back matter were set in Frutiger.

End User License Agreement

The templates in this package are provided to You on the condition that You agree with Watson-Guptill Publications, Inc. ("W-G") to the terms and conditions set forth below. *Please read this End User License Agreement carefully. You will be bound by the terms of this agreement if You open the sealed diskette.* If You do not agree to the terms contained in this End User License Agreement, return the entire package, along with your receipt of purchase, to Watson-Guptill, Inc., Department TM, 1695 Oak Street, Lakewood, NJ 08701, and W-G will refund your purchase price.

W-G grants, and You hereby accept, a personal, nonexclusive license to use the templates and associated documentation in this package, or any part of it ("Licensed Product"), subject to the following terms and conditions:

I. License

The license granted to You hereunder by W-G authorizes You to use the Licensed Product on any single computer system. A separate license, pursuant to a separate End User License Agreement, is required from W-G for any other computer system on which You intend to use the Licensed Product.

II. Term

This End User License Agreement between You and W-G is effective from the date of purchase of the Licensed Product by You and shall remain in force until terminated. At any time you may terminate this End User License Agreement by destroying the Licensed Product together with all copies in any form made by You or received by You. Your right to use or copy the Licensed Product will terminate if You fail to comply with any of the terms or conditions of this End User License Agreement. Upon such termination You shall destroy the copies of the Licensed Product in your possession.

III. Restrictions Against Transfer

The End User License Agreement, and the Licensed Product, may not be assigned, sublicensed, or otherwise transferred by You to another party unless the other party agrees to accept the terms and conditions of this End User License Agreement. If you transfer the Licensed Product, at the same time you must either transfer all copies whether in printed or machine-readable form to the same party or destroy any copies not transferred.

IV. Restrictions Against Copying or Modifying the Licensed Product

The Licensed Product is copyrighted and may not be further copied without the prior written approval of W-G except that You may make one copy for backup purposes provided You produce and include the complete copyright notice on the backup copy. Any unauthorized copying is in violation of this agreement and may also constitute a violation of the United States Copyright Law for which You could be liable in a civil or criminal suit. You may not use, transfer, copy or otherwise reproduce the Licensed Product, or any part of it, except as expressly permitted in this End User License Agreement.

V. Protection and Security

All reasonable steps shall be taken by You to safeguard the Licensed Product, to ensure that no unauthorized person shall have access to it, and to ensure that no unauthorized copy of any part of it in any form shall be made.

VI. Limited Warranty

If You are the original consumer purchaser of the diskette in this package and it is found to be defective in materials or workmanship (which shall not include problems relating to the nature of operation of the Licensed Product) under normal use, W-G will replace it free of charge (or, at W-G's option, refund your purchase price) within 30 days following the date of purchase. Following the 30-day period, and up to one year after purchase, W-G will replace any such defective diskette on payment of a $5 charge (or, at W-G's option, refund your purchase price), provided that any request for replacement of a defective diskette is accompanied by the original defective diskette and proof of date of purchase and purchase price. W-G shall have no obligation to replace a diskette (or refund your purchase price) based on claims of defects in the nature or operation of the Licensed Product.

The templates in this package are provided "as is" without warranty of any kind, either expressed or implied, including but not limited to the implied warranties of merchantability and fitness for a particular purpose. The entire risk as to the quality and performance of the templates is with You. Should the templates prove defective, You (and not W-G) assume the entire cost of all necessary servicing, repair, or correction.

Some states do not allow the exclusion of implied warranties, so the above exclusion may not apply to You. This warrant gives You specific legal rights, and You may also have other rights that vary from state to state.

W-G does not warrant that the functions contained in the templates will meet your requirements or that the operation of the templates will be uninterrupted or error free. Neither W-G nor anyone else who has been involved in the creation or production of this product shall be liable for any direct, indirect, incidental, special, or consequential damages, whether arising out of the use or inability to use the product, or any breach of a warranty, and W-G shall have no responsibility except to replace the diskette pursuant to this limited warranty (or at its option, provide a refund or the purchase price).

No sales personnel or other representative of any party involved in the distribution of the Licensed Product is authorized by W-G to make any warranties with respect to the diskette or the Licensed Product beyond those contained in this End User License Agreement. *Oral statements do not constitute warranties,* shall not be relied on by You, and are not part of this agreement. The entire agreement between W-G and You is embodied in this End User License Agreement.

VII. General

If any provision of this End User License Agreement is determined to be invalid under any applicable statutes or rule of law, it shall be deemed omitted, and the remaining provisions shall continue in full force and effect. This End User License Agreement is to be governed by and construed with the laws of the State of New York.